Raw Colour with Pastels

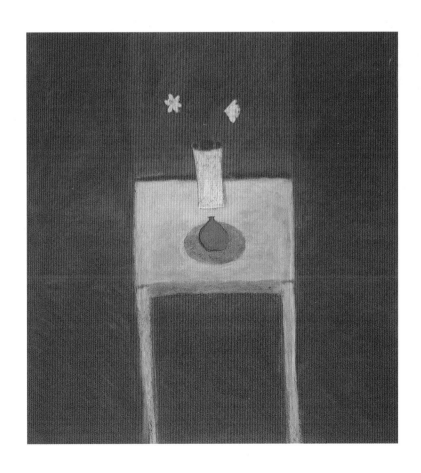

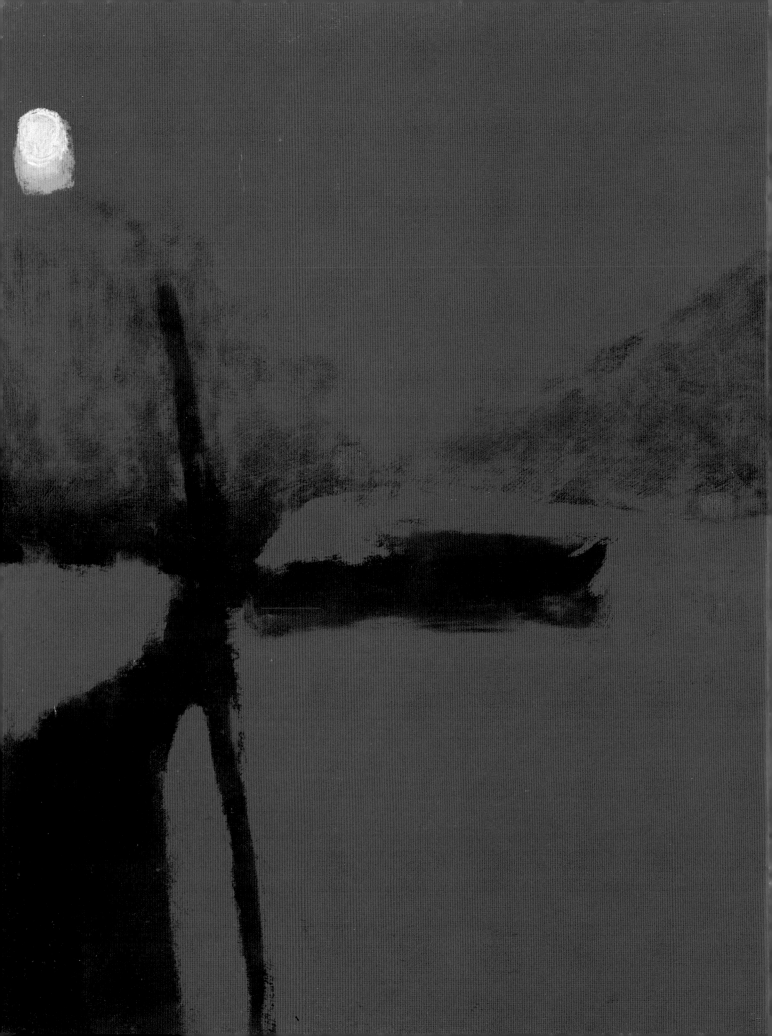

Mark Leach

Raw Colour with Pastels

HALF TITLE PAGE
Still Life with Fig
Pastel on paper
76 x 71 cm (30 x 28 in)

TITLE PAGE
Winter Night, Grand Canal
Pastel on board
75 x 80 cm (31 x 32 in)

RIGHT
Cotignac (detail)
Pastel on board
53.5 x 58.5 cm (21 x 23 in)

First published in the United Kingdom in 2006 by
Batsford
151 Freston Road
London
W10 6TH

An imprint of Anova Books Company Ltd

www.markleach.net

Book concept and packaged by
angelapatchellbooks.com

ISBN-13: 9780713489996
ISBN-10: 0 7134 8999 5

A CIP catalogue record for this book is available from
the British Library.

10 9 8 7 6 5 4 3 2 1

Reproduction by Classicscan, Singapore
Printed by Craft Print International Ltd, Singapore

This book can be ordered direct from the publisher
at the website: www.anovabooks.com, or try your
local bookshop

Distributed in the United States and Canada by
Sterling Publishing Co.,
387 Park Avenue South, New York, NY 10016, USA

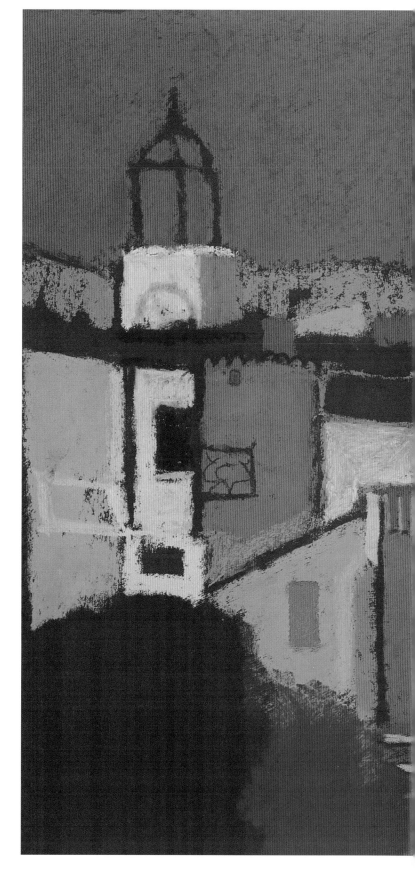

Contents

Acknowledgements

I would like to thank Angie Patchell for the original idea for this book, and for her experience and enthusiasm in helping me bring it together. Her confidence and encouragement were a constant inspiration. I am also very grateful for the wonderful photography of Colin Underhill, whose quiet dedication and skill contributed so much.

Special thanks to John and Kate Hersey of Unison Colour for so kindly finding the time to show me around their fascinating workshops. Finally, a great big thank you to Gaby, Ben, Sam and Simon for leaving me to get on with it.

Introduction

We all live in a world full of colour. If we can see, then what we see is colour, and only colour. Our eyes react to varying light waves that our minds interpret through the sensation of colour. Sight is our most refined sense: it gives us information, and it gives us pleasure. To work with colour is inspiring. It is a universal language that needs no translation or dictionary. Colour provides an almost limitless vocabulary with which to communicate how we see and how we feel. It has the power to explain and excite, sadden or stir, arouse yet calm.

Right:
Mark Leach in his studio.

Because colour is all around, and always there, we often take it for granted. Turn your eye from this page and you will immediately be bombarded with a million hues, tones and shades. Generally, we process this visual confusion as information, rather than something sensual or emotional. For the latter we look to artists. Sound is also all around us, and it is musicians who refine that sound into something of beauty. As a painter, I have always felt that my purpose is to craft colour in a similar way, to see through the confusion and seek harmony and beauty.

Burgundy Village
Pastel on board
75 x 83 cm (30 x 33 in)
A simple composition based on a dominant red hue gives a flavour of the Burgundy countryside.

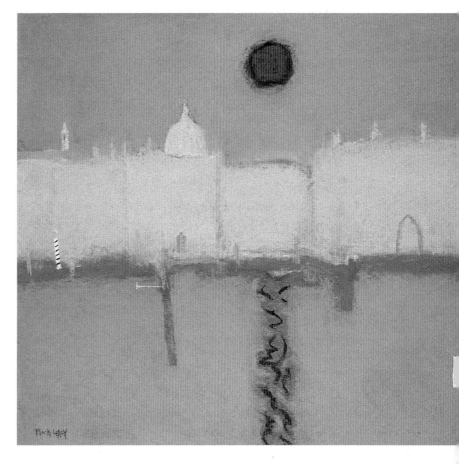

Grand Canal III
Pastel on board
70 x 80 cm (28 x 32 in)
There is often a sense of both excitement and quiet reflection about Venice. The blues and greens of the local light set the tone for this study of the Grand Canal. The reflected sun creates a contrast of colour temperature, which brings vitality to the temperate blues.

My passion for colour has grown over many years. Since starting as a landscape artist, where subject matter was the prime concern, I have become equally interested in the way colour affects that subject matter. Paintings are no more than two-dimensional colour and form. This is where their power lies. If I aim to capture, or create, something evanescent such as a sense of place, it is only through choice and application of the right colours that I will make this happen. To express how I feel about what I am painting, I must also make the best use of colour. If I feel passionate about a particular subject, I can best show that through using the colours of passion – strong reds for instance. Working to understand the endless properties and power of colour has helped me to express myself more fully. Colour is my tool, and I use it to create, as much as interpret or represent. Like Matisse, I use my colour to cause sensation, and to express how I feel. This is the purpose of my work.

To create with colour, we have to look to the natural and chemical pigments. These organic and inorganic substances reflect colour in its strongest and purest form. These pigments constitute the basis of all paints, dyes and colourants. We have used them to express and communicate since the dawn of mankind: they are colour in the raw. As a painter, I use pigment in all its forms. Each has its benefits, but to me the most rewarding, both in terms of usability and purity of colour, has to be soft pastel. This is the least adulterated method of handling pure pigment, and probably the closest we can get to working directly with raw colour.

In the last few years, the popularity of pastel has increased dramatically. Thanks to the enthusiasm and skills of both amateur and professional artists alike, the medium now holds equal status with all other painting methods, such as oil, watercolour and acrylic. In many cases, it transcends these methods. As a professional artist, there are often times I am asked to produce pastel work in preference to other mediums. I do not find this surprising. If approached correctly, the brilliance of colour, and quality of texture of pastel are unsurpassed. Pastel is nearly all pigment – colour at its purest. The powdery texture reflects light in all directions, bringing paintings alive. For the artist, pastel is a joy to work with, for it brings out the best of both drawing and painting skills. Line and colour become one.

In this book I explore my love of colour, and the path I have taken from landscape painter to colourist. The book is not just another practical guide to colour theory or pastel painting. Successful and worthwhile art is the product of inspiration, vision and enthusiasm, far more than practical technique. My aim is to inspire by sharing my thoughts and experiences from over twenty years of exploring colour through the pastel medium. There are plenty of technical considerations for those that need to know, but I hope to explain and encourage as much through ideas and passion as through practical know-how.

My approach to painting, and to pastel in particular, is not necessarily the most conventional. I like to paint on a fairly large scale, and refuse to be limited by accepted disciplines. This attitude has helped me to test pastel to its limits, and often beyond. I have found that it rarely lets me down. I also like to work quickly, and capture inspiration as it strikes. For this, pastel is unrivalled. My subject matter is all around. There are favourite themes, which I cover in Chapter 3, and different techniques for different circumstances. In everything I do, I look for balance, both in how I compose and subject matter. The overriding theme of my work is the balance of humanity with nature. This is as essential for my painting as it is for life itself. To this end, I mostly paint from recollection, in the studio. To see what is essential I need distance, and I find memory is the best tool for filtering out the unnecessary. Because of this, a lot of my work tends towards the abstract – but then all art is a form of abstraction. I consider this further in Chapter 4. My efforts have taken me down many roads, and it continues to be a journey of discovery and delight. I have proved to myself that there is no right or wrong way of doing things, that passion and enthusiasm will always overcome and, however much we have learnt, with each new painting the wonderful process of discovery and creation always starts anew.

Cherry Tree, Villecroze
Pastel on board
53 x 58 cm (21 x 23 in)
There is a certain tension in this painting of a cherry tree growing in the back streets of the Provençal village of Villecroze. Strong diagonals draw us in all directions, and the contrast of cool and warm reds creates further movement. I intended the simple shape of the cherry tree to bring calm and stillness to the composition.

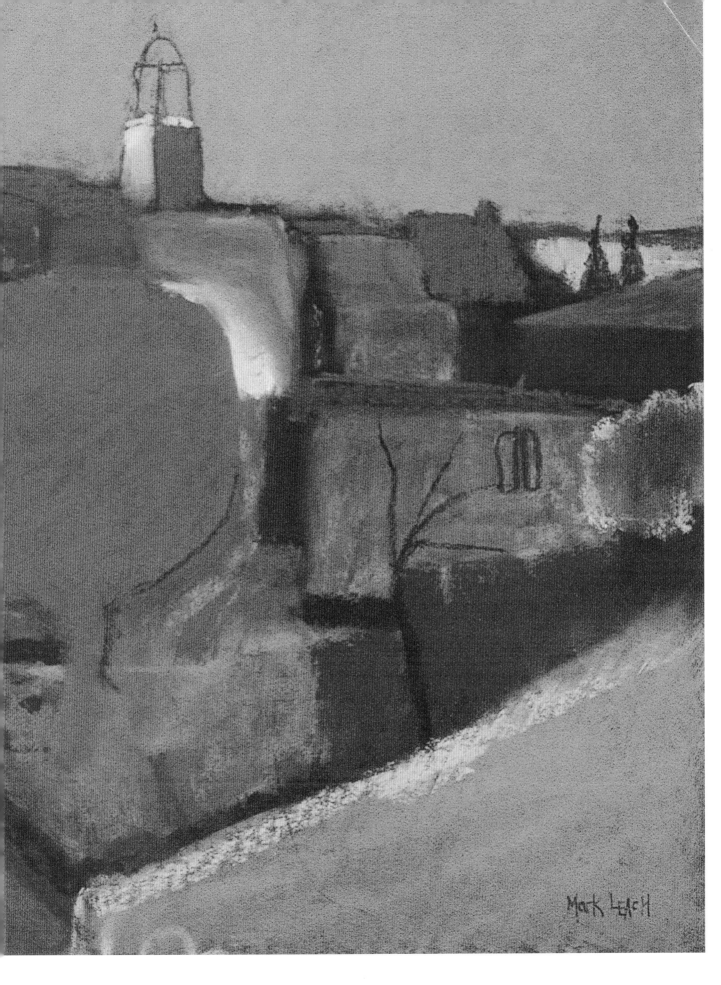

Flowers in Blue
Pastel on board 30 x 23 cm (12 x 9 in)
All my favourite blues come together for this small flower
study. It is important for me that all areas of the painting
have the same strength and excitement of colour.

In producing this book there have been certain problems to
address. Firstly, my long-held belief that the purpose of a painting
is to communicate that which cannot be put into words. Also,
that if a painting needs any explanation, then it has failed in that
purpose. Secondly, that the special qualities about which I am
enthusing, the texture of pastel and subtleties of its hue and tone,
may not necessarily be apparent through reproduction. These
concerns are inevitable, and in many ways similar to those that
have to be faced with any creative process, including painting. In
fact, I found that putting into words what I have previously left
unsaid has opened my own eyes to many new possibilities, and
other ways of seeing. The quality of reproduction is, in most
cases, far better than I could ever have wished. Writing the book
has added to my own understanding of what I do, and why I do
it. It is a great privilege and pleasure to share these thoughts and
ideas in the process.

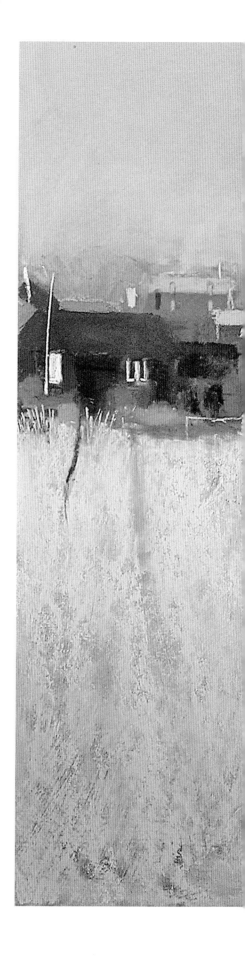

The Lighthouse at Aldeburgh
Pastel on board 70 x 80 cm (28 x 32 in)
The light of the Suffolk coast is gentle yet strong. There is
little shade, and natural colour is often muted and faded.
Against this we can enjoy the contrast of artificial colour, of
painted house and boats. The old lighthouse and
surrounding buildings at the southern end of Aldeburgh
provide a wonderful collection of abstract form and colour.

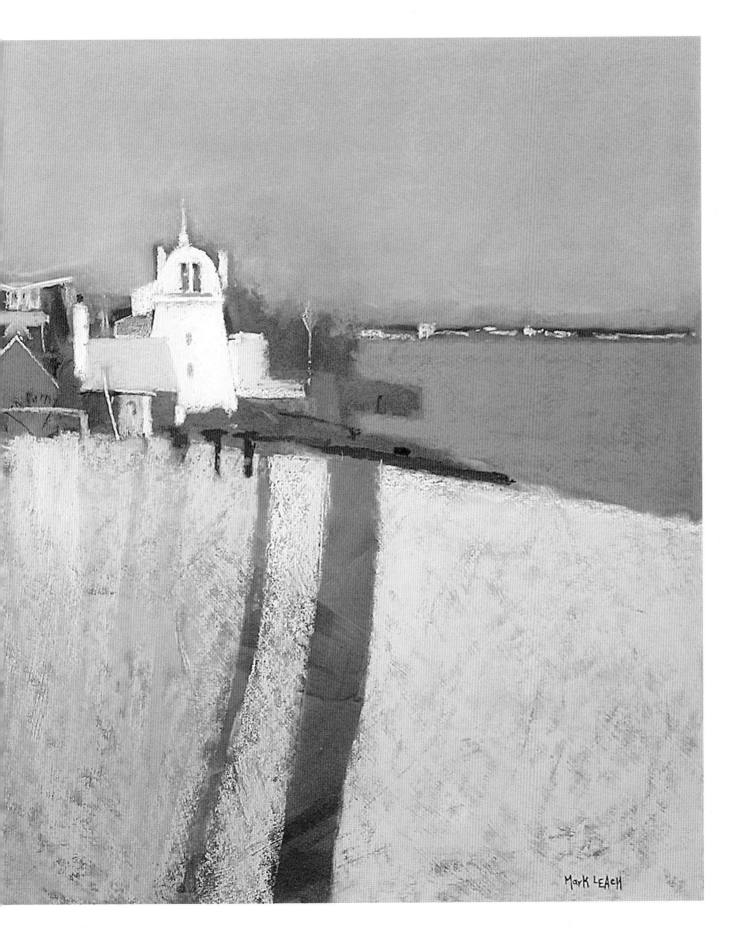

Working with Pastels

Pastel is the closest we can get to painting with pure colour. The word comes from the Italian *pastello*, meaning 'small quantity of paste', referring to the gum or wax that is bound with ground-up pigment to produce sticks that allow the artist to sketch and paint with the strongest, most natural colours available. The purity is invaluable – unlike all other media, pastel colour remains as applied, without darkening or alteration once dry. An almost infinite range of colour, tints and shades (obtained by the addition of black or white) can be created, with many further mixes available on application.

Painting with pure pigment can be traced back almost to the dawn of humanity. Our ancestors communicated pictorially through pigment long before the written word, and perhaps even before speech – recent research from Africa has discovered what may be paint-grinding tools dating back almost 400,000 years. The famous wall paintings discovered in Stone Age caves at Lascaux in Central France and Altamira in Spain, which date to between 17,000 and 11,000 years ago, were created from natural materials such as iron oxides, heated to produce various different colours. In the modern age, pigment continues to be used to communicate ideas. Drawing with natural and dyed chalks can be traced back to Renaissance masters such as Leonardo da Vinci (1452–1519) and Antonio Allegri (1489–1534, better known as

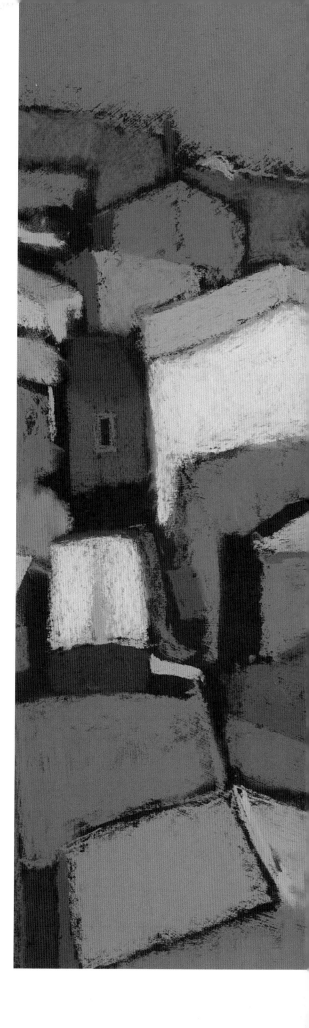

Roquebrune II
Pastel on board
70 x 80 cm (28 x 32 in)
Roquebrune clings precariously to the blue hills of the Côte d'Azur in southern France. The colours reflected off the buildings are a mixture of the ancient patina of stone and the strong Mediterranean light. Blue prevails, in the sky, the hills, the sea and the cool shadows. I show this through a strong blue under-painting, which is left to dominate. A few strong shapes of contrasting and complementary pastel heighten the effect.

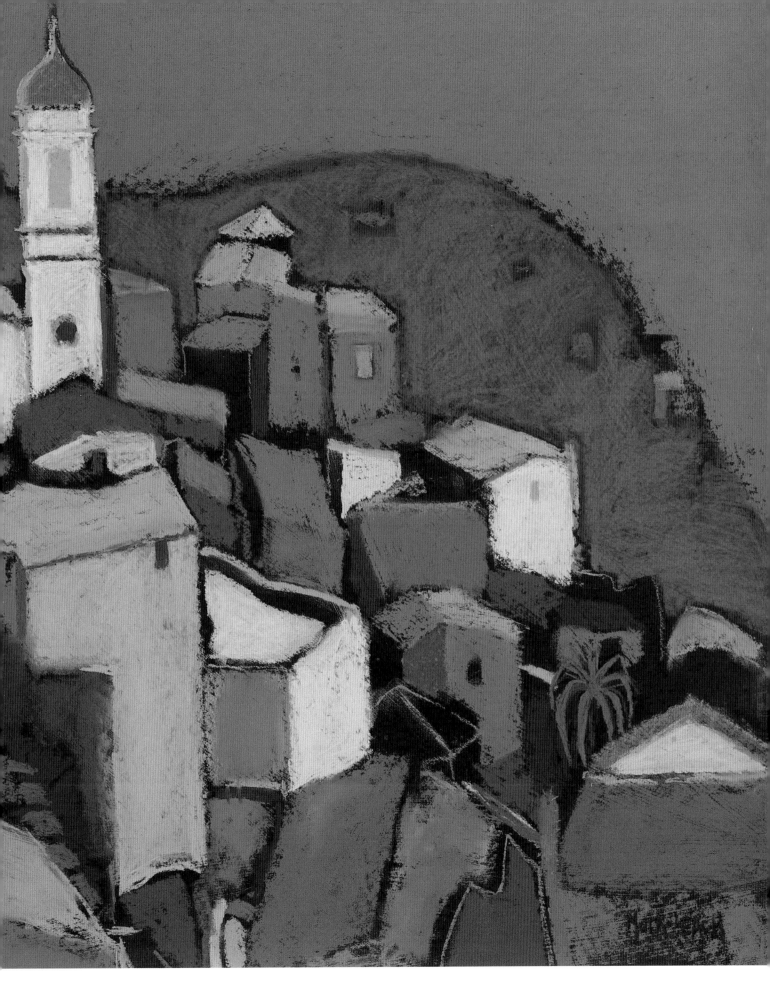

Correggio), who found the quick and tactile qualities of the materials ideal for preliminary drawings. Pastel gained in popularity during the 18th century, and became the favoured medium for society portraits. It continued to be used extensively until the early 19th century, when it temporarily lost favour. The Impressionists and Post-Impressionists were to rediscover its value, with artists such as Edgar Degas (1834–1917), Pierre Auguste Renoir (1841–1919) and Paul Gauguin (1848–1903) becoming enthusiastic proponents of its natural qualities.

Today, pastel is increasingly becoming one of the art world's favourite mediums. Artists and collectors alike are learning to value its natural beauty and permanence. No longer used only for sketching and preliminary work, pastel now holds its own with all other painting mediums as a significant contributor to contemporary art.

Inspired by Pastels

Pastel has allowed me to paint, draw and even sculpt in colour. My inspiration comes from what I see in the natural world. What I see is light, and light is colour. When I look at a rich, red rose, or the warm orange glow in the embers of a wood fire, my urge is to reach out and grab the colour, to possess it and make something of it. This is impossible, of course, but pastel allows me the next best thing. With pastel I can work with the very colours of nature, an almost endless palette of colour sensation that not just imitates nature but is nature, since so many of the pigments used come from natural sources.

It is important however to remember that the physical qualities in objects that give the appearance of colour are not absolute. When we look at a blue sky, the colour comes from the scattering of the sun's light by air molecules, and as the sun's angle to the atmosphere changes, so does the colour – blue light is scattered when the sun is high in the sky, and progressively redder wavelengths as the sun gets lower and its light has to travel through more of the atmosphere to reach us. In the same way, the colour of solid objects around us is the wavelength of sunlight that they reflect. Looking around, therefore, what we see is a barrage of different wavelengths of light, each with its own unique range of associations for the human mind.

Since I first started as a landscape painter, I was always aware of the limitations of paint to (literally) reflect the world in this way. The colours of oils and acrylics were splendid in their own right, but I always felt that I was limited by the flat solidness of the colour, rather than being able to use the reflected light of nature itself. For many years I included physical matter in the paint to try to overcome the problem – dust and earth from the hills I was painting, sand, grit, plaster and clay – all to break up the flatness of the paint and introduce a truer sense of the natural world. In the end, the paintings were more like sculptures, and all that texture was diluting the colour. I felt I was losing the challenge and joy of working in two dimensions, but more importantly, I was losing the purity of colour. How was I to find a way of working with, and reproducing, the wonderful colours all around me in a natural way that truly reflected the landscape?

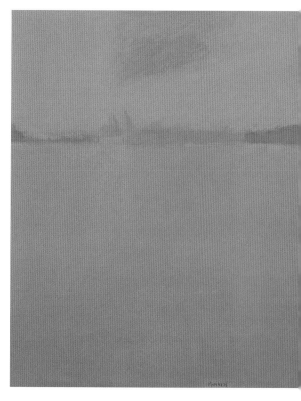

Towards the Salute
Pastel on paper
70 x 60 cm (28 x 24 in)
The chalky texture of pastel is ideal for capturing the misty, shimmering light of the Venetian lagoon. Unlike paint, the small, dry granules of pastel reflect light in a similar way to fine molecules of water in the air. There is a sense of looking at actual light.

The answer turned out to be pastel – soft sticks of the most natural pigments, unaffected by the binders used in liquid paint mediums, and the purest colours available to us. In retrospect, to have overlooked this most obvious of mediums seems absurd, but the moment the solution occurred to me, I knew my path was set. No medium is perfect, and all have their weaknesses, but somehow I knew that pastel would work for me, and that I would make it my purpose to master it.

Saint Tropez Sunset
Pastel on board
35 x 40 cm (14 x 16 in)
I enjoy composing landscapes that include the principal elements of land, sea and sky. This is one reason that blues often predominate in my work. Reflections and sunsets are a fine way of bringing these elements together.

San Marco
Pastel on board
75 x 80 cm (30 x 32 in)
Once again, I am aiming to recreate the Venetian light through the texture of pastel. To capture or create a sense of place, I find texture and colour far more important than any detailed study of architecture or topography.

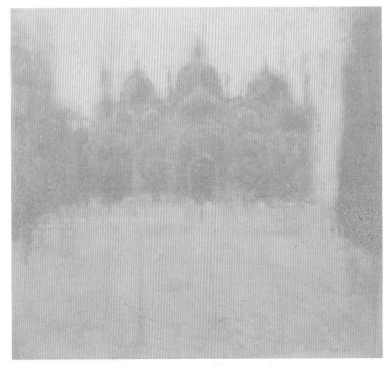

Types of Pastel

Pastel is a generic term for pigment bound together with just enough resinous substance to make a solid stick that can be held and manipulated. This can include crayon, chalks, coloured charcoals, oil pastels and oil bars, as well as the most commonly used soft pastels. What is shared by all of these is that they are dry mediums that are shaped to be held, and applied directly. This does not mean that they are therefore just drawing mediums. Drawing implies the use of line and, as those who have attempted it can attest, line drawing is not best achieved using large, almost clumsy, bars of colour. In fact, I would suggest that it is far easier to 'draw' with paint and a fine paintbrush than the average pastel stick. I would therefore say that the most important characteristic of pastel is that it is the most direct and convenient way of applying colour pigment directly to a surface.

It is the ability to work with pure pigment that makes the pastel medium unique. For my purposes, it is the so-called soft-pastel sticks that best provide this. Soft pastels should not be confused with chalks, which derive from natural or fabricated chalk that is dyed. The soft pastels used throughout this book are produced primarily using natural minerals such as cadmium, cobalt and natural or man-made earths. These pigments, ground up into a powder, are combined during manufacture with a small amount of filler and gum to make a paste that is then shaped as required, and dried.

Oil pastels and crayon are made in a similar fashion but use oil or wax as the binder. Oil pastels can provide striking colours and, unlike soft pastels, can be easily blended and mixed on application to produce further colours. Although they do not totally dry, over time the oil binder tends to evaporate, as with oil paints, which leads to slight colour changes. It is for this reason that I treat oil pastels and bars as more akin to paint, and the effects produced through this medium are possibly best achieved through painting.

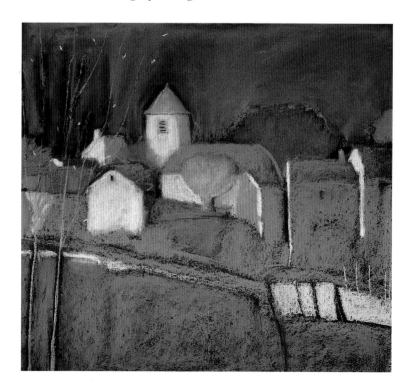

Garonne Village
Pastel on paper
55 x 60 cm (22 x 24 in)
I have used a limited palette of Unison blue-greens over a very dark base of blended blue-violet to capture the cold early-morning light of this small French village. The slightest touches of red-orange in the leaves bring immediate depth and drama, and help accentuate the stillness of the blues.

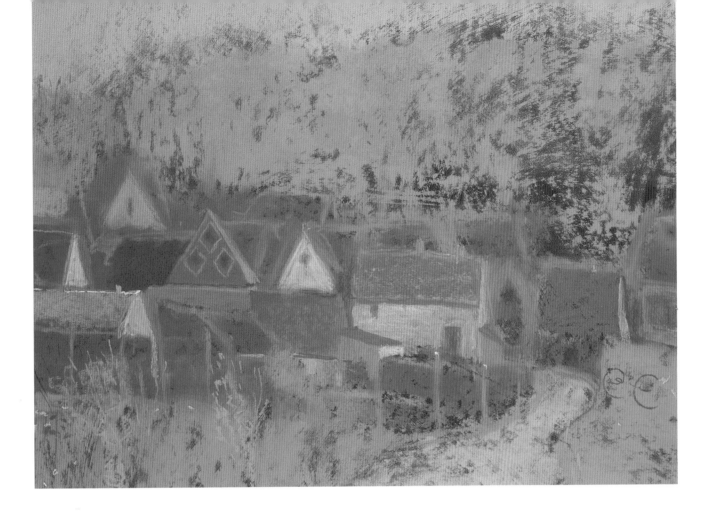

Villers-la-Faye, Côtes de Nuits
Pastel on board
58 x 52 cm (23 x 21 in)
A gentle study of a typical Burgundy village,
midway between Beaune and Nuits St Georges.
A heavily textured under-painting allows the base
colour to shine through the layers of pastel, which
brings unity to all the various shapes and colours.
This luminosity is best achieved using harder
pastels, as softer ones give a deeper, more
opaque texture.

Soft pastels are produced in many ranges, both handmade and
factory-produced. The most common brands available include
Unison, Rembrandt, Daler-Rowney, Winsor and Newton,
Sennelier and Schmincke. In the United States, Nupastel sticks
are also widely used, while in Australia, the Art Spectrum range
is a favourite. Each of these brands tend to be distinguished by
their colour range and their relative hardness. Pastel hardness
is dictated by the amount of binder: more binder means less
pigment, but allows for more detailed drawing.

Unlike paint and oil pastel, soft pastel colours cannot be mixed
on application. Colours can only be combined by gentle layering.
It is therefore necessary for pastels to be available in a large range
of colours, tones and shades – many of which, in other mediums,
would be created by mixing. Each manufacturer offers their own
unique, wide-ranging palette of pastels in which each colour is
designed to blend with the others in that maker's range. I will
discuss this in the following section.

My own preferred brand of soft pastels are Unison. These are
handmade by a small company in Northumbria and provide a
subtle palette of nearly 400 shades influenced by the distinctive
landscape and light of Northumberland. For me, their size and
consistency are just right for my more expressive works, but I also
make use of most of the other makers' ranges to some extent for
reason of detail, texture and colour shade. I do try to keep my
basic working palette as small as possible, so that I can fully get
to know my colours and master them, but that is usually only a
starting point, and it is essential to have a large colour range to
hand both for inspiration and expression.

Colour Range

Artists' pastels are usually based on high-quality natural organic and synthetic pigments (see Chapter 2 for more on their composition) to which either black or white is added to produce up to 500 or more colour variations. For instance, the famous German company H. Schminke produces a very attractive range of beautiful extra-soft pastels based on 54 pure pigments, each of which is varied by four additional shades: one with black added, and three with varying amounts of white to give progressively lighter tints. In addition there are a variety of grey tones, darker colours, and pearl and lustre effects, giving the pastel artist a total range of over 400 colours to choose from. Although most manufacturers tend to work with the same basic set of pigments, each has developed their own distinct palette, sometimes over the course of centuries, so between them the total variety of colour available to the pastel artist is almost infinite.

Even though there is such a large choice of colours available, it is probably way beyond the means of most artists to maintain such a selection in the studio. The majority of manufacturers offer boxed sets of the most usable colours, sometimes themed towards a genre such as portrait or landscape. These can be helpful to the novice, but one soon finds a range of colours and shades to suit personal taste, and one can then expand from this as time and experience progresses.

The hardness of the pastel may also dictate the colour range needed by any one artist. I tend to use the harder pastels, such as Rembrandt or Inscribe, for initial under-painting, as they do not fill the 'tooth' of the paper to the degree that the softer pastels do. They are also better for final detail work, as they are able to provide finer lines. Considering this, it makes sense to maintain a representative range of both darker and brighter shades for the hard pastels, and one generally finds that manufacturers allow for this in their selection of pastels for sets.

Over the years I have tried to build up and maintain a comprehensive palette of soft pastels, with the emphasis on the three primary colours (red, yellow and blue). Although I consider myself a landscape painter, I am first and foremost a colourist. Because of this, I have tended to shy away from the more subtle earth colours – greens and browns – which I would prefer to evolve from mixing the primaries. This is a totally personal approach, but I hope that the method is reflected in the paintings.

Left:
A small box of favourite pastels that I use for sketching.

Saint-Germain Morning
Pastel on board
75 x 80 cm (30 x 32 in)
A touch of colour and elegance on a cold, damp morning on Paris's Left Bank. I have used a straightforward palette of primary and secondary colours to bring life and contrast to the greys and neutrals of the wintry streets.

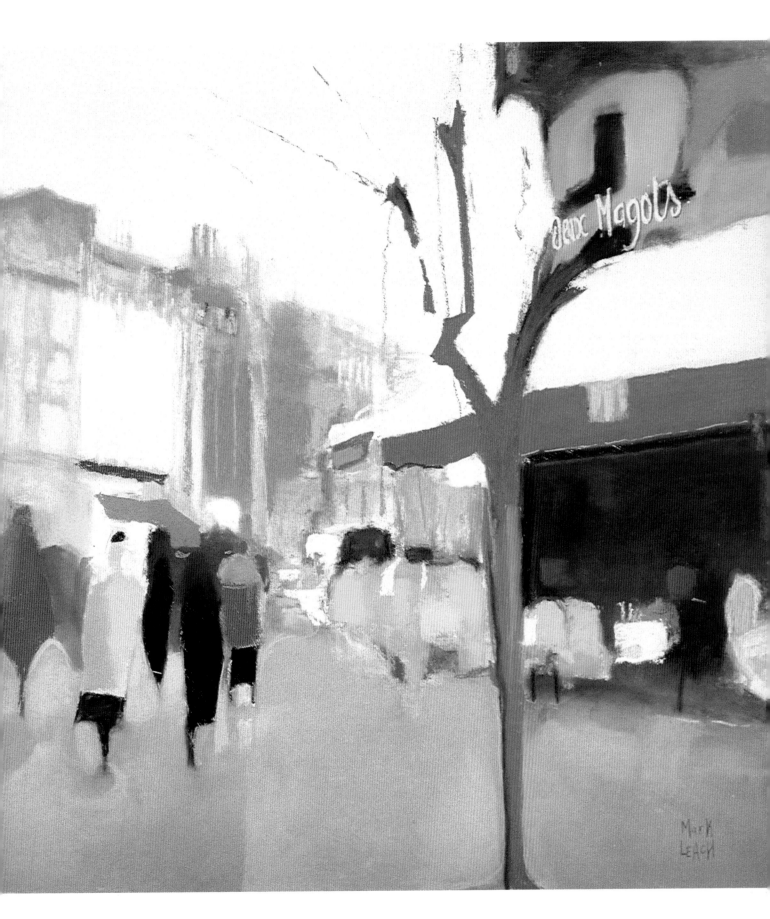

Making Pastels

The pastel-making process is relatively straightforward but requires careful monitoring of the quantities involved. Mineral, organic and chemical pigments in the form of powder are bound into sticks using agents such as gum tragacanth or rice starch. Sufficient binder is needed to hold the pigment together and provide a stick that can be held firmly but that will also allow the pigment to attach to the paper or support, and provide a good cover of colour without too much pressure. The more binder that is used in the mixture, the less colour will be transferred to the paper and the more pressure needed to do so. Too little binder, on the other hand, and the pastel stick will either crumble in the hand, or leave a deep and dense layer of pigment dust that will simply fall off the paper. Furthermore, the amount of binder needed for each pastel cannot be a constant factor across all colours, as each pigment has its own chemical composition. This is naturally further complicated when different pigments are combined within a single stick.

Whether factory- or hand-made, all soft pastels are produced in a similar manner. In both cases, consistency of texture and colour are paramount. Most manufacturers use between 50 and 80 pigment colours from various origins, the best-known of which include mineral-based ones such as the varieties of sienna and ochre, organic ones such as carmine, and ones produced by industrial chemistry such as cadmium. The colour range of factory-produced pastels tends to be based on the established pigment colours, whereas specialist handmade pastels, such as Unison's, often have their own distinctive palette of colours produced from mixed pigments. All the basic colours and their associated tints and shades are monitored carefully to ensure that a particular stick of, say, a blue-green shade that you bought ten years ago but have only just got around to using, is still matched by a stick that has just come off the production line.

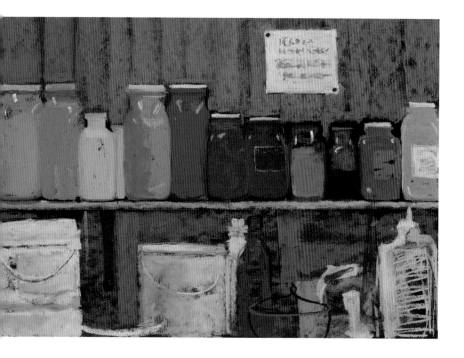

Pigments
Pastel on paper
45 x 68 cm (18 x 27 in)
In the Unison workshops in deepest Northumberland, jars of the purest and most natural pigments prove irresistible. This sketch is made using those pigments.

The principal difference between factory-produced and handmade pastels is in the extrusion process. Handmade pastels, such as my favoured Unison, tend to be bound using pestle and mortar, spooned individually on to specially prepared drying paper, then rolled by hand. In a factory-made process, a dough is kneaded by machine and then forced through worm extruders that shape and then cut the mixture into the individual sticks. In both cases the pastels require around eight days to dry before being hand-labelled and packed. The standard size of most manufactured pastels is roughly 65 mm (2½ in) long, and slightly fatter than a pencil. Unison also produce a range of extra-large pastels, about twice the size of the standard sticks, which are especially useful to those who are inclined to the extravagant and the monumental (such as myself!).

Autumn by the Seine
Pastel on board
70 x 80 cm (28 x 32 in)
There is little formal composition to my feelings for a golden afternoon by the river Seine. Without any conscious planning, I simply let the intrinsic qualities of my pastels go to work and let the colours and textures tell the story.

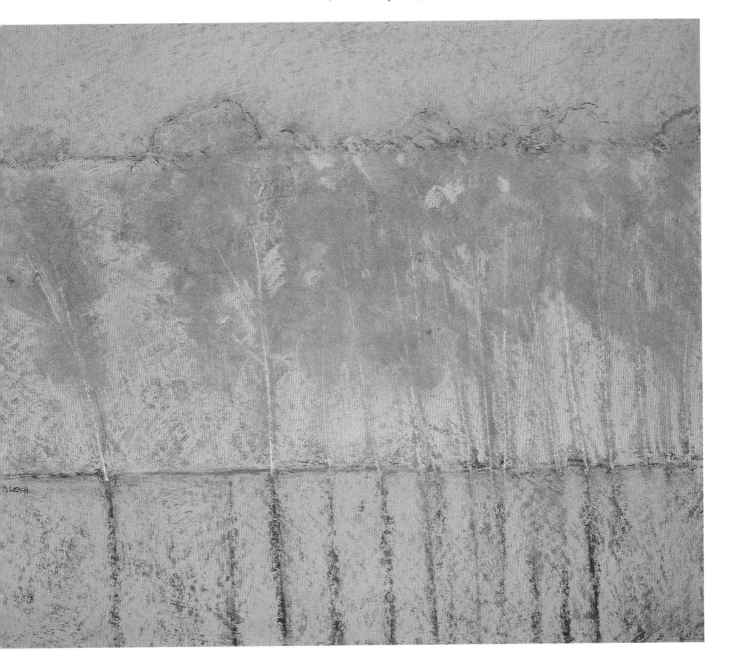

Tools and Equipment

As a sketching medium, pastel is unsurpassed in its portability and ease of use. A small selection of favourite colours and a pad of suitable paper is all that is needed. Maybe a putty rubber and small can of fixative would also be useful, but these are not essential. Compare this with the equipment required for oil or watercolour work, such as brushes, liquids and easels, and one can easily see that pastel is a medium that does not rely on tools. This is a tremendous benefit, but does not mean that working with pastel is not aided by the right equipment.

I work primarily in a studio environment (see Chapter 4). This means that I do not have to restrict myself when it comes to equipment. In fact, the more equipment I have to hand, the more reassured and relaxed I can be. As a minimum for studio work, I would recommend a large, angled easel with supporting board, a very large table to hold a full range of pastels, putty rubbers, dry brushes of various sizes and shapes, possibly rubber and foam blenders, and paper stumps, fixative spray, and a bag of either flour or ground rice for cleaning the pastels. I would also recommend a convenient bowl of water for rinsing the hands, and an endless supply of tissues and reusable kitchen cloths for every possible purpose.

All pastel artists have their own favoured method for storing their pastels, but many flat boxes will be needed to maintain some sort of order. For loose pastels, a layer of ground rice in the base of each box will help to keep the sticks clean and separate. I used to cover all my pastels diligently at the end of each session to protect them from sunlight, but I have since been informed by John Hersey of Unison that this is totally unnecessary, as the colour pigment should last indefinitely.

Putty rubbers are helpful for general erasing but nearly always damage the support-surface texture to some degree. Once used, they will reduce the number of eventual layers that can be applied to the surface. More gentle erasing materials, such as fresh bread (not the crust!) or brushing with a dry brush should always be tried first. I also make good use of brushes for drawing into the pastel, either by removing top layers or going down to the base under-painting. This too can be done in a vigorous and expressive way with the putty rubber – it all depends on your style of painting.

The use of fixative is always a contentious matter among pastellists. Certainly, most would agree that it is best avoided at the final stage. In all cases, pastel pigment will fall off a finished painting to some degree. It is far better to accept this, and make special compensation in the mounting and framing. Where fixative can be helpful is in the intermediate stages, where I am happy to use it to give me an extra layer or two to work with. Preparing your own fixative is a good way of ensuring a dilute mixture, but there are some perfectly adequate aerosol sprays available. Most are generally light, although one or two are not and certainly should be avoided. Be warned – many pastel paintings, including a good few of mine, have been ruined either by a bad fixative, or through not ensuring the spray is flowing evenly before applying. Always treat fixative with a lot of care.

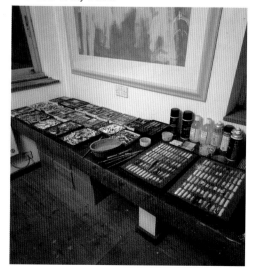

Below:
The tools of my trade.

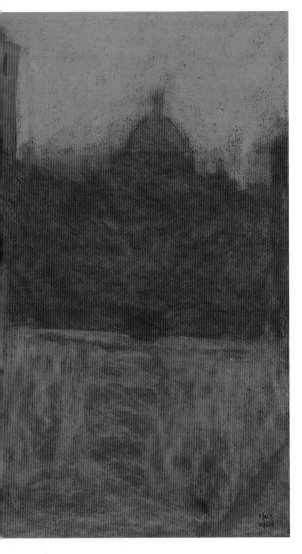

San Pietro, Venice
Pastel on paper
75 x 70 cm (30 x 28 in)
This simple composition is brought to life and given character through the texture of the support. In this case, I used a plain white, rough watercolour paper. I blended in a combination of reds and umber pastel, which was subsequently fixed. A pale yellow tint was used to highlight the sky and water. A putty rubber gave distance to the bell tower and dome. Drawing into pastel, with either a dry brush or putty rubber to reveal the underlying support, can be a very effective way of sketching and composing.

Choosing Supports

For pastels to work at their best, it is necessary for the paper or support – such as card or canvas – to have a suitable texture. Without this, the pastel will not adhere to the surface. Ordinary drawing paper, and the finer watercolour papers, can be used for very simple sketching, but some of the pastel dust will always be lost. A good texture will allow a build-up of pastel layers, which is essential for producing strong and vibrant images.

I have experimented with various ready-made papers and cards from time to time. All have different degrees of texture in the paper itself, or are pre-primed with gesso and grit. There are even very fine sandpapers that hold the pastel extremely well. My favourite papers are the Art Spectrum Colourfix range, which are strong, provide a good tooth, and have a very good range of strong, light-fast colours. I also use the Sennelier Pastel Card, which has a beautiful texture, but is water-soluble and so has to be treated with a lot of care. Other popular papers in the UK include those made by Winsor and Newton and the Ingres and Tiziano ranges from the Fabriano Mill in Italy. In the United States, Kay Wallis papers are very well regarded, and the Canson range is also very popular. Artists must decide for themselves what suites them best, but in my experience the stronger the texture, the happier the artist.

In addition to the ready-made papers, textured watercolour papers hold the pastel reasonably well, although the layering they allow is limited. Similarly, a rough canvas, properly primed, can be used to some effect.

My pastel work tends to be large, the majority of paintings averaging 90–120 cm (3–4 ft) square. This does rather limit the choice of pre-prepared papers and supports. In many respects, pastel is still considered a sketching medium, and the size of manufactured pastel papers, and even the sticks themselves, often reflect this. This does not mean that larger papers are not available, but they are not always easy to find, and are often in a limited selection of colours. Mostly I work on acid-free, extra-thick mount card, which I have primed with a mixture of one-third acrylic gesso, one-third pumice powder, and one-third water. I then under-paint with a strong wash of acrylic paint, to which I add another dash of pumice dust (just in case there are any small gaps in the initial priming). This method gives me good control of the texture, which can be varied by the amount of dust used. It is also a robust support suitable for any form of mixed-media approach, and which can even be re-primed in sections should reworking be necessary.

The ability to under-paint in the exact shade of colour I require is probably the major reason for making my own boards. An important concern with ready-made papers is not only that there is a very limited choice of base colour, but that these colours are all opaque and uniform.

The under-painting will always dominate the finished work, and its initial application and brushwork will set the tone of the painting and provide inspiration throughout the working process.

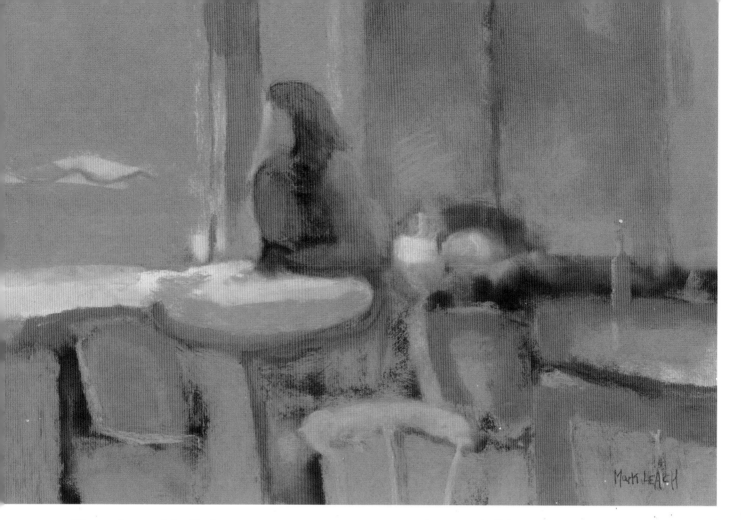

Drawing with Colour

As I discussed earlier, I consider the use of pastel to be possibly the furthest extension of the idea of drawing without physically working pigment or paint by hand. It is the last method I would consider for a simple line or hatched tonal sketch. Pastel pencils are well suited for these purposes, but I am sure a brush or possibly a palette knife would be preferable. When I see a stick of pastel I simply see a block of colour, to be spread and moulded and smoothed and blended, a light-reflecting substance that gives shape and form to colour, the way clay gives form to a pot.

So my approach is to draw with colour. This requires a special way of looking at the world. From childhood onward it is natural to draw with line, to identify and represent the world by the outlined shape of things. Instead of depicting the substance of the objects we see, therefore, we note only the point where different things meet; this is the basis of all drawing. Drawing gives expression to our primary instincts to represent the world in a linear way.

As we mature, so does our drawing. As older children we progress to colouring in. We start to see the world in a more sophisticated way. The blue line of sky at the top of the page now spreads and is seen as a coloured shape. The round faces of the people are made flesh-coloured, leaves are green and tree trunks brown. And as our minds grow and develop, we realize that objects do not consist of just one colour, that not every leaf on the tree is the same shade of green. We are training our mind to sense the subtleties of colour.

In Retrospect
Pastel on paper
40 x 58 cm (16 x 23 in)
Deep in thought, and all around is little more than a blur. The subject here is the mood and the ambience. There is no specific drawing, just subtle variations of hue and tone evolving from the basic under-painting.

My attitude is that this way of seeing, and looking, must be continually trained and matured. At some point we come to realize that what we draw are not coloured-in shapes, but a total mass of reflected light waves, a cocktail of colour. Maybe, because of the way we developed as children, or were taught at school, our brains give shape to our images through creating linear models, using lines as a shorthand way of identifying and interpreting, but we should not let this restrict the way we work. Our intellect should tell us that all we see is colour, and that this is how we should draw and reflect our world. Not so much a 'colouring-in' process as a 'colouring-out' one.

Pastel encourages and facilitates this approach. By working with large slabs of colour I start by summing up the essence of the image, and work upwards and outwards from there. Any shapes or lines occur only as they would in nature, through converging colours. For example, in the painting of the conversation *At Lunch* shown below, all composition and design was done by gradually applying different shades of red to a deep-red background and slowly building up subtle blocks of colour. There was no initial linear design, and my only concern was controlling colour balance. This allowed the composition to evolve as a whole. Only when the composition is nearly complete would I consider adding the odd hint of a drawn line, to accent or contrast.

At Lunch
Pastel on paper
45 x 58 cm (18 x 23 in)
Here I encourage a sense of intimacy and sharing by using closely related colours.

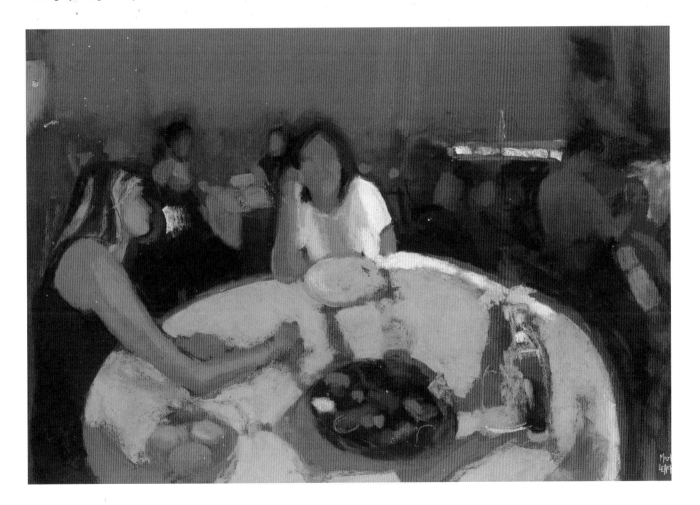

Mixing Colour

When it comes to colour, it is important not to approach a pastel work as you would an oil painting or watercolour. With paint there is almost always an intermediate stage, where various colours are spread on a palette and mixed and possibly diluted before application to the working surface. A maxim for painting is: never mix paints on the paper or canvas. But with pastel one does not have the benefit (or hindrance, depending on one's attitude) of this method. One's palette of colours has been kindly prepared by the manufacturers, and it is these colours that will go directly on to the picture surface. If one is to mix colours, then this has to be done on the painting itself, either through careful layering, or gentle blending. Pastel boards and paper are designed to take a number of layers of pastel to facilitate this, and this can usually be extended through various fixing methods. Many pastel artists will recommend a light-to-dark approach to building up a pastel painting (laying down the lighter colours first and layering the darker colours on top). This does not appeal to me – it feels wrong for the medium and does not suit my temperament. Far better to get a strong defining colour down to start with, create a composition with further strong colour – whether complementary or analogous – and follow that with subtle light and shade as necessary. Applying a darker shade over a lighter colour will, in my opinion, tend to overpower it, even when blended. The reverse tends to mirror natural light, where the brightest reflection will be on the surface of an object.

One can of course start to treat pastel pigment as if it were paint, by adding water or spirit and working it on the surface with brushes. There are no rules, and this has worked well for many artists, most notably Degas, who often used steam to soak blended layers into the paper before adding further pastel. As with paint, any addition of liquid to the pigment will result in the colour darkening. This is also the case with spray fixative. The effect will not only be darker, but the 'sparkle' of the pastel will, to some degree, be lost. But a benefit of wetting the pigment is that applying a fresh layer of the same pastel to a layer already wetted or fixed will add an extra vibrancy to that colour. I would sometimes recommend fixing or wetting colour if a subsequent colour is either opposite in temperature (for instance, a 'cool' green against a 'warm' orange), or complementary (on the opposite side of the colour wheel – see Chapter 2). In these instances, simple layering, and especially blending, can often lead to a very dull result. A fixed surface will help to maintain the qualities of the second colour.

However, all pigments differ, as does the chemical make-up of each pastel stick, so it is not easy to generalize. I would recommend that you try every approach you can think of to see what actually works best for you. Having said that, nearly all methods of colour mixing on the paper will to some degree muddy and flatten the refractive properties of the pastel pigment. No matter how carefully it is done, any overworking of the first layer of pastel will reduce its impact, and it will be almost impossible to return to the earlier point. Far better to work as much as possible with the colour palette available, and avoid mixing unless absolutely essential.

Lovers in the Park
Pastel on board. 75 x 100 cm (30 x 40 in)
I wanted to get as much colour and light into this scene as I could without losing the natural hues and tints of
the plane trees. Pastel encourages you to detect and make best use of the constituent elements of colour.

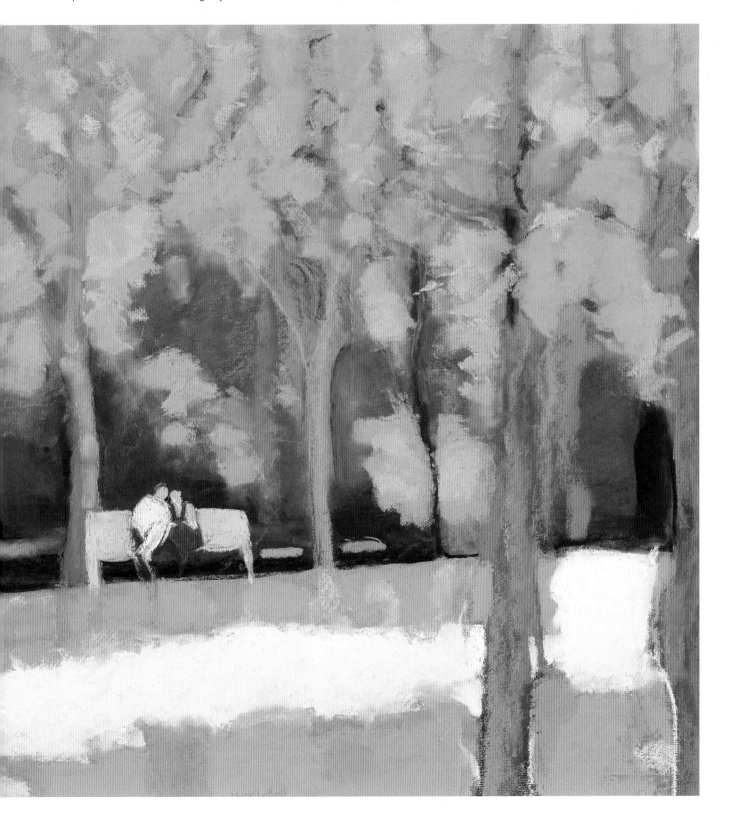

Applying Texture

In addition to colour and form, I would consider texture to be one of the most important compositional tools when working with pastel. Although we can suggest depth in a two-dimensional image, usually through perspective or tonal effects, it is the texture of the medium itself that gives us a real depth. Ever since Paul Cézanne (1839–1906), many Western painters have treated the painting not just as an illustration but also as an object in its own right. The illusion of depth has been replaced by the flat picture plain, where each part of the painting has equal importance and there is an overall sense of balance. The illusion of reality has therefore, to some extent, taken second place to the quality of the brushwork, the beauty of colour and form, and the texture of the picture surface. This is most apparent in the development of abstraction as an art form, but the progression has made itself felt in nearly all aspects of modern painting, and is now an integral part of the picture-making process.

Texture in a pastel painting is dependent on the surface of the support being worked on. Whatever your method of applying pastel, if the support is too smooth it will not be possible to build up layers and create a textured look. The rougher and grainier the support, the more pastel will be held, and the more its natural texture will be apparent. I would always recommend using as few a layers as possible in any pastel work. To produce the best textural qualities in a pastel painting, nothing beats a single strong layer of pastel laid over a similarly strong under-painting. If you do feel the need to build up layers and maintain the textural quality then, as mentioned earlier in relation to colour blending, each layer needs to be fixed in some way. Without this, each subsequent layer tends to flatten, and the sense of texture is lost. Once again, Degas was very aware of this. Quite often, he would turn each layer into a paste through the addition of spirit and leave it to dry before further applications of pastel.

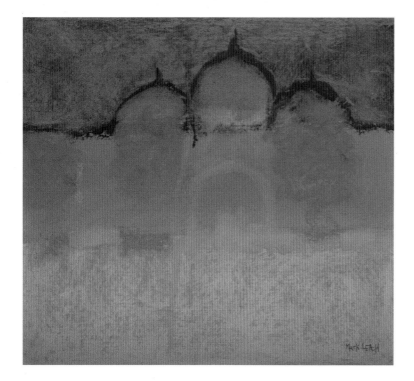

San Marco
Pastel on board
35 x 40 cm (14 x 16 in)
In this impression of the church of San Marco in Venice, I let the texture of the under-painting dictate the work. A very thin and gently applied layer of pastel sits on top of the textured surface, and lets the under-painting shine through.

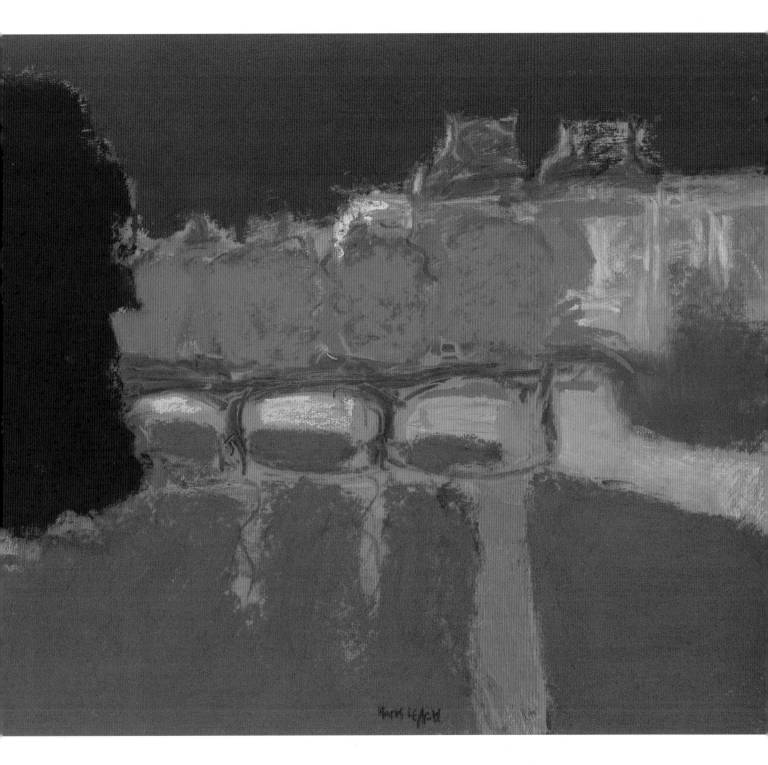

Pont Neuf
Pastel on board
48 x 60 cm (19 x 24 in)
A heavy application of dense areas of pastel contrasts with a pale base colour to give depth and character to this simple study of the Seine and the Louvre museum.

Texture can therefore be created simply through the depth of a single layer of pastel, which can give a beautiful, plain buttery look, or be suggested by gently layering different colours to create a sparkling, vibrant effect. A balance and contrast of different textures brings a painting to life in a way that no mere flat picture surface can ever simulate. It is an essential aspect of the pastel painting process which must be considered and carefully planned for from the very beginning.

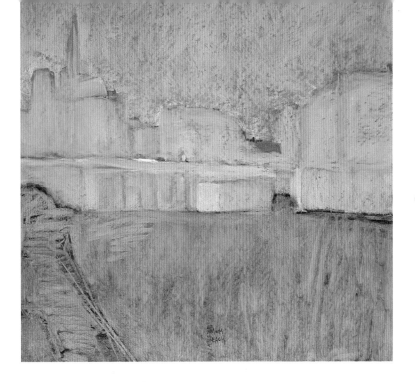

Under-painting

Pastels always work best when applied over a base colour – an under-painting. The contrast enhances the colour and generally holds the painting together. If one does not under-paint, then the effect will be similar to watercolour – it will make a light-to-dark approach necessary, which, although perfectly acceptable to some eyes, I find a waste of the strong pigment to hand.

Earlier I emphasized the importance of under-painting to my work – it is at the very heart of my composition, and the key to each painting. The colour chosen for the under-painting will set the tone for the whole work, in the same way that a symphony is usually based around a predominant key. Even if the finished painting is totally covered with pastel, the initial under-painting will tend to dominate and influence: firstly, because no one pigment is so opaque that a prior layer of colour will not show through to some extent; secondly, and more importantly, the base colour, and the way it has been applied, will influence and inspire every stage of the composition. If a painting is principally about colour and form, then the under-painting is the very foundation upon which the whole work must stand.

It is for this reason that I always prepare and under-paint my own supports. Ready-made papers offer a marvellous selection of textures, but for me, the colours are never what I want. Even if I were occasionally to find a colour that I could work from, I find the uniformity stifling. Plain pastel papers can of course be prepared and under-painted, either with paint or a layer of pastel that is then wetted or fixed. Either method will slightly reduce the original texture of the paper, but hopefully will give you the exact colour you want.

I usually prepare my own supports using archive-quality mount board. I prime it with gesso and pumice powder (see Choosing Supports, page 25), and then colour it with an acrylic wash. To this wash I will normally add a portion of extra grit (pumice, marble dust or ready-prepared pastel ground) to ensure the whole surface is fully textured. As I emphasized earlier, the choice of

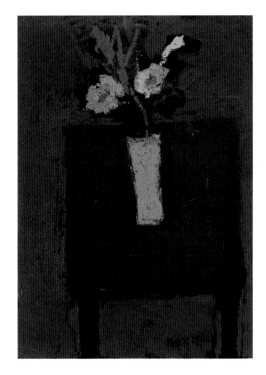

colour is the essential ingredient. I will normally want it to be as strong as possible, but the application can be uneven, giving a sense of movement and life to the painting even at this initial stage. An important principle I follow is that the painting should contain no colour darker than the under-painting. The darkest shadow or shade in the painting should therefore be a point at which the under-painting shows through. With that caveat, the choice of colour can be dictated by an idea I already have, or quite often I will simply create a colour that reflects my mood, and use that as a basis for inspiration. The under-painting is best treated as either complementary to the predominant pastel colours, to give vibrancy and movement, or closely related, for a more tonal and atmospheric work. For many of my paintings I work with a limited palette centred on one of the primaries, so my choice of base colour is therefore reasonably straightforward. Should the finished work require an assortment of contrasting colours, I will mix a neutral base coat that contains elements of all of them. An under-painting with this combination will then hold the painting together without forcing a prevailing tone. In all cases, a composition can be nicely balanced in the final stages by some touches of pastel that match the colour and shade of the original under-painting.

San Giorgio
Pastel on board
35 x 40 cm (14 x 16 in)
This composition is nearly all under-painting. I rubbed dry yellow pastels into a wet red acrylic undercoat to capture the patina of dry stone Venetian walls. Once dry, I briefly sketched in the outline of the church of San Giorgio Maggiore and added just a touch of dry pastel for highlight.

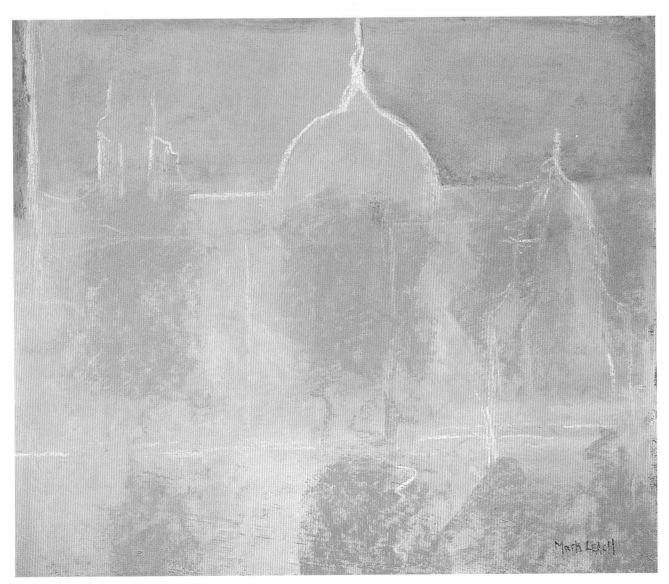

Mixing Pastels with Other Mediums

We know that pastels consist primarily of colour pigment.
Pigment is the closest we can get to holding pure colour in
our hands, and pastels are probably the best way to handle
the pigment and apply it directly to our painting. This does

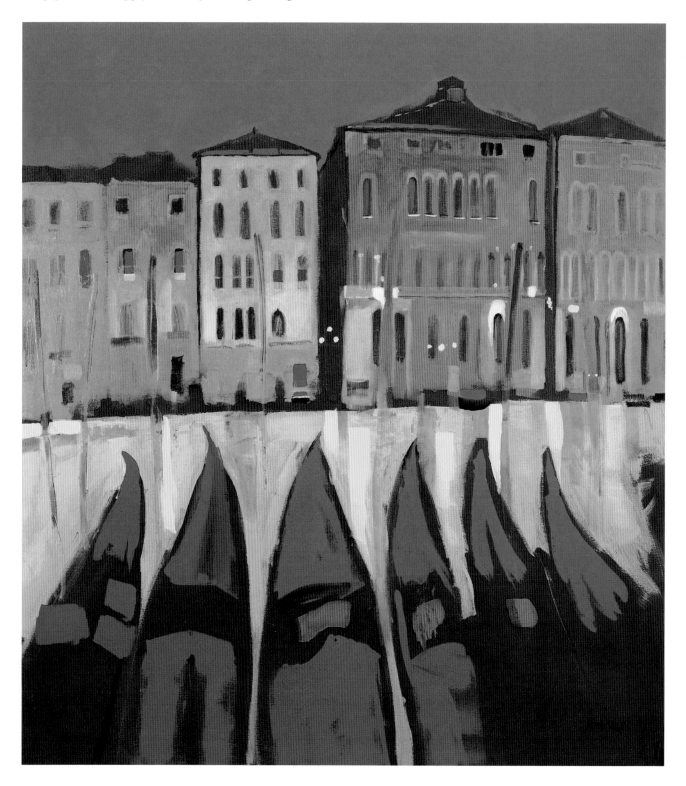

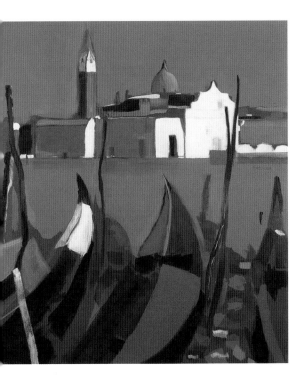

San Giorgio – Late Afternoon
Acrylic and pastel on canvas
130 x 120 cm (52 x 48 in)
As the sun starts to sink below the domes of the
Salute, a strong light is reflected off the lagoon on
to the façade of the church of San Giorgio.
I rarely use pure white, but in this case the
dramatic chiaroscuro effect proved irresistible.

Venice Nights
Acrylic and pastel on canvas
135 x 120 cm (54 x 48 in)
Balancing a limited palette of strong
complementary blues, oranges and yellows
creates an exciting yet sophisticated sense
of colour.

not mean that I consider pastel the 'best' medium; it is simply the method I favour for working with colour. The pigments used to make pastel are exactly the same as those used to produce all other painting media, so whatever our chosen method of working, we are ultimately using the same colours on the same supports.

So what is the final difference – what qualities mark out a pastel painting from an oil, watercolour, acrylic or oil pastel? If we ignore the factor of colour permanence, then the most noticeable difference is texture. The texture of the picture surface denotes how the light – that is, colour – is reflected back to us. Pigments suspended in oil or a water-based medium appear wetter, and therefore also darker. The qualities of the binder itself also affect the way the light is reflected. In addition, the various pigments appear different depending on the type and amount of binder – anything from opaque through to translucent.

Each type of painting is therefore unified by texture, but this does not mean that a painting must be limited to that texture. I see no reason for any one painting to be classified by, or limited to, one particular medium. Experimentation can open up all sorts of possibilities, and by using pastel to enhance and complement other media in the same picture we are exploring the world of colour to the full.

The under-painting technique discussed earlier is itself the most common form of mixed media with pastel. My preference for under-painting is acrylic and other water-based paints, which I feel work better with pastel than oils. If one does use pastel in conjunction with oils it is best to avoid any water-based materials altogether and only dilute or paste the pastels with spirit. An under-painting in acrylic or watercolour need not be considered simply a base colour, but as a painting in its own right, to which pastel can be added at any stage. The final work will need to be treated and protected as a pastel painting unless the pastel itself has been properly fixed and possibly varnished.

There are times when I am required to produce large unframed works on stretched canvas, for places such as hotels and office buildings. Pastel is not usually the first medium to come to mind for such works, but even in these situations I find I can make very good use of it. The two canvases of Venice shown here have almost the appearance of oil paintings, but in fact they are an expressive mixture of both pastel and acrylic. All the initial composition was in pastel, which allowed me to work quickly and capture emotions as they occur. I then blocked in larger areas with acrylic paint, but left small areas of the skeletal pastel drawing to enhance the overall composition. Additional pastel colour was then applied to the still-wet acrylic, to give an exciting combination of texture and colour shade. Once dry, the acrylic-pastel mix can be varnished like a normal acrylic painting. Any areas of dry pastel cannot normally be varnished, but will need to be if the canvas is not to be framed under glass. A few layers of sprayed fixative will usually allow varnish to be applied without too much loss of original colour. Although I would categorize and market these works as acrylics, neither of the paintings would exist without the inspiring properties of pastel.

Inspired by the Classics

Having discussed the technicalities of contemporary pastel painting, and how I have attempted to master it, it is important to take note of how others have been inspired by the medium over the centuries. I have mentioned how coloured pigments have been used to illustrate and communicate since the dawn of humanity. That we are still using this method certainly emphasizes its importance to us, and possibly gives it a significance similar to speech or writing in terms of how our civilization has evolved. We are told that, if treated properly, the colour in pigment can last indefinitely, and the marks we make now may well prove a permanent record for all generations to come. Not a bad thing to remember when we next take pastel in hand.

When looking back to the prehistoric cave paintings, such as at Lascaux in south-west France, we feel an instant rapport with the people of that time. There is no need for translation or interpretation – a few simple smudges of charcoal and metal oxides let us empathize with the emotions, hopes and fears of these ancient people. We sense their concerns over the practicalities of survival, their respect for, and awe of, what was all around them. What we also recognize is an appreciation of beauty. The bulls and prancing horses are not caricature, but are painted with love and affection. The powerful shoulders of the bull and the curve of the horn have a poetic, aesthetic quality that celebrates life.

Fast-forward 15,000 years and has very much changed? If we were to show these ancient people a Degas nude, or a luxurious, colourful fantasy by Odilon Redon, I am sure there would be a similar rapport. Once again, the marks of a few coloured pigments would communicate our own attitudes and sentiments in a simple, intimate and yet profound way.

Louvre
Pastel on board
70 x 80 cm (28 x 32 in)
The shock of the new confronts the dignity of the past, and ornate magnificence pays respect to minimal elegance. I was determined to pay my respects to these splendid structures without fuss or controversy.

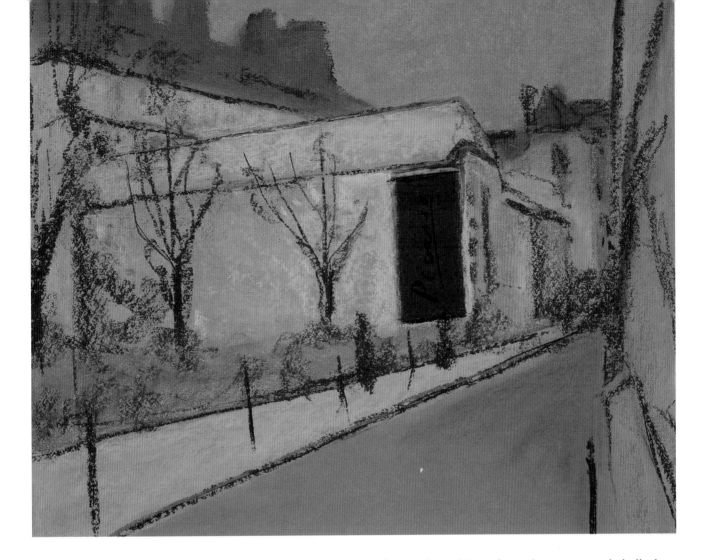

Musée Picasso
Pastel on paper
68 x 70 cm (27 x 28 in)
The Picasso Museum in the Marais district of
Paris can be a welcome sanctuary from the bustle
of city life. The large red banner says it all.

I believe it is the tactile qualities of pastel, pigment and chalk that encourage this degree of intimacy and communication. Knowing that an artwork has been expressed through the very hands and fingers of the artist brings us that much closer to them. If we consider the preliminary chalk sketches of the Renaissance masters, including Leonardo and Correggio, there is an immediacy and charm that their larger oil paintings often have to strive to capture. The fashionable society pastel portraits of the 18th century, by artists such as Maurice de Latour (1704–1788) and Rosalba Carriera (1675–1757), create an affinity with the viewer through delicacy of touch as well as mastery of the medium. This applies also to the Impressionist masters, especially Degas, whose explorations with pastel were to have such a marked effect on the way we paint today.

It is important that we continue to celebrate and benefit from this magnificent heritage. By looking at what has gone before we are able to see more clearly where we now stand. The greatest pastel paintings can be found in major art galleries around the world. In the Musée d'Orsay in Paris, the National Gallery in London, or the Museum of Metropolitan Art in New York, one will find examples of the artists I have mentioned. Studying this inheritance is invaluable, and at the same time we must remember that, with today's pastels, even the novice has a set of tools that the great artists of past centuries could only imagine in their wildest dreams. Imagine what they would have made of what we have now, and let that thought be an inspiration.

The Joy of Pastels

In summary, being aware of the methods and practicalities of pastel painting is important, but this should never limit one's inspiration. Pastels will mostly do what you want them to – there is very little to be wary of. I would always recommend that you stick with what you first have in mind, and make the tools work for you. In this respect, pastels will always offer the simplest and most straightforward approach – simply pick up a stick and away you go! If it does not work out, little is lost and something is always learnt.

Because I work as a professional artist, and the pressure of commissions and exhibition deadlines is ever present, there is always a fear that painting may become routine. The worst thing that could happen is that I start thinking of the work as no more than a job, and the act of inspiration and creation simply a means to an end rather than a pleasure in its own right. It is important to retain the spark of inspiration and work as the moment moves me. The joy of pastels, above all else, is the immediacy. With paint there is always preparation, and having mixed the paints on the palette, the need to make full use of them before they dry. There is the waiting for paints to dry on the canvas; watching the colours slowly change and darken, while hoping that I can recreate the same colours again; washing the brushes and putting them away. This is all routine and cannot be avoided, but it slows and tempers the creative process. When I am ready to work, I like and need to work quickly, to best capture my feelings before the sensation inevitably fades. Only pastels let me work in this way. Provided I have supports already prepared, I can be in my studio and working in a matter of minutes. If striding across the hills, I can capture sensations as and when they occur with pastels and paper carried about in the pocket: colours, movement and the emotion they inspired.

At these times my pastels are my best friends, allowing me to share my thoughts and express my passions in my own way. Our world is full of light, and we continually experience it, and remember it, through colour, form and texture. Pastel allows us to share this with others in the purest and most straightforward way.

Sunlight – Montmartre
Pastel on board
70 x 50 cm (28 x 20 in)
I used very strong blue shadows to emphasize the brightness of the sun. Although I did not want this strong shadow in the trees, it is often necessary to balance a dominant colour across a painting. A few touches of the same cobalt were essential to give the painting unity.

Place Furstenburg
Pastel on board
50 x 28 cm (20 x 11 in)
An intimate study of Place Furstenburg, where Delacroix had his studio. The composition was built up with simple slabs of colour to avoid the sense of an architectural study.

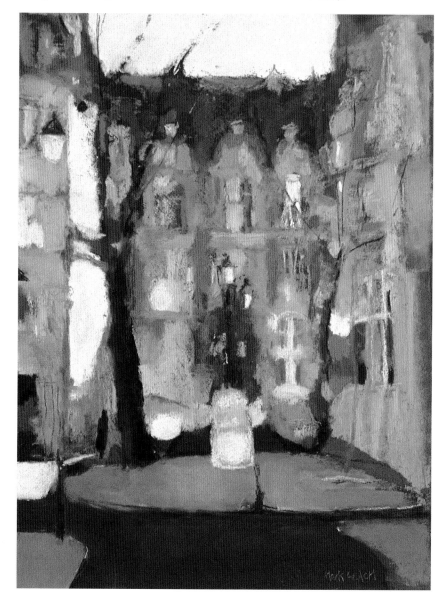

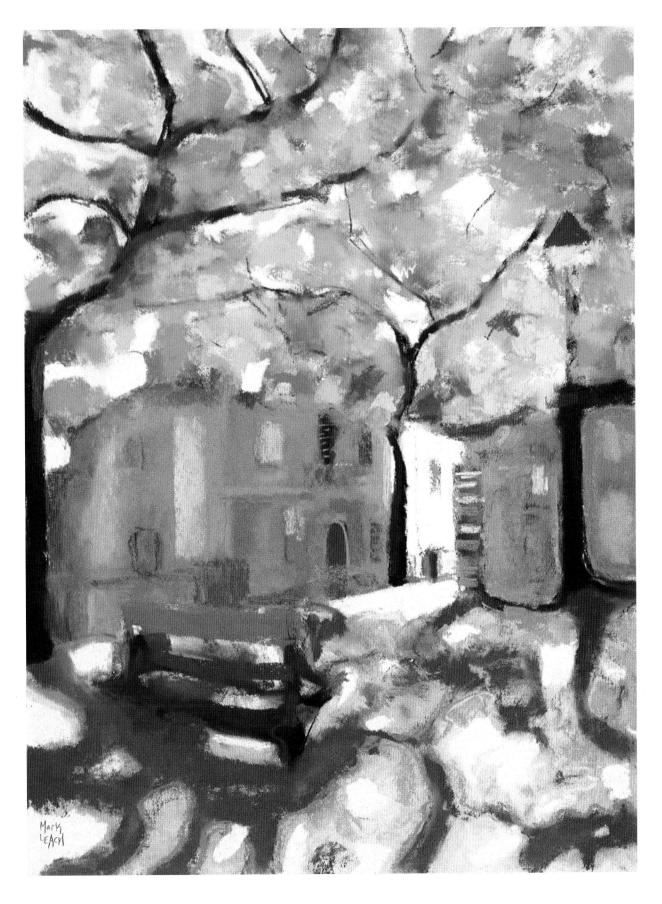

The Power of Colour

Colour is how we see the world, and it is how we make sense of what we see. Each waking instant our brains are bombarded with colour as reflected light waves give form and meaning to everything around us. Colour is not something we look at but is how we experience light itself.

Our eyes sense different wavelengths of light as different colours. As Isaac Newton discovered, if you shine pure white light through a prism, the various wavelengths will be slowed down to different extents by the glass and will separate, appearing from the other face of the prism as separate colours, seen in the form of a spectrum spread out like a fan in order of their varying wavelengths, from red at one end to violet at the other. We detect the colour of light as a particular energy level (corresponding to wavelength) of light as it hits the retina and is interpreted by the brain, and we detect the colour of objects in the same way. All light waves consist of photons, small particles of electromagnetic energy, and when these hit a surface, the chemical make-up or pigment of that surface will absorb some wavelengths and reflect others. An orange, seen by normal sunlight, absorbs all the waves except the orange ones, which are the ones reflected back to us. A white object contains pigment that reflects all colours (since white light is a composite of all the visible wavelengths), whereas a truly black object absorbs all light waves.

Parc Monceau
Pastel on board
58 x 70 cm (23 x 28 in)
A fireball of natural colour. This is how it hit me, and this is how I painted it. The subject of this painting is simply colour.

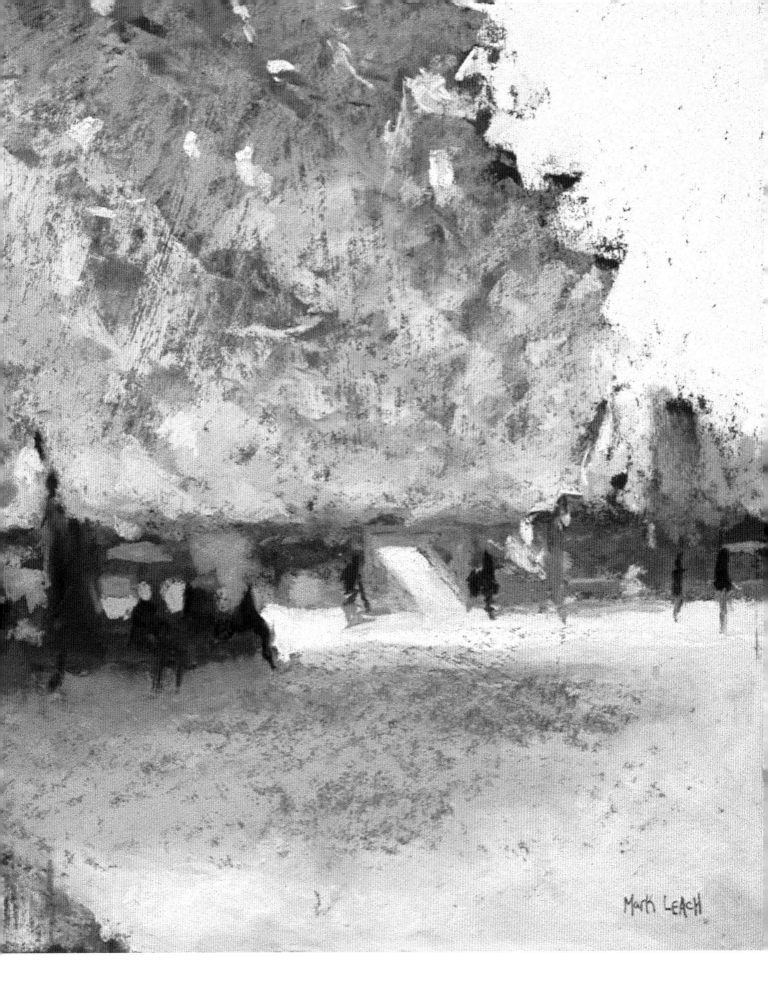

Mark LEACH

Understanding the basic science of light goes some way to answering how colour comes about. What it does not answer is why colour affects us so profoundly. When we look at the natural world, we see that colour is fundamental to the way plants and animals function: attracting, repelling, camouflaging and communicating all make use of colour.

Painting is also about communication, the expression of ideas, emotions and beauty. As visual artists we use light – that is, colour. There is simply no other way for us to work: colour is all. Even a pencil drawing is no more than a contrast between shades of black and white. Colour is fundamental to the way we all relate to the world, and how the world talks to us; as an artist, it is my first language.

Emotional and Physical Balance

Before we even begin to paint, we have to consider that pure colour alone can cause a response, both psychologically and physiologically. At the basic physical level, our eyes process reflected light rays in different ways. For instance, red has the longest wavelength that our eyes can see. Red tends to evoke physical anxiety, which may be related to this sense of marginal visibility, whereas green, which lies right in the middle of the visible spectrum and is therefore the colour in which we can perceive the finest gradations of shade, tends to have a restful effect. If we then consider the purely psychological effects common to us all, driven by memory and association – such as red and orange with fire, blue with sea and sky, the changing colours of the seasons – we can begin to understand how powerful the language of colour is. Combined with the fact that our eyes are capable of identifying more than 16 million different colours – each of which might appear to us in almost any form or texture – and the range of emotional possibilities becomes almost infinite.

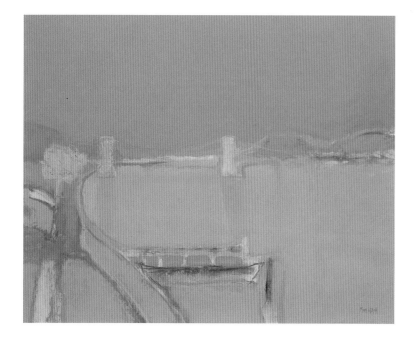

Bridge at Les Andelys
Pastel on board
83 x 90 cm (33 x 36 in)
Muted blues and greens physically calm the mind, as well as reflecting the peace and tranquillity of the riverside.

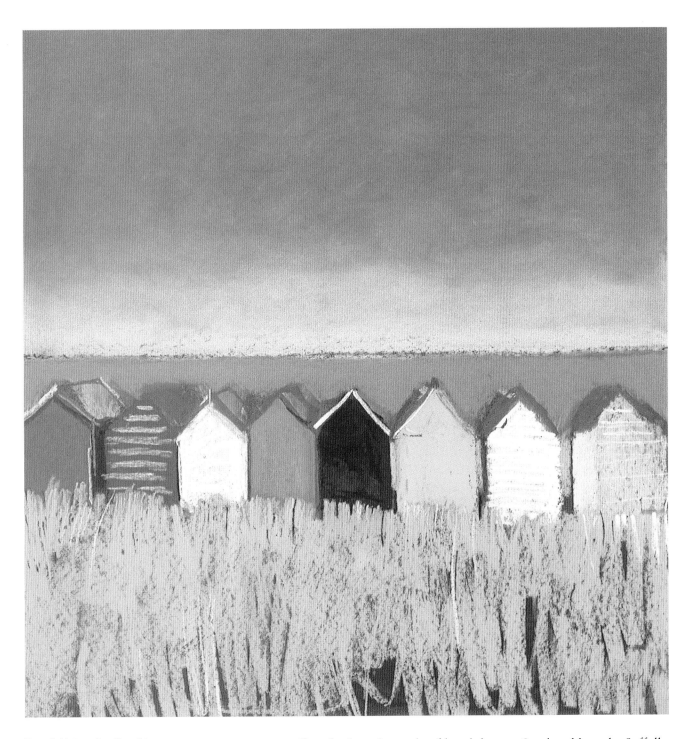

Beach Huts – Southwold
Pastel on board
80 x 75 cm (32 x 30 in)
A favourite subject and a good example of how
we all use colour to express our individuality.

If we look at the study of beach huts at Southwold on the Suffolk coast, we experience both a physical and an emotional response. Before we are even conscious of the subject matter, our eyes and minds have reacted to each colour in a purely abstract way. The central red dominates, but our retinas are constantly absorbing the different wavelengths from the blues, greens and yellows at the same time. It is almost like listening to a song, where the colours represent different notes. Only after experiencing this automatic reaction do we start to see the painting in a conscious and subjective way. The simple forms and textures add words and meaning to the song, memories are triggered, and the colours relate to the natural world. Through this I aimed to achieve a sense of the British seaside: a balance of movement and calm, joy and repose.

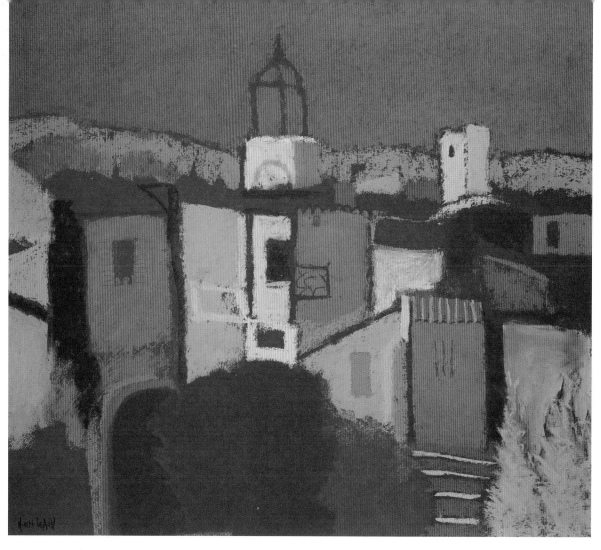

The Passion of Colour

Colour has the ability to describe many emotions. We only have to consider how we use colour terms to express our most intense feelings to realize how closely we feel this relationship. We talk of people being red with rage, green with envy, having a yellow streak or feeling blue, to name but a few – and in languages around the world, similar descriptions are used. Colour is so closely associated with how we feel that it has become almost the language of emotion.

This gives the artist a very powerful tool. We all accept that music has the ability to evoke feeling and change mood. At a very basic level, most would agree that a major key can uplift, while a minor key can sadden. In painting, similarly, a hot colour such as red can excite and a cool colour such as green subdue and cause reflection. Composers tend to consider the emotive impact of their music rather than using it to try to tell a story. If inspired by the song of a skylark, say, a composer will probably not try to imitate or transcribe that sound, but will evoke its emotional elements as the basis for a piece of music. I believe that painters should approach their composition in a similar manner. We should never simply try to recreate what we see before us – leave that for the photographers and illustrators. What we see before us is colour, and colour is the key to our emotions. By using colours in the way a musician uses notes, through balance, harmony, counterpoint, loudness, muting, we are in control of what we want to say through our painting.

Cotignac
Pastel on board
53.5 x 58.5 cm (21 x 23 in)
The typical Provençal village of Cotignac baking in the reds and ochres of the midday sun. I have used elements of colour and form from an earlier sketch to produce an almost abstract composition.

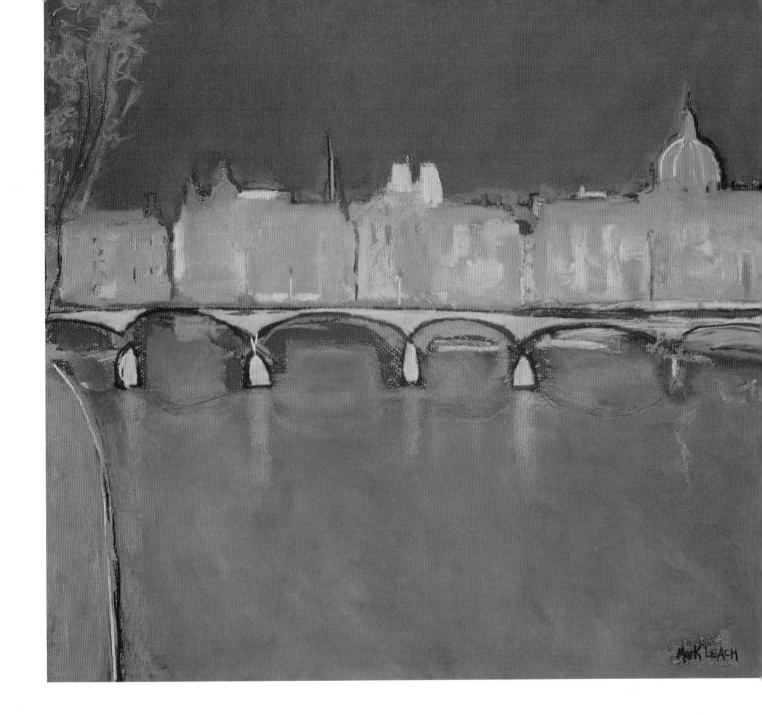

Pont des Arts and Institut
Pastel on board
80 x 85 cm (32 x 34 in)
This painting is, to some degree, representational.
The bridge, towers of Notre-Dame and dome of the
Institut anchor the sense of place. However, it is
only through colour that I can describe how I feel
about being there.

The Pont des Arts in Paris has always held significance for me.
On a cultural level, this marvellous old iron footbridge across
the Seine acts as a link between the grandeur and pomp of the
Parisian right bank and the creative and intellectual aspirations
of the left bank. On summer evenings, students from the nearby
Sorbonne meet here to picnic and exchange ideas. It is where I
nearly always gravitate towards when in Paris. To me it represents
the main artery and cultural centre of the city. I have painted it
many, many times. In this bold pastel I used a base colour of
yellow – the colour of hope, excitement, anticipation and
optimism. This has been muted with complementary blues and
green, the colours of Paris. These help to temper the optimism
and introduce a sense of uncertainty – what will the day bring?
Key to the painting are the strong reds and orange, a counterpoint
to the other colours and a final crescendo that gives the painting a
structure and purpose – a storyline.

Seeing Colour

Although colour is all around us, we should never take what we see for granted. The light continually plays tricks on us, and so do our minds. We are all aware of optical illusions, but in truth all optics are an illusion. We only see what our brain interprets, and colour is always a matter of interpretation. If we look at a white handkerchief in a darkened room, we will see it as white because we know it is white, even though there is strictly speaking not enough light in the room to tell us what colour it is. And if we close our eyes, we are able to see colours even though there is no light (the same part of the brain that interprets the eyes' signals, the visual cortex, is also used in imagined visualizations, such as in dreams). Most importantly, the colour that we do see is always relative, depending on its context: we hardly ever see a 'true' colour – that is, one unmodified by proximity to another – since any one colour will change its apparent hue when placed next to another. This is probably because in such a case the cones and rods in the retinas of our eyes are having to change from processing one set of light waves to two or more at the same time. For this reason, I think it important when painting to consider colours collectively, not in isolation. This sounds obvious, for what else are our paintings but colours placed next to each other? What we have to master – and it only comes with time and experience – is a continuous sense of colour interaction. Working with soft pastels is a great benefit in this respect, for all our colours are there in front of us and we can acquaint ourselves with them all individually. I have many favourite hues and shades that I have got to know over the years, but more importantly, I have learnt how these colours interact with each other – for instance, how a particular green will appear bluish in some situations, and yellowish in others.

To become fluent in this, one should consider every colour as part of a whole (that is, as part of the visible spectrum that in aggregate makes up white light). So blue is not just blue, but more importantly, the part of the spectrum that grows out of violet and then feeds into green. Another useful way of imagining colour as part of a whole is the artist's colour circle, or wheel. Many versions of the colour wheel have been published since Newton's original discoveries, as well as similar triangles and spheres, all designed to show the breakdown of white light into its constituent colours. Each variant serves a purpose, but painters will mostly use that based on the three pigment primaries of red, yellow and blue, which are spaced equally a third of the wheel's

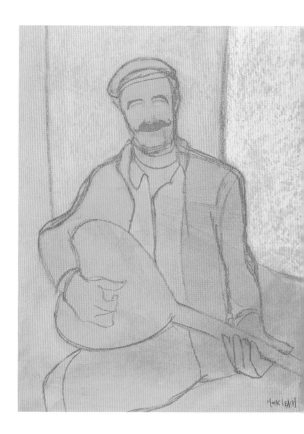

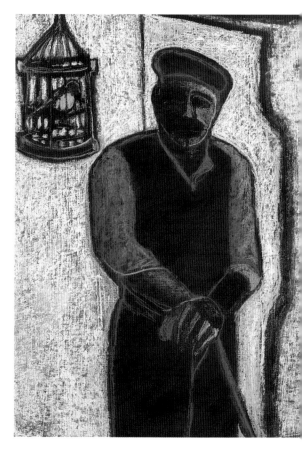

Thomas
Pastel on board
85 x 70 cm (34 x 28 in)
In this study of Thomas playing his bouzouki, I left the wonderful yellow under-painting to dominate. I realized that any further colour would have detracted from the simplicity of the subject.

Theo
Pastel on board
88 x 68 cm (35 x 27 in)
That we can capture a whole lifetime of experience with just a few strokes of pastel is a constant wonder to me.

circumference apart. Mixing two adjacent primaries will produce a different colour, which occupies the space on the wheel midway between its parent primaries. Thinking of colour in this way does have the drawback that it encourages the idea that colour is segmented into primaries, secondaries, tertiaries and so on. This helps us to identify colour associations, but we must remember that light waves are not segmented – all colours flow into their adjacent colours seamlessly, since the visible spectrum is spread across a continuous range of electromagnetic energy levels without any distinct boundaries between them.

I therefore use the colour wheel tentatively. I would not want it to influence or dictate my emotional response to colour, and colour harmony, since this could very easily lead to work becoming formulaic. However, it is very difficult to appreciate the joy of colour harmony without some understanding of the science involved, which the colour wheel provides.

Towards Sacré Coeur
Pastel on board
48 x 53 cm (19 x 21 in)
The more we experiment and understand how different colours relate to and affect each other, the greater our power to express.

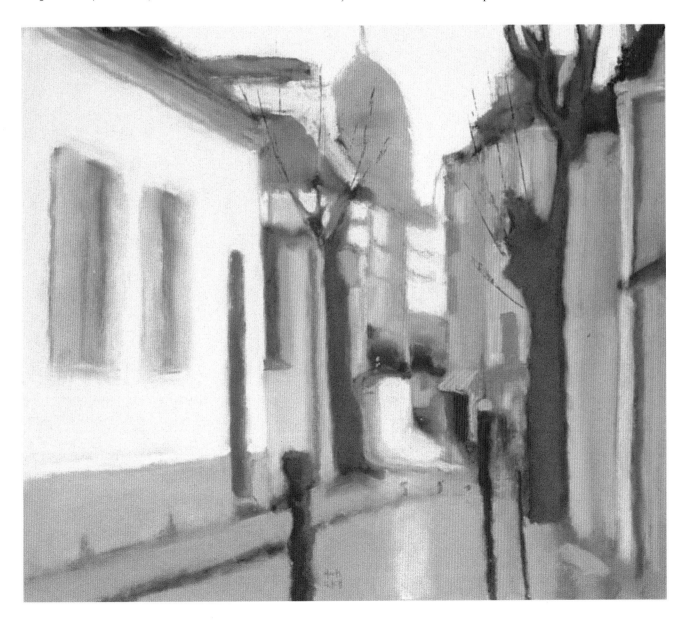

Colour Harmony

The effect of colour harmony is difficult to define. In music, our ears and mind are attuned to specific harmonics of sound which we can instantly identify as being relatively consonant or dissonant. With colour hue and tone the distinctions are less clear – there is no physical reality in light that corresponds to dissonance. But we nevertheless have a sense that certain colours appear to go well together, and that some possibly clash, though the effect is often tempered, and usually we consider it a purely personal sensation. In some ways we can put this down to conditioning. Western music splits the octave arbitrarily into twelve distinct segments, which allow for simple harmonies that we have become very familiar with. Similarly, although we have familiar names for the principal colours, distinctions are less strict and colour harmonies far more flexible.

Having said that, it is natural for our eyes to seek out harmony in colour, in the same way as we do with most other things. It is said that beauty is the natural product of good order, and I would totally agree. When I set out on a painting, the journey is all about creating harmony. Whether the painting has subject matter from the physical world or is pure abstraction, the creative process is all about balancing form and colour. No doubt there are painters who are more concerned with representing or illustrating what is before them, but even they will inevitably be driven subconsciously towards harmony and balance, or the painting will never feel complete.

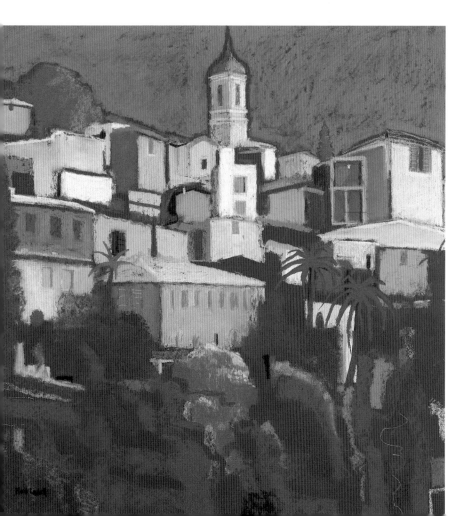

Roquebrune III
Pastel on board
80 x 75 cm (32 x 30 in)
Strong complementary yellows against a blue background bring immediate depth and movement to what would otherwise be a fairly flat composition.

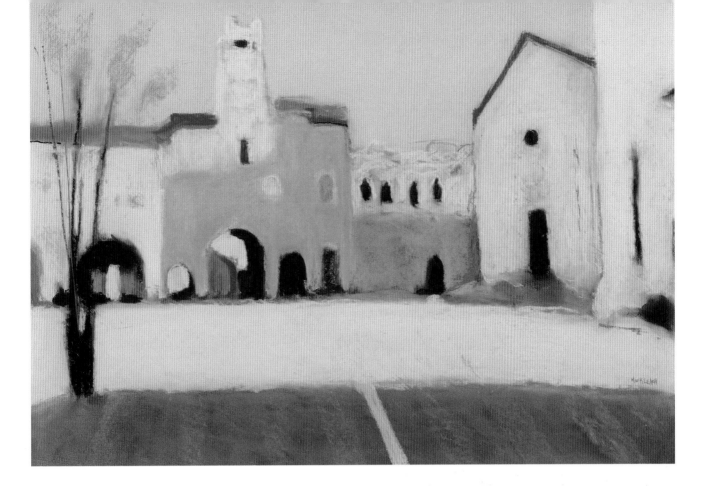

Oderzo
Pastel on board
70 x 80 cm (28 x 32 in)
Oderzo is a lovely old town in the Veneto region of Italy. As the sun moves over the central square, the colours of the buildings and the shadows they cast change constantly. You are reminded that all colour is relative.

The way artists view colour association these days is influenced very much by the French chemist and dye maker Michel Eugène Chevreul (1786–1889). It was his book, *The Principles of Harmony and Contrast of Colours* (1839), which was to inspire the Impressionists to move away from traditional painting methods and see colour as a creative force in its own right. Although both Leonardo da Vinci and Johann von Goethe (1749–1832) had noted that colours have an effect on each other, it was Chevreul who identified that our perception of the effects of colour were dictated not by the chemistry, or pigment, of the reflecting surface, but optically. Most importantly, that after viewing any colour the eye would see a complementary after-image that would influence the brain's perception of adjacent colours. If you take two colours from opposite sides of the colour wheel (that is, complementary colours) and place them together, the apparent 'brilliance' of each will be enhanced. This Chevreul defined as the 'harmony of contrast'. If two colours from adjacent positions on the colour wheel are viewed together, they too will be influenced by the after-image. He also identified harmony of scale: the principle that the larger the areas of colour, the greater the degree of contrast. Conversely, with smaller areas of colour, the greater the tendency to grey. We can see this in the experiments and works of the Pointillists.

In essence, Chevreul's view was that colours are at their best when they are either closely related (next to each other on the colour wheel), or complementary (at opposite sides). Following on from this, more subtle harmonies could be introduced through ideas such as split-complements, triads and the use of a dominant tint. These principles of colour harmony still hold today and best explain the approach to colour – whether conscious or unconscious – I use in my own painting.

Using Closely Related Colours

By using a palette of colours adjacent to each other on the colour wheel we set an emotional tone for the painting. Because the colours are all from either the warm or the cool side of the spectrum, there is little contrast between the colours, so the painting will appear more calm and contemplative. We should also note that the juxtaposition of violently contrasting colour is also relatively rare in the natural world. If we look into a fire we tend to see associated reds, oranges, yellows and violets – all close to each other on the colour wheel. Leaves in the autumn follow the spectrum from green through yellow to orange and even red. Exceptions generally stand out – think of certain bird plumage and butterfly markings, for instance, which often use complementary colours (from opposite sides of the colour wheel) for reasons of attraction or warning to predators. The fact that these seem quite unnatural-looking is testament to their rarity.

For best effect when composing with adjacent colours, it is recommended to use either the primary colours of red, blue or yellow, or the secondary colours of orange, green or violet as the dominant hue. In my case, this rule most often applies at the time of under-painting. My natural instinct is to choose one of the three primaries as the underlying tone of the painting and work out from there, starting with the most closely related colours. We have seen that this is how colour evolves in the natural world, and I find it the most natural way to make my painting progress. Using a secondary colour for the dominant tone, such as orange or green, has less impact, but can create a more refined and tranquil impression.

The painting of the Observatory in Greenwich Park is one of a series of large pastel works to celebrate the dawn of the new millennium. It is a quiet, reflective painting with elements of both sunset and sunrise, of coming to an end and looking towards a new beginning. Because I wanted to create a mood rather than tell a story, I used a limited palette of adjacent colours and kept detail to a minimum. The predominant under-painting is a strong ultramarine with the basic composition sketched in using cobalt blue. These cool blues give a sense of distance – the eye is drawn into the painting and up the hill. Tints of adjacent blue-green and blue-violet give movement and depth while maintaining overall balance. Any use of colour from the opposite side of the colour wheel would have immediately drawn attention and upset the sense of stillness and timelessness.

Another way of creating harmony similar to that of adjacent colours is the use of the dominant tint. This is achieved by applying a final layer of a particular hue to a painting, which tends to draw together the colours beneath. Pastel is not best suited to this approach, but it is possible, especially after fixing. Since the direct approach of the Impressionists to colour and natural representation, the use of a dominant tint can sometimes make a painting appear old-fashioned and contrived. However, it is always worth experimenting, and I have sometimes found it a useful way to tone down excessive contrasts, either through lighter tints or complementary ones.

Aldeburgh II
Pastel on board
80 x 70 cm (32 x 28 in)
Large areas of blue, and little in the way of detail or contrast, emphasize the sense of emptiness and isolation in this famous old Suffolk fishing village.

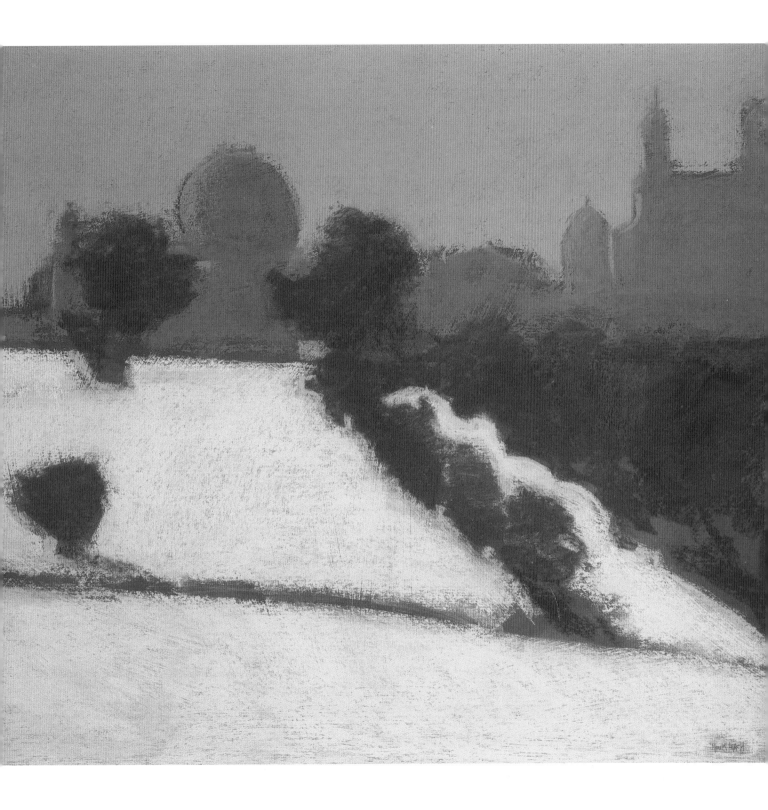

Greenwich Park II
Pastel on board
75 x 90 cm (30 x 36 in)
The dawn of the new millenium.

Creating Contrast

There are three principal methods of creating contrast in our painting: complements, tonality and temperature (I will look at the last two in the following sections). Before we even consider subject matter, a knowledgeable use of these abstract techniques can add, as it were, a third dimension to our two-dimensional work. I find that achieving a satisfying balance of these elements is nearly always the primary concern when starting a composition. Quite often, before I have even started to think about subject matter, I will be balancing forms through contrast. A good abstract composition of colour and form is essential to every painting, including representational ones. From this foundation will always come ideas and emotions that I can then follow and develop.

When I am not looking simply for the calm and contemplative in a painting, I am usually keen to draw attention to either a particular feature or to the subject matter as a whole. This is best achieved through contrast. When we think of contrast we normally consider the difference between light and shade (that is, a strong tonality), where dark areas come forward and light areas recede. Tonal balance is essential for successful composition, but if we ignore the effect of colour, and how different colours contrast with each other, then we are only addressing part of the situation.

We know that all colours have an opposite (complementary) on the colour wheel, and that this colour is the image left briefly in our eyes once we look away from an object of the original colour. It is this relative effect which makes two complementary colours both appear brighter when placed next to each other. For instance, if we put a red square on to a larger complementary green square, the green after-image surrounding the red square will increase the amount of reflected green light we see from the green square. The red square will be enhanced in the same way. The effect is most noticeable with the primaries of red, green and blue, but applies to all hues, especially if the hues are of equal strength (saturation). We should also note that opposite colours fall into the warm versus cool category, providing yet another form of contrast, with warm colours appearing closer and cool ones having distance.

The use of complementary colour is the most obvious method of creating colour contrast. However, the effect can sometimes be too strong, and a little unsettling. In many cases, the use of split complements can provide a more refined result. This is where the two colours either side of the direct complementary are contrasted, for instance blue with red-orange and yellow-orange. This works best when the dominant hue is a primary or secondary, but there are no strict rules.

If we wish to explore the possibilities of colour contrast even further, we can consider the harmony of triads. This approach imagines an equilateral triangle superimposed on the colour wheel, with its corners created by the primaries red, yellow and blue, and then rotates the triangle so that its corners run through other triads of colours with equivalent separation between their

Canal du Midi
Pastel on board
45 x 33 cm (18 x 13 in)
A combination of both tonal and complementary contrasts create a sense of strong light.

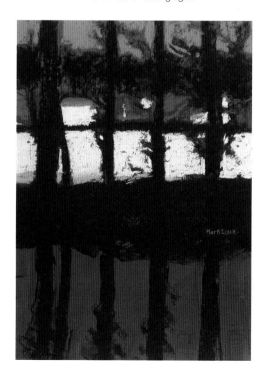

three parts, including sets of secondaries, tertiaries and so on, giving a variety of visual and emotional effects.

The simple, bold study of plane trees along the Canal du Midi (opposite) uses heavy contrast to emphasize the strong light of southern France. A dark shade of blue-violet pastel was drawn into a wet acrylic ultramarine under-painting, reducing pastel texture and encouraging a flat and opaque darkness. I then used a toned-down tint of almost complementary yellow to contrast and highlight the fields beyond. By tempering the yellow in this way, I created a tonal and colour contrast that was striking without being too energetic, which would not have suited the calm of the canal. A few touches of complementary red and green give a suggestion of depth and movement, without which the painting would seem a little flat.

Silent Trees – Canal du Midi
Pastel on board
35.5 x 46 cm (14 x 18 in)
Humanity and nature in harmony – I wanted to create a sense of calm and timelessness through a very balanced composition and muted tones. The yellow light reflecting off the canal helps to balance the background with the dominant verticals of the trees.

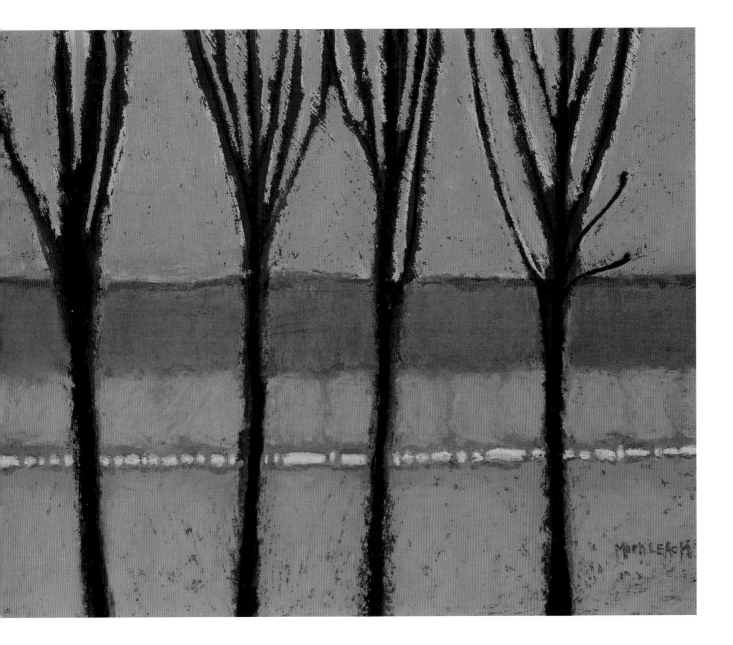

Tint, Tone and Shade

When considering the properties and harmony of colour we tend to think in terms of hue – that is, colour in its purest and brightest form. In principle, a spectrometer or computer can identify millions of possible hues, and although the human eye can see all these colours, we can only consciously differentiate about 180. For artists, the number of hues at our disposal is dependent on available pigments, which for most paint manufacturers number in the region of 80. This still provides an extensive range, especially when you consider that in most languages there are only names for 11 specific colours, including grey, black and white. All other hues are generally seen by us as variations on these.

What gives the artist full scope for all potential colours is the ability to lighten or darken hue by adding white (tint) and black (shade). With soft pastels, because premixing of colour before application is not possible, the manufacturers go some way to pre-empting this. In most pastel ranges there will be up to six shades of a particular hue – the majority being lighter tints created by the addition of white, with one or two darker shades containing added black (or in some instances, the complementary hue). In addition to this, there are normally a large selection of greys (tones) created through the addition of both black and white. We know that manufacturers often provide in excess of 500 shades of pastel, which goes to show just how important and necessary tints, tones and shades are to the artist.

For all colour tones, the basic assumptions on colour harmony still hold. Because black and white are respectively a combination, or absence, of all colours (in terms of pigment mixing, though not light mixing), when they are added to any one hue, that hue still retains its position on the colour wheel. What we have to be aware of is how tinted and shaded colours affect the overall balance of composition (the tonality). We also need to be aware of the change in emotional effect. Both tints and shades reduce the amount of colour we see, with an equivalent reduction in the effect that colour has on us. The more white in a colour, the more light has been absorbed and the softer the appearance. We should not necessarily equate white with brightness – strong light causes strong colours, and this is how we should show it. A darkened hue, meanwhile, may add richness and contrast to a painting, but there will similarly be a loss of colour impact. Toned pastels, in which both black and white have been added so that the colour is modified in the direction of a grey, creates a very neutral effect. This can be a useful compositional tool. It was JMW Turner (1775–1851) who first noted that colour brilliance was enhanced when placed next to grey. This is especially true if the grey is based on a hue complementary to the one next to it. Careful use of grey can reduce colour interaction and let certain colours speak for themselves.

All these tonal effects must be managed very carefully, especially when using pastel. The great number of tints and shades that are readily available can be an easy distraction. I would recommend all pastel artists to make themselves aware of which of their pastels are closest to the true colour (the pure pigment colour, without added black or white) and always to take these as the

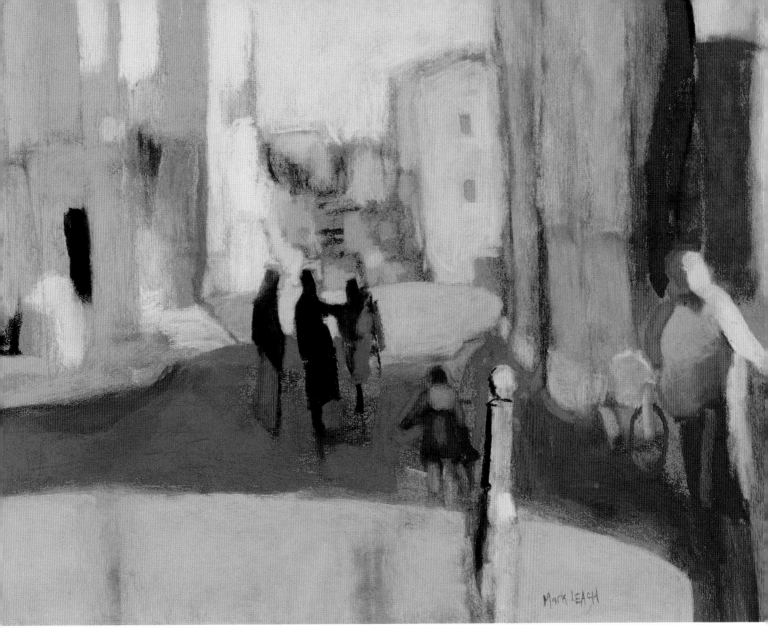

Street Life – Arles
Pastel on paper
45 x 58 cm (18 x 23 in)
Harsh sunlight bleaches colour but brings
life to the shadows.

starting point. As a composition progresses, working dark to light, I introduce paler and sometimes darker shades while keeping as close to the primary hue as possible. I very rarely have use for the lightest tints and the darkest shades of any colour, and in most cases have never owned any. Even white and black rarely appear in my work. Remember that the picture's darkest shade or shadow should be in the under-painting, while for highlights, a paler complementary is usually the most effective.

The painting of street life in Arles is an example of using tinted and toned hues to soften the impression of the strong southern light and produce a well-balanced composition. In the heat of the day, all life is in the shade and shadows. In the open squares, by contrast, the strong sunlight bounces off walls and drains colour from everything around. Starting with a balanced triad of pure hues (blue-violet, yellow-green and red-orange), I refined the strong tonal contrast through paler tints and grey tones so that no one feature predominated. This has made the scene more accessible, since we are not squinting into the bright light, looking in, but standing in the calm of the shade, and feeling a part of what is going on around us.

Colour Temperature

One of the most influential yet most often overlooked of compositional tools is colour temperature. We have seen that the warmer colours in the spectrum – the reds, oranges and yellows – appear to advance towards us. We naturally associate these colours with the heat of the sun and fire, hence the association with warmth. Even on a physical level, it is known that staring at the colour red can provoke a response in humans that increases blood pressure and adrenaline levels, and thus body temperature. The cooler colours – green, blue and violet – appear, on the other hand, to recede into the distance, occupying a different 'plane' of the picture from the warm colours. We think of these as cool, perhaps 'winter' colours. Intermediate colours tend to be classified as cool or warm depending on their relative position on the colour wheel. For instance, ultramarine is thought a warm blue because it is closer to red.

We should not confuse contrast through temperature with complementary contrast. Although pairs of complementary colours always comprise one warm and one cool colour, this does not mean that the hottest and nearest colour (red) complements the coldest and most distant (violet). Complementaries are only direct opposites on the colour wheel – they are how our eyes restore and maintain balance. If you place a red square on a larger green square, both colours, as noted before, will appear more vivid: a contrast of brilliance. If you then place the red square on a larger violet square, the red appears to float above the violet. In this case you have a contrast of distance.

These purely objective effects of colour temperature are a powerful aspect of composition. I once produced a painting with a dominant red sun on a deep ultramarine background that caused the eyes to literally pulsate when looked at indirectly; the eye simply could not cope with assimilating two such different wavelengths at the same time. In purely abstract terms, warm and cool colours will appear on different picture planes, and it is easy for this to upset the overall balance of a painting, particularly in landscapes, if not given proper attention. If a sky is to be blue, and a foreground a warmer hue, then we will always have a painting of two halves, with the top half receding from the bottom. For a fully balanced two-dimensional painting this is not ideal, and often has to be overcome by other compositional techniques.

For the sake of compositional balance, therefore, as well as setting an emotional ambience, I tend to let either a cool or warm hue dominate. My skies are very rarely blue unless the rest of the painting is! In my study of the old Fournaise restaurant on the banks of the River Seine outside Paris, it is the cool, muted colours that first speak to the viewer and set the emotional tone. The painting is part of a series of works taking a contemporary view of the Seine, especially those parts frequented and painted by the Impressionists. In the late-19th century, the Fournaise restaurant was the scene of much gaiety, as depicted most famously by Renoir's *Boatmen's Lunch* (1880), a painting full of colour and life. Today, although still operating as a restaurant, things are more subdued, quiet and sober. I used the cooler blues and greens to reflect this. I wanted the painting to feel empty

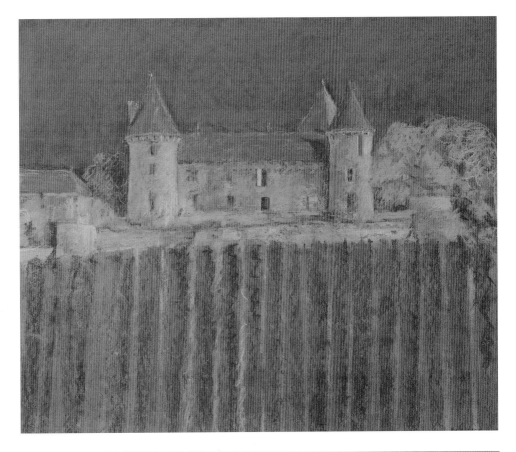

Rully
Pastel on board
53 x 63 cm (21 x 25 in)
The Château at Rully in
the Chalonnaise region of
Burgundy produces some
wonderful fruity red wines.
A warm vanilla glow
seemed appropriate.

La Maison Fournaise
Pastel on paper
43 x 56 cm (17 x 22 in)
Cool colours recede into
the distance as we look
back on the Seine of the
Impressionists.

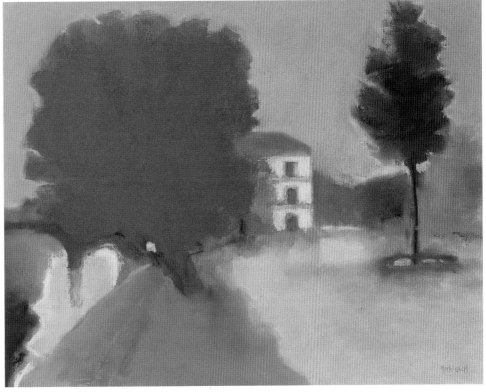

and distant with a sense of retrospect, and these colours
helped achieve this by not demanding attention. A hint of
red complements and enhances the effect of the green and blue
hues, although it is muted with blue to keep overall balance.

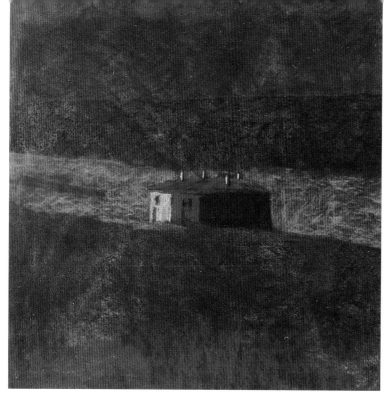

Tuscan Farmhouse
Pastel on paper
68 x 70 cm (27 x 28 in)
Neutral shades of umber over a hot red base
suggest baked earth under a burning Tuscan sun.

Vaucluse
Pastel on paper
42.5 x 50 cm (17 x 20 in)
Nearly all neutrals are a mix of purer colours. Here
I have enhanced the earthy ochres and umbers by
introducing constituent pinks and crimsons.

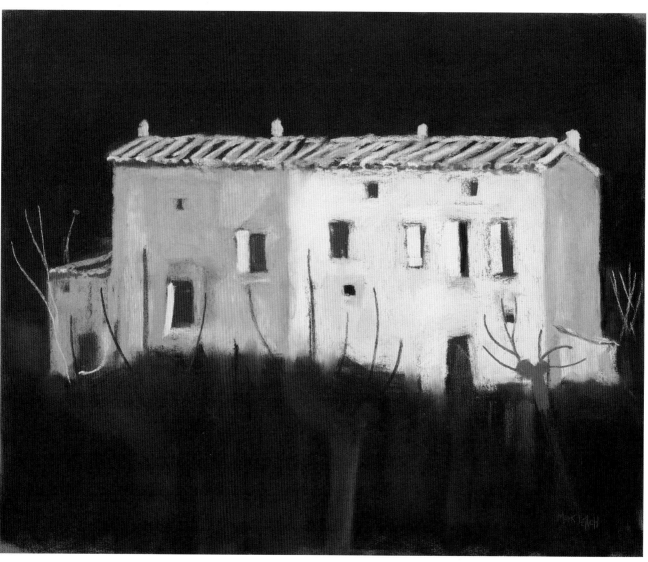

Earth Colours and Neutrals

We term earth colours those that derive from natural pigment. They are colours that reflect the land and nature. In truth, all artist's colours are created using pigment that can be found in nature, but we tend to use the term specifically for those colours that do not appear man-made or synthetic, that do not have a specific hue on the colour wheel, but that we see every day, all around us. They come from natural pigments that have been used since the beginning of humanity, including minerals such as iron and ferrous oxides, magnesium and cobalt. The best-known earth colours on the artists' palette include ochre, sienna and umber. They are predominately what we would term 'brown' colours, or those hues that tend towards brown through mixing. Because the colours come directly from natural pigment the resulting pastels are of good strength and quality, even though they are not identifiable as hues on the colour wheel because they cannot be mixed from adjacent colours. We usually think of such colours as useful in landscape painting, but these earthy shades are just as much at home on the portraitist's palette. I make little use of the majority of earth shades, but this is a purely personal decision. Even though it is difficult to mix pastel hues, and the resulting mixes are not as strong as natural pigment, I prefer to think and work from primary and associated hues. The resultant mixes may tend towards earth colours, but I like to know where the colour comes from.

We sometimes refer to earth colours as neutral. Neutral colour is defined as that which has no natural hue, which means a mixture that cannot be referenced on the colour wheel. However much we segment the colour wheel, regardless of the number of divisions, we can mix two adjacent colours and still create a harmonious intermediary. But if we mix hues from non-adjacent segments, the result is a colour that cannot be defined by a hue. This colour may lean towards a particular hue, but it will never appear pure: there will be a sense of clash or muddiness. Pure neutrals are a mixture of two pure complimentary hues, or of the three primaries. The result tends towards grey or brown – the same result that is seen if we spin the colour wheel. Neutralizing colour through a gentle layer of complementary colour can be a useful way of toning down a hue that is too bright. With pastel this should be done with great care, so as not to lose the underlying hue, or turn it to mud. Indeed, excessive use of neutral colour is best avoided with most media. It is always preferable to use a pure pigment colour whenever possible – there are certainly enough for most purposes. A mixed colour will never be as bright and saturated as a natural pigment, even at primary level. It is possible to create neutrals with pastel where the underlying hues remain visible, through gentle layering rather than blending. These have more life and resonance than will be had by mixing paints, but once again the result will suggest grey.

Whereas most pastel manufacturers base their palettes on shades of the standard pigment colours, hand-made pastels, such as Unison, do augment their ranges through carefully mixed neutrals. As this is a very personal decision, I do try to avoid ready-made colour mixes. Far better to stick to pure hues and be fully in control of the creative process.

Greys

Grey is by definition a mix of pure black and white. Technically it is not a colour as, like the earth colours, it is without a corresponding hue on the colour wheel. With pastels and paints, the term grey is often applied to the more neutral shades – mixtures of white and black, but with an undertone of a particular hue. They may also be the product of mixed complementaries. The more familiar processed greys available include Payne's Grey, Dove Grey, Olive Grey, Warm and Cool Grey, although these are not based on specific pigments and may well vary between manufacturers.

Although a pure grey will add little to a painting, I find that those with a slight hue bias can stimulate the stronger colours to great effect, and it thus provides the artist with yet another form of colour contrast. Neither complementary, tonal or temperature based, a grey can perform a neutralizing contrast to a colour next to it. This effect can dilute usual colour interactions, and so let individual colours be seen in their own light. The same applies to colours placed on black and white, but with grey the effect is less dramatic and far more manageable. As with black and white, a slight colour bias in the direction of a complementary or matching hue is best. In either case, if there is a predominance of grey in a painting it is probably best for the associated hues to include a degree of white tint, or the clash of neutral and pure colour can be a bit unsettling.

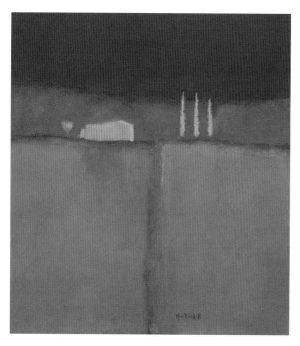

Umbrian Landscape
Pastel on board
85 x 55 cm (34 x 22 in)
Tints and shades of blue violet calm the eye and add poise and dignity.

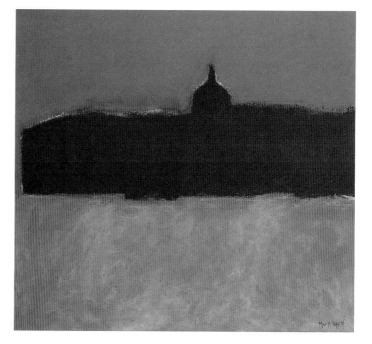

Burgundy Village
Pastel on board
55 x 60 cm (22 x 24 in)
Too much pink and red in a painting can seem raw and overbearing. I have tempered this second study of an earlier work by introducing a neutral grey. Pink and grey work well together – an attractive mix of the masculine and feminine.

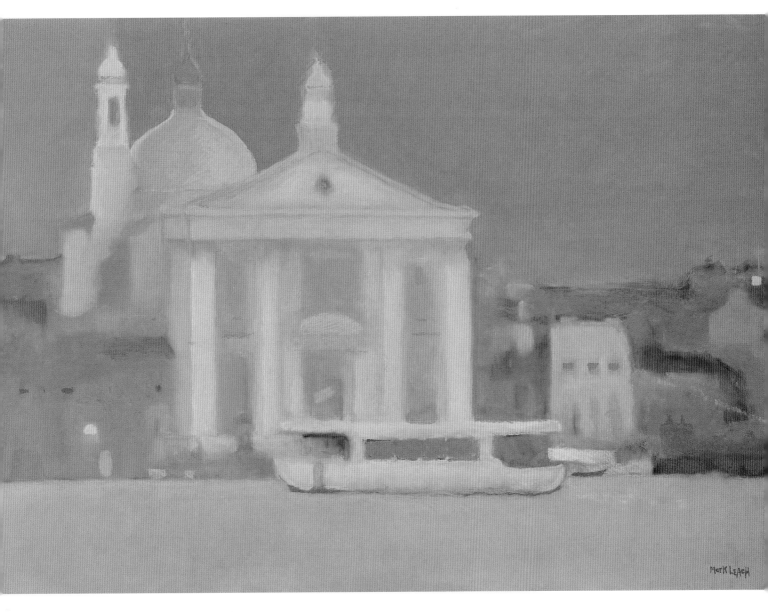

Giudecca, Venice
Pastel on board
70 x 100 cm (28 x 40 in)
The setting sun brings fleeting colour to the dome of
Il Redentore, as the rest of Venice fades to grey.

Because grey suggests formality I also enjoy the way it can bring a sense of dignity and seriousness to a painting. Sometimes colour can say too much. Even when there is one dominant hue and colour interaction is minimized, that hue can still appear too forceful and demanding. Grey in a painting can quieten the colour dialogue, give the eye and mind some rest and, in addition, add strength and sophistication.

If anywhere has a quiet dignity, it must be the city of Venice. First and foremost, for me Venice is about reflected light, that wonderful green-blue that touches us from every direction. The majority of my paintings take this as the very essence. Sometimes, however, this sense of light and colour can detract from all else that Venice is. In the painting of the view across to the island of Giudecca and Palladio's church of Il Redentore, I chose to use cool greys for the natural elements of sky and water so as to give more elegance and presence to the buildings. This is no architectural study, but rather a suggestion of the calm and dignity of mankind. Without the greys, that sentiment would have been far less profound, and the painting would have a different meaning.

Black and White

It is questionable whether, in a book on colour with pastel, there is room for a section on black and white. Neither is a true colour in the sense that they do not appear within the colour spectrum. From an artist's point of view, we can make black, but white has to be bought. True black is a mixture of the primaries, and white the absence of any other colour. Both are used as additives that help create the various tints, tones and shades of other colours that are such a feature of the pastellist's palette, but is there also a place for them in their own right? I would argue that, in their purest form, and as with true grey, both black and white have a neutralizing and deadening effect on a composition. The best place for them is in purely tonal (that is, black-and-white) compositions. With paint, they are a necessary part of the palette, as that is how various tones and shades are reached. But with pastel paintings, they are best left in the box. Only with the purest of abstract works have I found myself reaching for these colours – and I have nearly always regretted it.

However, as with the grey shades, as long as there is an underlying hue bias, a sense of warm or cold, a black or white effect can be made more acceptable. If working on a colour composition, on the very rare occasion where true black or white are required, their presence can be harmonized by an overlying or underlying hue that reflects the rest of the painting. Rather than using this approach, however, I would suggest that the darkest tones and palest tinted pastels of other colours are more than sufficient for this purpose.

Of course, some occasions do cry out for black and white alone. There are times when the absence of colour can be more effective than the presence. By using black and white only, we can avoid that part of the brain that processes colour and go for the dramatic more than the emotional. You can equate it to listening to the percussion section in an orchestra, the exciting bangs and crashes of black against the silence of white. *Burnt Hillside – Cevennes* is an early work of mine that comes to mind. This large painting reflects the harshness and drama of the aftermath of forest fire on the ancient hillsides of the Cevennes in southern France. In this case, only the use of black and white seemed appropriate. All that was natural had gone – all colour burnt away. In fact no white is used here, just black with the white of the paper showing through. Most pastel blacks are very intense and overpowering, so for this work I actually used some charcoal, which I had picked up on the burnt hillside itself and which I therefore hoped would bring authenticity to the image. The charcoal was worked into wetted watercolour paper, which gave an intensity to the sky and allowed me to then rub away and effectively draw out the marks of land and trees using strong tissues. Final drawing work was done with a putty rubber. At one stage I was tempted to add some strong red, a gash of colour (I am often tempted to add some pure colour to my black-and-white compositions – it can be very effective), but in this case I felt the absence of colour was the essence.

South Downs Way II
Charcoal and pastel on paper
45 x 45 cm (18 x 18 in)
One of a series recording a trek along the ancient rounded hills of the South Downs. Dramatic contrast encourages us to walk towards the light.

South Downs Way IV
Charcoal on paper
45 x 45 cm (18 x 18 in)
By limiting our palette to black, white and grey we increase the significance of shape and form.

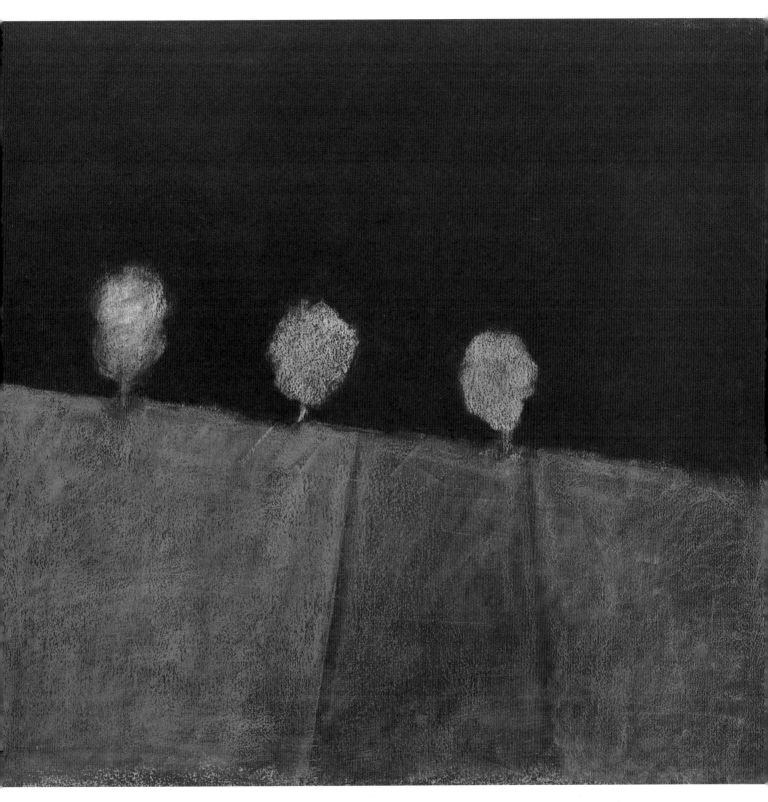

Burnt Hillside – Cevennes
Charcoal on paper
75 x 78 cm (30 x 31 in)
A devastating fire has taken all colour from this scene. Pure
black and white symbolise both an end and a new beginning.

Using Colour to Create Mood

I do not use colour to reflect what I see, but to express how I feel, or want to feel. In the everyday world we constantly take in a myriad of colours of all shades and hues, so much so that we have little time to absorb and reflect. We are affected physiologically and psychologically by these colours, but because things change so rapidly, they rarely bring about one particular emotion or mood. We can overcome this visual turmoil by gazing out to sea, say, or up into space. This produces a calmness and peace of mind that we often put down to thoughts of travel or the great unknown. In fact it is mostly a way of resting our eyes and minds from the effects of all that colour. The same effect can be had by merely closing our eyes.

Through painting we can seek out the essential in what we see, eliminate the confusion of too much colour, and reveal underlying ideas and emotions. If we simply attempt to reflect all that our eyes see, then we achieve little, other than a certain respect for our technical expertise. We have the world itself for all that. What I think we should attempt to do is use colour to tell a story, and use the known properties of colour as a language to express how we really feel.

For my purposes, I aim for simplicity and directness, often using the profound psychological effects associated with single colours. The ability of red to quicken our pulse and raise blood pressure has already been mentioned. Stare at blue and it will do the opposite. Waiting rooms are often painted green to induce calm.

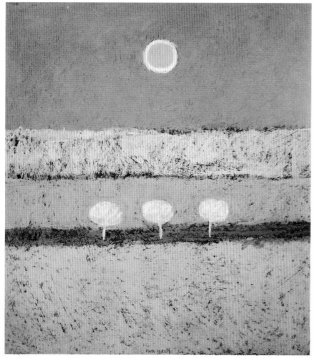

La Mancha IX
Pastel on paper
75 x 70 cm (30 x 28 in)
Distant horizons – the landscape is bleached.

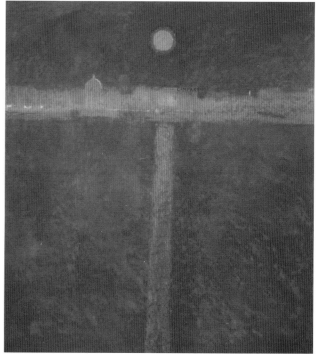

Lido II
Pastel on paper
75 x 70 cm (30 x 28 in)
Pale Venetian moonlight. All is calm and reflective.

Restaurants are frequently decorated in orange and peach to encourage appetite. This deployment of colour is something that artists do intuitively, and certainly the last thing we should ever want is to reduce the process to a rigid formula. But having said that, the following generally applies:

Red This is the colour of energy, passion, aggression, and excitement. It is loud, hot and extrovert.

Yellow The first colour our eyes detect. Optimistic, joyous, brightening, happy, spontaneous. It adds light and vitality.

Blue The most popular of all colours. Inspires hope and peace, reflection, contemplation, nostalgia. Calm, cool and introvert.

The secondary colours also have individual characteristics, often a combination of their primary components:

Orange Freshness, warmth, kindness, generosity, honesty.

Green The spirit of the natural world, refreshing, openness, calm, energy, youth, dependability.

Purple Feminine, excitement, eagerness, erotic, spiritual, religious.

As we combine these colours further, or tint and shade them, we are able to evoke more subtle emotions. If, for instance, we add white to red, the resulting pink will calm the aggressive, and turn passion to nurture. If the pink leans to violet, it may suggest the audacious or fervent, whereas an orangey pink may reflect and inspire compassion, or the maternal.

Lagoon Sunset
Pastel on paper
75 x 70 cm (30 x 28 in)
Venetian lagoon. Here the reds and yellows excite and stimulate.

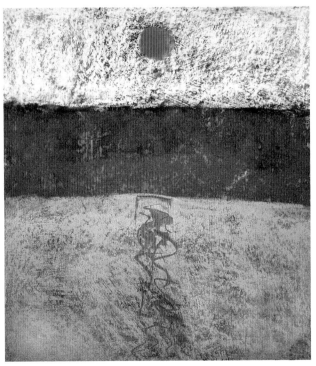

West Side
Pastel on paper
75 x 70 cm (30 x 28 in)
A view across the Hudson River to the dazzle of Manhattan.

Limited Colour Palette

If the mood of our painting is suggested by the colours we choose, then it stands to reason that the fewer colours we use, the more noticeable a particular mood should be. This is why colour is so important. If I chose only to draw, then I would lose my most expressive tool, and would have to rely to some extent on caricature. I need colour to orchestrate and harmonize, to cause an effect through colour relationships.

I have mentioned that I consider the initial plain under-painting to be fundamental to the effectiveness of the finished work. For a true colourist, this plain undertone can sometimes express all he or she wants to say. There have been many in the world of Abstract Expressionism and Colour-Field painting who have expressed themselves through painting what appears to be a single colour. The deep-black canvases of Ad Reinhardt (1913–1967) or the wonderful rich ultramarines of Yves Klein (1928–1962) tell us that sometimes one pure colour can be more than enough. With these works, the artist is saying no more than 'look at the colour'. What we, the viewer, get from the painting comes from inside us, as it always will. We see this sentiment taken a stage further in the works of Mark Rothko (1903–1970), who would do no more than juxtapose two colours, yet create a thing of awe and great beauty through his simplicity of approach. The power of these works taught me early on to aim for that simplicity. It may be cliché, but I think the adage 'less is more' should be the first thing taught to art students. Our works are made to stimulate the viewers' imagination – and the less we put in, the more this will happen.

The most obvious way of creating strength through simplicity is to work with a limited palette of colours, and the fewer the better. This does not mean throwing out half your wonderful collection of favourite pastels. I do think it important to have as much colour as possible at your disposal. What is necessary is to limit the colour you use in any one picture, so that each colour will make its own impact. I usually choose a strong colour that is

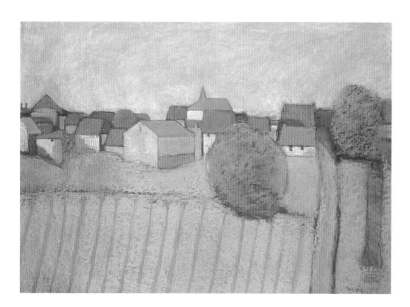

Magny-les-Villers
Pastel on board
83 x 115 cm (33 x 46 in)
Here I used only cool shades of blue and green to suggest a rural scene under a pale northern light.

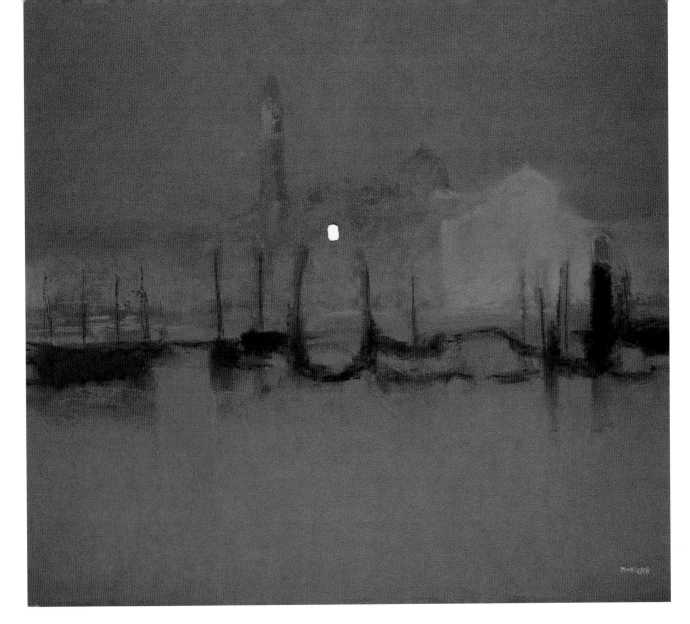

Venice Nocturne
Pastel on board
75 x 85 cm (30 x 34 in)
Painting at night naturally limits the colour palette.

either complementary, or close in hue, to the shade and colour of the under-painting or prepared paper. I then make as much use of this as I can to sketch out a balanced tonal composition. Even at this stage I would expect the composition to feel complete. If it doesn't now, it is unlikely it ever will. If I am very lucky, I may well be able to stop at this point. To be able to say what I have to say using only two balanced colours can be very satisfying. If I need to say more, then further pastel is applied, but once again using only analogous or complementary hues, and only slight variations in tint or shade. All marks must be made with care, in the knowledge that each addition has the power to detract from something already laid down. A successful composition is all about simplicity of balance, and this can best be achieved by not juggling too many balls.

A limited palette of ultramarine over a darker shade of the same hue was used to suggest a foggy winter's evening in Venice. This painting is all about atmosphere: the single deep blue conveys a heavy calm – the city is still. A dash of bright and complementary colour breaks the silence, while at the same time making you more aware of it. A fading Venice sighs and breathes gently into the night.

Subjects to Paint

As an artist, the question is not so much 'what to paint?', as 'what not to paint?' Our subject matter is everywhere around us and as our eye becomes more trained, we tend to see beauty even in the mundane and incidental. As artists, we want to share our vision of the world, to explore all our passions, and express our joys. However, we will never paint the whole world, and with this in mind it is necessary to work within parameters that we set for ourselves. We must therefore identify what really matters to us. Possibly it is those things that you just cannot put into words, but simply have to express. Maybe it is something straightforward, such as sailing boats crashing through the waves or the natural beauty of flowers. To many this is not a problem: they know what they want to paint, and the only question is how. Others love the craft of painting, the physical and emotional activity, but are unsure what they have to say. In all cases, identifying your personal passions and developing a style that suits your particular talents are the essential first steps in becoming a unique and accomplished artist. Only from that starting point will we then develop, and finally master, the skills to express ourselves fully.

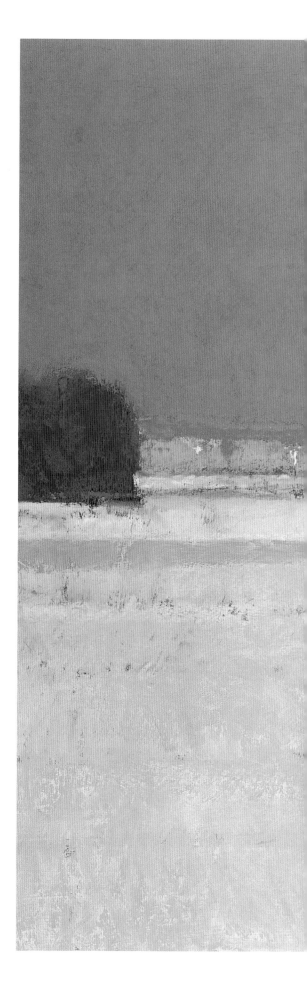

Chichester Cathedral from Hoe Farm
Pastel on board
75 x 93 cm (30 x 37 in)
Cathedrals are always a favourite subject of mine. They can be a magnificent symbol of our spirituality and what that can achieve. I like to put this in perspective though, in this case by a single blue flower.

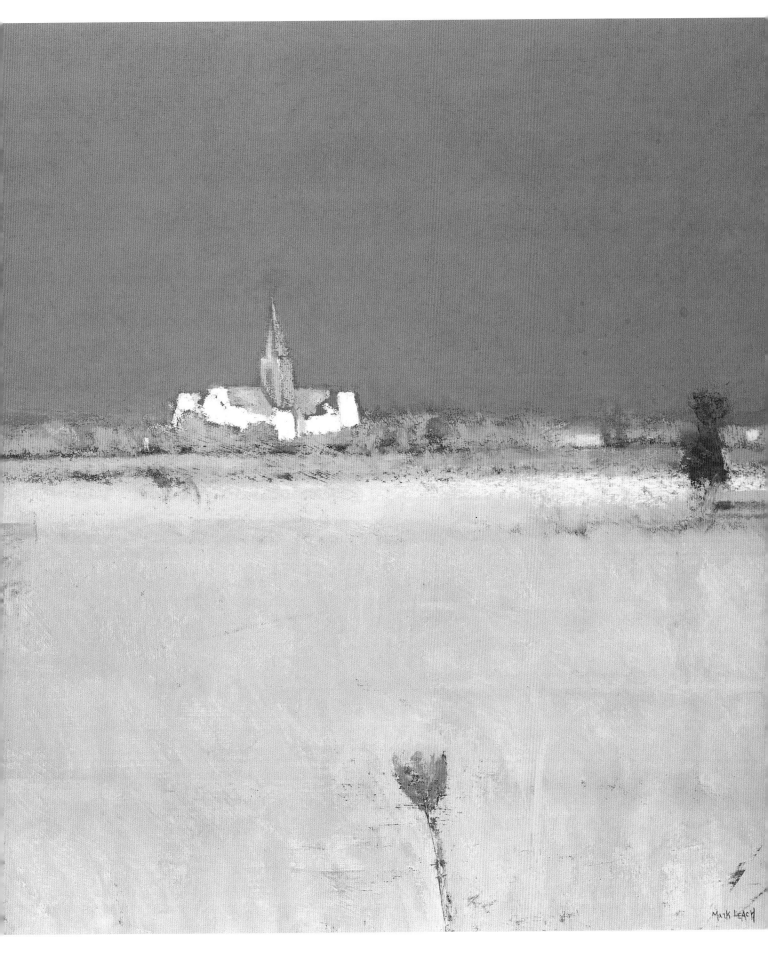

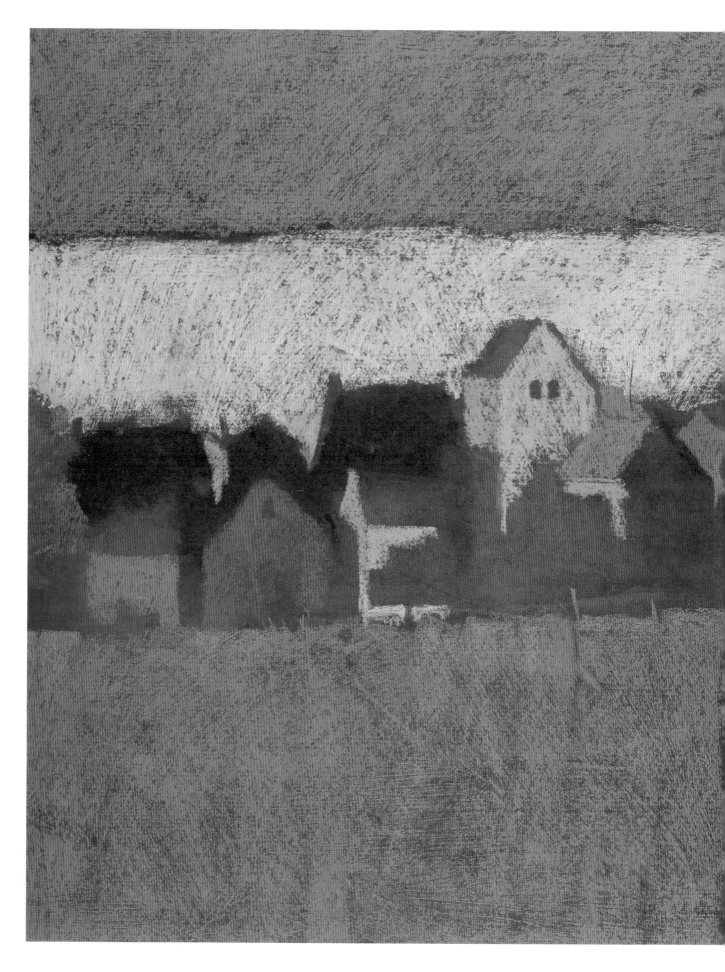

My overriding passion will always be the landscape. It is why I became an artist, and it is why I remain an artist. Of course, this does not preclude a love for much else that the world has to offer. The power of the landscape can be tempered by the tranquillity of domestic life, the bustle of the city with the intimacy of personal relationships. When I am not painting the great outdoors, I often concentrate my mind on a small still-life work – the here and now, rather than distant horizons. Another of my passions is the city, and how city life contrasts with nature. The dominant theme in most of my work is to show man in harmony with nature. The landscapes reflect on this, while the cityscapes allow me to show the other side of the coin. I find this attempt to find balance and harmony between different areas of my life to be essential to my work.

Whatever our inspiration, we should never forget that the painting itself is also a subject. All paintings are an abstraction of reality, and ultimately it is the process of abstraction that appeals to us. We all view the world differently, just as we feel, and wish to express, different emotions. It is the common language of colour and form that unites us, and this will always be our true subject.

Landscapes

In the studio I have a small wooden box that I use to keep odds and ends. I bought it somewhere in the Rocky Mountains about thirty years ago, but even now, when I open the lid, I am hit with a beautiful scent of freshly sawn cedar. This wonderful perfume brings back so many memories of long, balmy days walking through the pines, snow-covered peaks and golden pastures. There are similar sensations when I open a bottle of wine, perhaps a delicate but richly scented Burgundy, which will take me straight back to France and all the pleasures of the French countryside. These are landscapes that I have grown to love and that, over the years, have become a part of me. They are my passion, and they tell my story. Through my paintings I aim to share that story, imparting to the viewer an experience similar to that which those aromas always evoke in me. No one sees the world in the same way, but we all walk a similar path, and by looking for the essentials I hope to reach that common sense of beauty and meaning that affects us all.

Burgundy Village – Auxey
Pastel on board
76 x 84 cm (30 x 33 in)
One of a series of paintings of the Burgundy vineyards. By using colours that are adjacent on the colour wheel I have aimed for a sense of natural harmony.

Landscape Artists of the Past

It is interesting to reflect that painting the landscape only started to receive serious recognition in the West during the 19th century. Before then, nature and the countryside held little romantic favour, and the rendition of the land was little more than a backdrop to the main subject matter. Away from the towns and villages was a land to be feared – a place of vagabonds and robbers, dark spirits and all sorts of dangers. As cities and industry grew and transport developed, however, people started to look at the outdoors more favourably. Here, maybe, was a place to escape the grime and toil and return to a more natural way. Always the first to sense change, poets and painters encouraged this new way of seeing. In Britain, those such as Shelley and Keats, John Constable (1776–1837) and JMW Turner were to start us on the road to a whole new culture. In continental Europe, artists such as Gustave Courbet (1819–1877), Jean-Baptiste-Camille Corot (1796–1875), Jean-François Millet (1814–1875) and Caspar David Friedrich (1774–1840) would sow the seeds for Impressionism, and all that would follow. Nowadays, we tend to take this romance for granted, but we should not forget that, more than anyone, it was these great artists who helped to open our eyes and minds to see beauty in nature in the raw. I consider it a duty, a privilege and a joy to continue the task.

I have never consciously set out to paint a particular landscape. With pastel in hand and a plain board in front of me I simply start on an exciting journey of colour. Mostly I paint from memory in the studio, at least initially. As a painting progresses, I may refer to field sketches and photographs as necessary. If I start a painting directly from a sketch or photo, I find I set up a barrier between my thoughts and the freedom of composition. If you already have a two-dimensional image in front of you, then this will impose itself on your creative imagination, whether you consciously wish it to or not. I find it far better to work up a pleasing balance of abstract form, and then allow this to trigger memories and ideas that may well evolve into a landscape. If working from a sketch, or even out in the field, I find I am translating rather than creating. There is nothing wrong with this, and each to his own, but as an artist I simply prefer to emulate the free improvisation of jazz rather than the studied performance of the classics. In creating a landscape, then, I take an expedition – setting off into the unknown with little thought of method or destination. The finished painting will hopefully reflect this. To me a landscape is not simply a snapshot or a pleasant or picturesque view, but a journey. In this way, I hope to reflect life, a constant journey towards new horizons.

The Structure of the Composition

The common structure of a landscape composition is nearly always foreground, background and sky. However we alter our viewpoints or technique, we will see landscapes this way. This is how we are used to viewing the world. Very simply, the foreground is where we are, the background is where we are going, and the sky represents the unknown. Any hint of subject matter tells a story.

It is natural for our eyes to first be drawn to the horizon. This is the most powerful aspect of any landscape composition.

Winter in Provence II
Pastel on paper
55 x 58 cm (22 x 23 in)
In High Provence, the scent and colour of lavender fills the air even in winter time. The tracks in the snow draw us into the painting and beyond.

Following this, we seek out incidental subject matter – trees, buildings, clouds and so on. Finally, we note any foreground. In other words, we generally see and read a landscape painting from top to bottom. For this reason, the painting should not be bottom heavy. To keep the painting interesting we have to make sure the eye is drawn back into the landscape and towards the horizon. We can achieve this by ensuring there is equal weight to all areas – the sky, background and foreground should always be of equal importance and prominence. To journey through the landscape, we encourage the eye through verticals, to counteract the natural horizontals. Paths and roads are obvious examples, especially if there is a hint of perspective leading to a vanishing point. Simple abstract, textural marks are also an essential way of giving movement, direction and meaning to the land.

Winter in Provence III
Pastel on paper
55 x 58 cm (22 x 23 in)
A heavy winter sun balances the strong colours of the foreground.

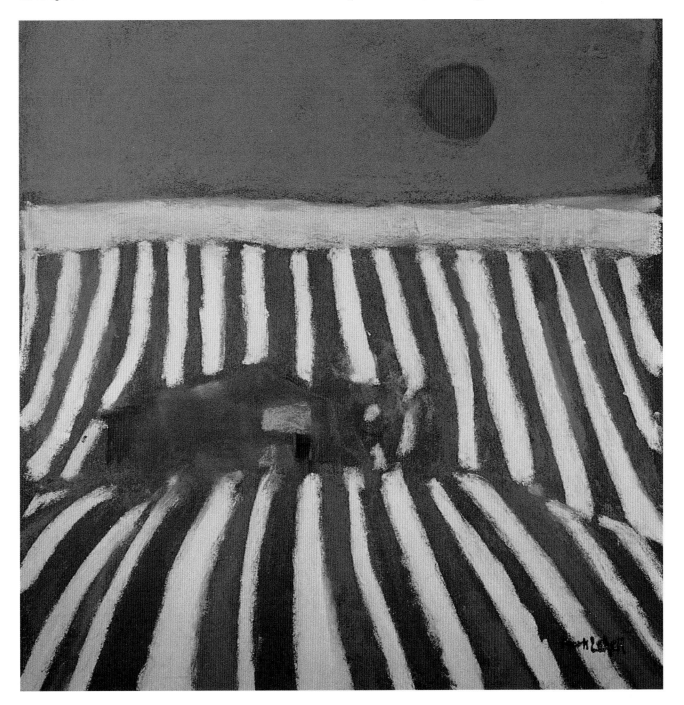

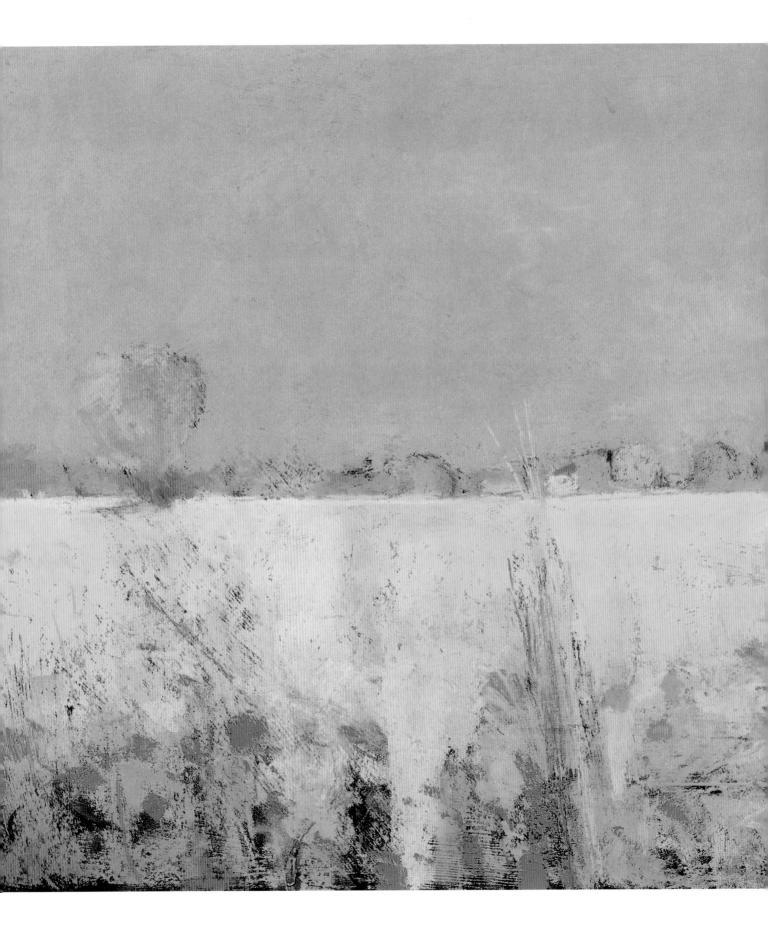

Although my concerns are the journey of life, there are times when we need to take a rest, to pause and enjoy the here and now. Normally I need some distance – mental and emotional as well as physical – from the places I paint. I need time to reflect, and to be able to paint with a longing for what I miss, and with hope for what may come. What is all around me can be overbearing, and it is often difficult to see the wood for the trees. There are exceptions. Not far from my home in Sussex are the ancient flatlands and grazing pastures of Romney Marsh. Here, one can see for miles in all directions. This is a land that the sea has left behind, drained and serviced by a network of canals and ditches that are a haven for fauna and flora alike. Apart from the hedgerows and the occasional wind-stunted oak, the only focal points are small hamlets and a large number of distinctive small churches. In the winter, the towers of the churches rise above the low-lying mists, and the sound of an ancient bell may break the silence. In the height of summer, they offer cool and calm sanctuary to both locals and weary travellers. Around the churches, some of the old sheep grazing has been turned over to oil-seed rape (canola), a broad swath of yellow that is slowly becoming an accepted feature of the English landscape. This is one of the few place local to me that I would paint directly – it would be a sin not to. The silence, the history, and the fragile and tenuous existence of the marsh folk makes a profound statement that is irresistible to the landscape painter.

The sketch of St Mary in the Marsh was painted on sight, in the mid-afternoon sun, using just a small box of pastels and an orange-red primed board. The horizon almost cuts the painting in two because this is how it is. Sky and land get equal prominence. Attention is drawn continually to the horizon, and this symmetry helps explain the peace and calm of the marsh. A strong sky balances the more active lower half, and the single tree helps to bring the two halves together. A hint of a track through the field tempers the strong horizontal, but we are not walking. A dash of complementary wild flowers suggests we are at ground level, at rest and at one with the landscape.

St Mary in the Marsh
Pastel on board
55 x 70 cm (22 x 28 in)
Summer brings the joy of colour.

Many landscape artists are concerned with capturing a sense, or spirit, of place. We try to seek out those elements that affect us, and re-create these in our paintings. I see this as a very important way of communicating. If done properly, we have a language that is far more immediate and direct than any written word. I take great delight in seeking this common visual rapport, of identifying just what it is that excites us about the landscape, and encapsulating it.

A Sense of Place

Is there such a thing as 'spirit of place' then, or are we just projecting our own feelings and emotions on to what we see? Obviously our emotions differ by nature of our character and experience, but likewise, there is much common ground. Who would not be attracted to the colours of sunset or sunrise, the golden leaves of autumn, the first fall of snow? These are uplifting experiences, full of contrast and colour. But we also see beauty in the fading light, the greys and neutrals of northern climes, the harsh and the bleak. We sense that different landscapes may cause different climates, each of which will also reflect light differently. A bare, chalky soil produces a hard light, whereas an area with sandy soil will feel more temperate. Or is it that the climate forms the landscape? We think we sense how human history and culture have affected the look of the land, but, equally, how the land has done much to shape the way we are. Most importantly, I think we are all conscious that our earliest ancestors evolved, as it were, out of the earth, and ultimately this is where we will return. It is this above all else, I believe, that makes us sense and respect the spirit of place.

It is probably those areas where we sense this the most that we return to again and again to paint. These are the places that have an effect on us that we hanker to express in our work. The indicators of place are many: the smells and sounds, the climate, the vegetation, the presence of man. We also measure what we see by what we have seen before, perhaps with a hint of nostalgia. From a visual point of view, what is essential to all this is the light. If we are to visualize spirit of place, it will be done through light – or, more precisely, the constituent raw colours of light. Better than any other medium, the texture of pastel pigment reflects light the way we see it in nature. This is why I am so drawn to it. These are colours that have come from the earth and natural life of our landscapes. The colours have evolved in the way the land has. The texture is also that of the land. What better way to capture or create a sense of place?

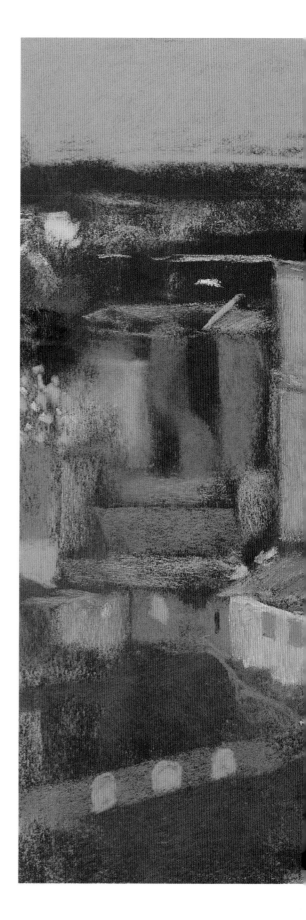

Provence Dawn
Pastel on paper
63 x 45 cm (25 x 18 in)
Contrasting cold blue shadows with warm autumn colours generate the strong, clear light of early-morning sunrise.

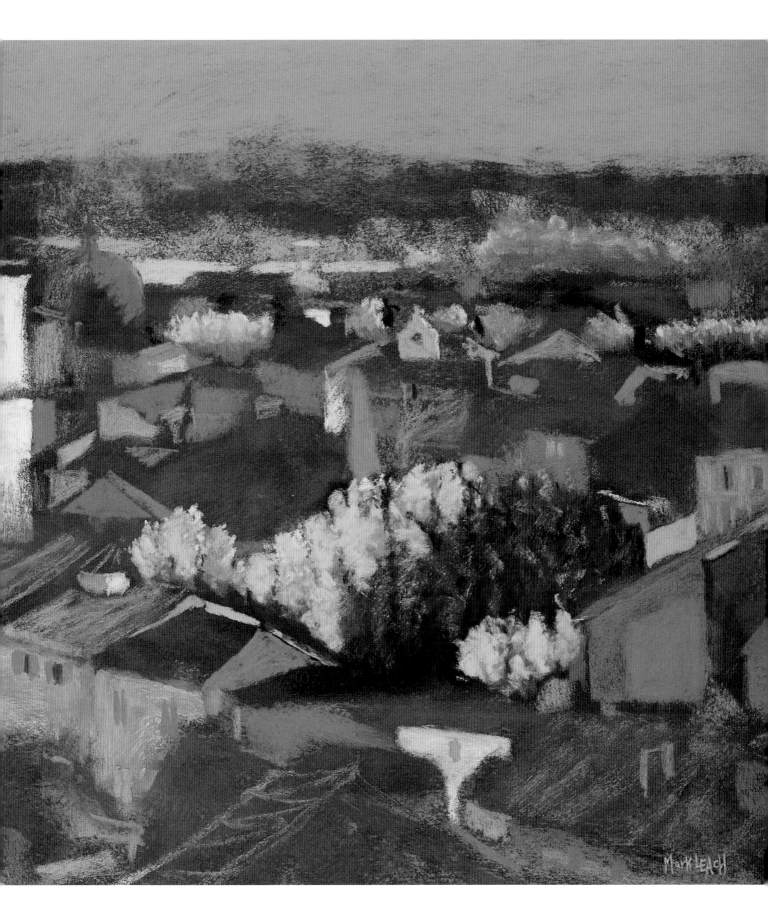

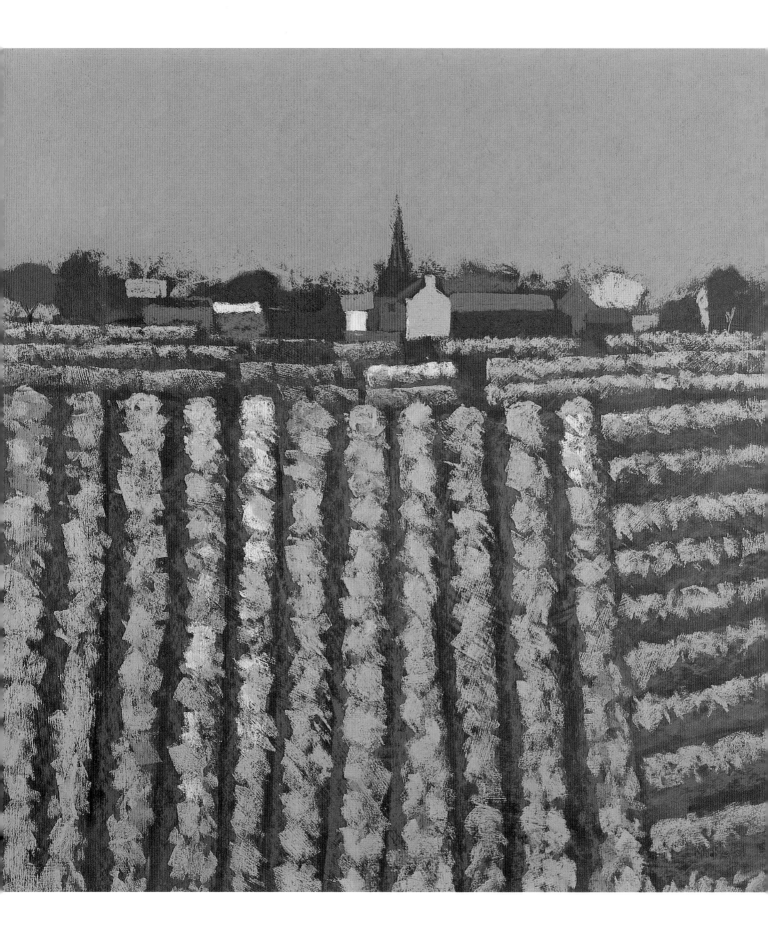

There are very few places I would not want to paint. The world is mine, full of sounds and sweet airs that give delight. However, there are places that are special to me, and it is these I generally concentrate on. As a professional artist, my work needs to communicate with as many people as possible, and this is what I want to do. I am sure all artists continually aim to paint the painting that is universally loved, however impossible that probably is. To this end, my landscape subjects tend to be places the majority of people who see my works will recognize, or may even have experienced themselves; if they were not, I would lose that sense of communication. This is very important to me. To paint strange and faraway places is enjoyable, but if it does not touch on some common feelings in the viewer then I see it as not much more than illustration, which is not my purpose.

Places to Paint

My very favourite places are those that are distant but accessible. France is probably my first love. These days I can drive there from my studio in only a couple of hours and immerse myself in a totally different culture. The change is a tremendous stimulation to my work. There are so many different aspects to France, and each geographical and cultural area has its own distinct character and atmosphere. One senses a closeness to and respect for the land there. It is easy to see how the people and villages and towns have grown up out of it, and are still very much a part of it. It is this sense of humans working with nature that inspires me. Mostly I find more than I could ever wish for in the French countryside alone, but from there I can also head for Spain or Italy. Who could say no to the high sierras, or the rolling hills of Tuscany and Umbria? Over many, many years, my paintings of these places have evolved into series: Provence, the Midi, the Rhone and Burgundy vineyards; the northern plains, the lagoons of Venice and the ochres and siennas of central Italy. Through painting on site and recollection in the studio I have sought to identify the intense feelings these places inspire. I have sought the colours that both represent atmosphere and express my emotions, and used these to create a personal statement. Each series is an ongoing journey, which evolves and changes as I do. There are highs and lows, twists and turns, sun and rain, anticipation, contemplation, and always something new just over the horizon.

Meursault
Pastel on board
75 x 70 cm (30 x 28 in)
The reds, golds and yellows of autumn express
the spirit and hopes of Meursault at harvest time.

Figures in the Landscape

It is only recently that I have given thought to introducing figures into my landscapes. Even my cityscapes were devoid of human life until a few years back. This is often the case with contemporary landscape painting, though why this should be so is difficult to explain. There are very few parts of the world these days that do not show the mark of humans. Indeed, the purpose of my own landscapes is to reflect on this. I can only guess that the presence of any human form immediately attracts the eye, and gives second place to what is all around. So if the artist's main aim is to seek or create a sense of place, then the place has to be the principal subject. As soon as the human form enters the frame, we start to tell a different story – a study of human life, not a landscape. This does not mean that we lose the sense of place altogether, but our instincts tell us to identify first with the people, and their relationship with the place they are in. The more human life we have in a landscape, the more this occurs: any more than two or three figures and the rest of the painting will prove little more than a backdrop. If we also wish to create that elusive sense of place in such a picture, we are going to have to be very clever. However, with just one or two figures the sense of place can still be achieved, and even amplified. Quite simply, if the figures take up more than half the picture space, then they will be the principal subject matter – our main concern will be who, rather than where, they are. If less than half the picture space, we will be more concerned with why they are there.

The Human Element

Figures are a fine way of introducing scale to a landscape. The relationship between trees and buildings can be open to interpretation, but the human figure will usually be seen as constant. Because we easily relate to the size, figures can also be a significant factor in the illusion of perspective. Figures at different distances will always create a noticeable sense of space. Because of this, and because figures will always dominate – with a similar effect to a highlight – the task of creating overall compositional balance requires a certain subtlety.

City parks are wonderful places to study and sketch human life. There is a noticeable sense of calm: children are free to play, mothers to chat, businessmen to unwind, lovers to hold hands. There is a feeling of community, yet also of isolation. People are aware of each other, but keep to themselves. Every one of these people has a story to tell. In the painting of my wife, Gaby, in the Jardin du Luxembourg in Paris, I have tried to suggest a sense of calm and deep thought. The figure is all alone, and the park is cold and empty. By keeping everything to a minimum, the figure small and still, the viewer can be drawn to many conclusions. Simple figures in the landscape can suggest powerful emotion such as fear, loneliness, despair, hope, contentment or love. The important thing is that the less we say, the more will be interpreted, and the more the viewer will relate to the painting.

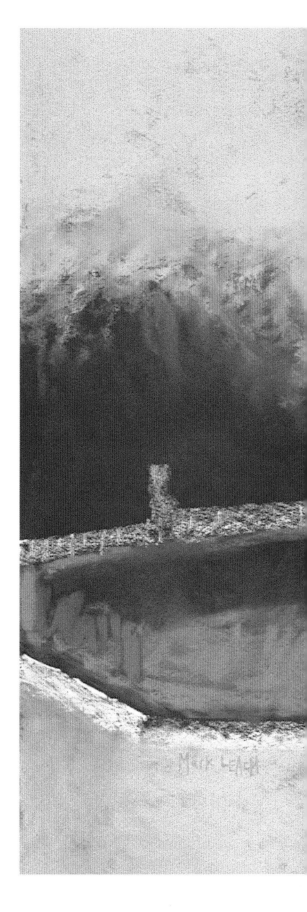

Gaby in the Jardin du Luxembourg
Pastel on board 75 x 80 cm (30 x 32 in)
The lone figure draws our attention, but a considered balance of colour, texture and tone give equal importance and weight to all parts of the painting.

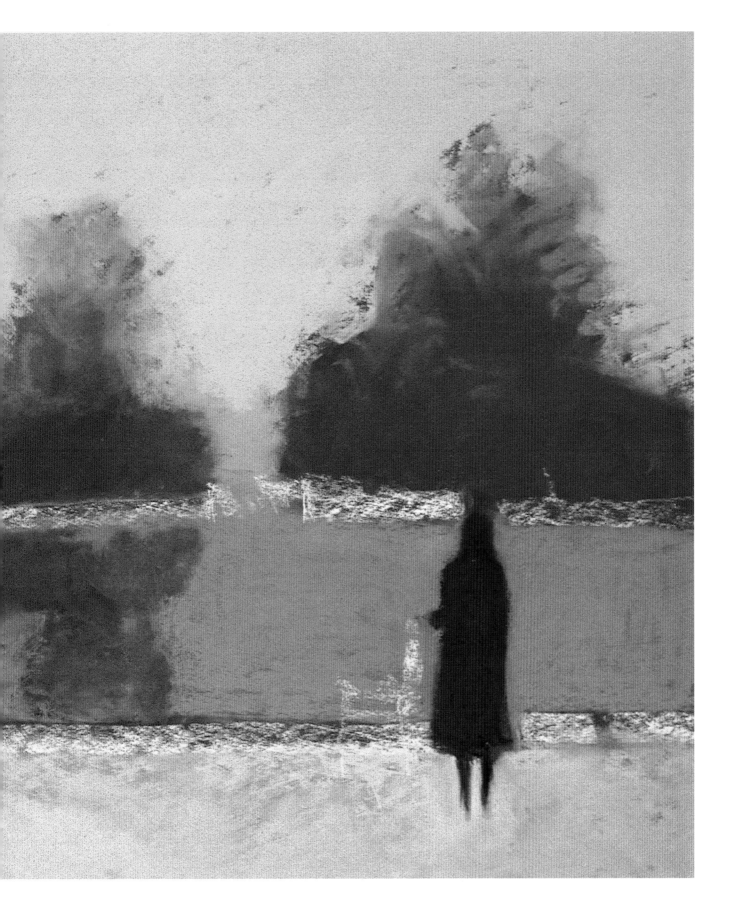

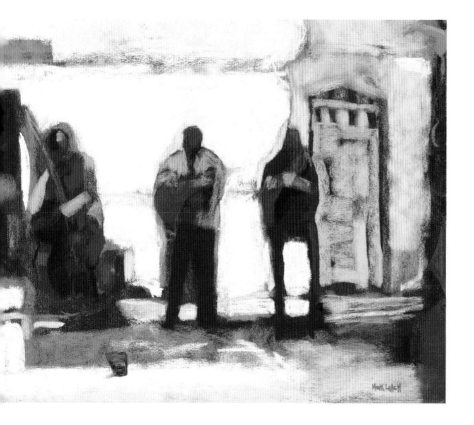

Street Musicians – Arles
Pastel on paper
45 x 58 cm (18 x 23 in)
The sound and colours of jazz brighten
the back streets of Arles.

Figures up Close

I am not, and never will be, a portrait painter. I think we should
all realize our limitations. Portrait painting is a very specialized
craft, and one that I am sure requires total dedication, probably
to the detriment of all else. Similarly, I have little interest, or
indeed much skill, in capturing or celebrating the human form for
its own sake. I am more interested in the stories people have to
tell than how they look. In other words, in my figure work I am
looking for a broad sense of humanity rather than physical detail.
And as with all my work, the important thing is to balance the
human with the natural. The figures must be in tune with what
is around them, and they must never dominate.

The Music in Art

It seems to me that artists always have a great respect for
musicians, and likewise musicians for artists. Painters love to
compare their methods to the making of music, equating colour
to sound, and composers often talk of painting with sound. I have
a great love of music, especially when it is live and spontaneous.
In my more abstract days, I would try and compose simply with
pure colour, and let that sing without any obvious figuration.
I have also tried to explore the joy of music through studies of
musicians at play. Street musicians prove great subject matter.
Musicians and instruments each have their own character and
personality, yet they share an unseen bond through the music that
unites them. This sense of unity can also be felt in Cézanne's card
players (painted in the 1890s), where different players around a
table share a common purpose. These aspects of a painting are as
important as structural balance when it comes to composition. It
can be equally pleasing, though, for figures to be unrelated – each
having their own story to tell.

Whatever we are trying to say, we must always remember that any human form will tend to dominate any picture it appears in, and that, to counterbalance this tendency and help to unite the picture space, equal importance should be given to all the surrounding spaces. I also try to avoid symmetry when rendering the human body, however true to nature it may be. Symmetry will often make people appear inanimate and posed. In fact, unless I am purposely suggesting calm, I will push against the symmetrical form of the body as much as I can, without resorting to caricature. I find this exaggeration and highlighting a natural way to treat other subject matter, and the principle can usefully be applied to figure work as well.

Street Musicians – Barcelona
Pastel on paper
50 x 57.5 cm (20 x 23 in)
Here the musicians dominate the picture space. Because of this, our attention is drawn to personality rather than place.

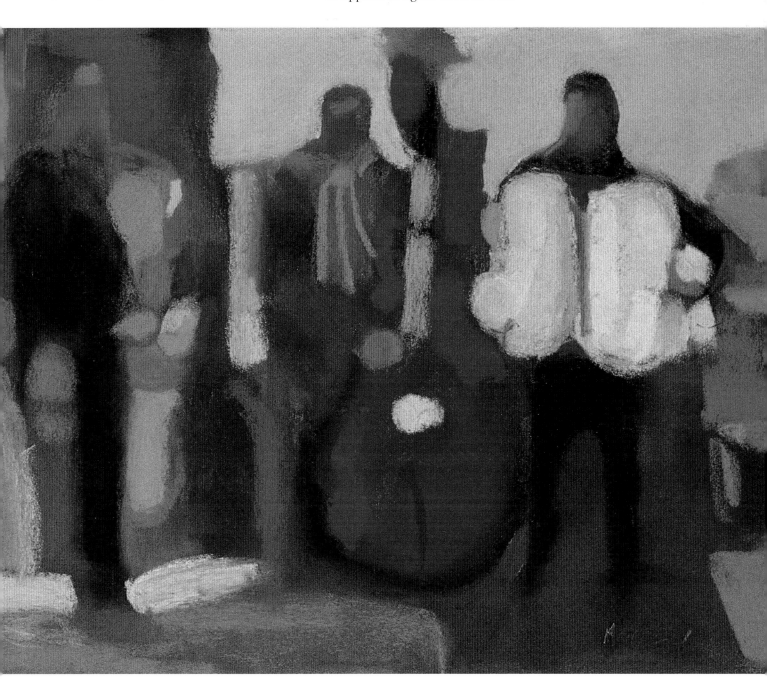

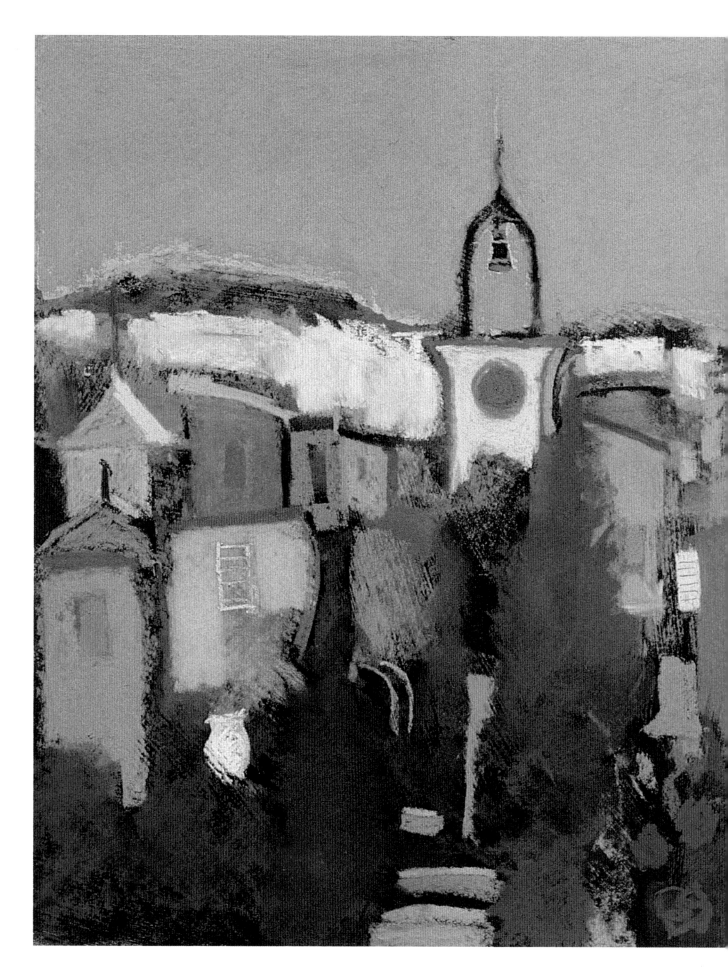

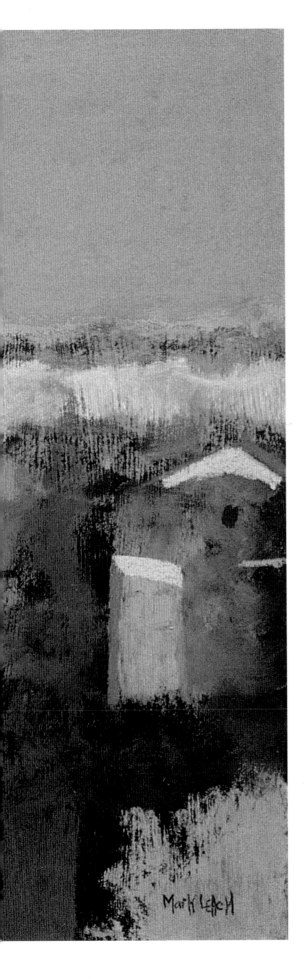

Village Scenes

I think many of us sense that village life is an ideal. To me it represents community and cohabitation on a manageable scale. A village is where people and families can live and work together, yet maintain their individuality. In essence, the village is a microcosm of society. It symbolizes the principles and purposes of the common man. Of course, this ideal is difficult to maintain in the modern world: we are all less dependent on our neighbours and local community than we used to be, but this does not stop us from thinking that maybe this is how it ought to be. These are strong and basic emotions, which are worth expressing and exploring. I am very drawn to depicting the village as a symbol of all that we hold dear. Within one painting I can use the village to express the main elements of humanity, community and society. The architecture is often old and worn, practical and necessary. The materials are most often local and contain the very essence of the land around. There is history at the turn of every corner, and all aspects of life through every door and window. These are not things that need to be spelt out, but they are an ideal way to express what I want to say – a proper harmony between humanity and nature.

Nothing typifies these sentiments more evocatively than the beautiful old hill villages of Provence, deep in the south of France. Usually perched high on ancient hills and rocks, and surrounded by fields of lavender or olive groves, aged vines, cherry and almond trees, these villages appear to have been here since time began. Certainly, much of the architecture has changed little since Roman times. The wonderful old tiles on the roof tops are still fashioned in the same way as the Romans did, and street layouts are often dictated by early ramparts and fortifications. There are narrow streets and alleyways that keep out the heat of the sun, and plane-tree-dappled squares, home to cafes and boules players. Every village has at least one church tower, each with its own unique bell tower silhouetted against an azure sky. It is difficult to think of better subject matter for the pastel artist. It is as if the old dry walls and dusty landscapes are made from the very pigment of the pastels themselves. In some instances they are. The beautiful village of Roussillon in the Lubéron appears in all the shades of ochre, mined from the nearby quarries, and changes in hue from yellow to gold to a rich red as the light changes, all complemented by the greens of the pines and the deep blue sky. For all this I am eternally grateful. Wherever I am, a part of my heart is always in Provence, and because of this I never lack for inspiration.

Cotignac II
Pastel on board
40 x 48 cm (16 x 19 in)
Colour perspective is used to balance and bring together foreground and the distant golden hills of Provence.

I have to admit to a slight weakness for the grape, and the rewards of a well-cultivated vineyard. To sip at a glass of fine wine from an area I know can be like drinking in its soul. I like to think I can taste the very sweetness of the land. In many ways, I would hope for my paintings to have the same effect. This is probably why I am often drawn to paint the wine regions, such as the Côtes du Rhône or the splendid châteaux of Bordeaux. The colours that these places inspire in my mind are as subtle and complex as the tastes and bouquet of their wines. When I reach for my pastels, it is my palate that inspires my palette.

Painting in Themes

In much of my work, I find it very satisfying to work in series. I try to relate back most of my work to a particular theme, such as 'The Colours of Tuscany' or 'Venice Nocturnes'. In this way I can develop a theme over many years. Each painting does not stand alone, and forms a part of something bigger and ongoing. One series that I continually return to is the famous villages of the Burgundy region. Burgundy is a large area of central France that reaches from just south of Paris in the north to near Lyons in the south, and from the Loire in the west to Dijon and the foothills of the Alps in the east. There is enormous diversity to the land, yet a singular strength of character and purpose that I find very inspiring. The towns and villages are not always the most picturesque, and the landscapes are far from dramatic, but what I am keen to capture is the integrity – the way the land, villages and people are all very much a part of the same thing. Once again, I find this symbolized by the village, which is central to so much of the way of life. As with most French villages, it is the church spire, or spires, that prove a pivotal focal point. These spires tend to reflect the architecture of the village, and in Burgundy are often steep and beautifully tiled. Church spires always give a dramatic vertical contrast and focus to a landscape painting. The effect is often irresistible, but I also take great delight in the contrast between the straight lines and flat planes of the buildings and the rolling hills of the countryside. This can allow for strong abstraction, but with purpose.

Painting the vines themselves is always a challenge. Many details of landscape can have a complexity and uniformity that is enormously inspiring in real life – fields of sunflowers, waves on the ocean – but very difficult to suggest as an overall impression. The French take great pride in the way they lay out and maintain their vines, and it is important to suggest this. However, large areas of stripes in a painting are notoriously dominant, and it takes great compositional skill to balance them with other areas. It is a skill I have yet to develop to my own satisfaction, but it is a challenge I continue to relish.

Angely
Pastel on board
55 x 65 cm (22 x 26 in)
The wonderful abstract shapes of the buildings of Angely, near Chablis, are captured in shades of rich, burgundy red.

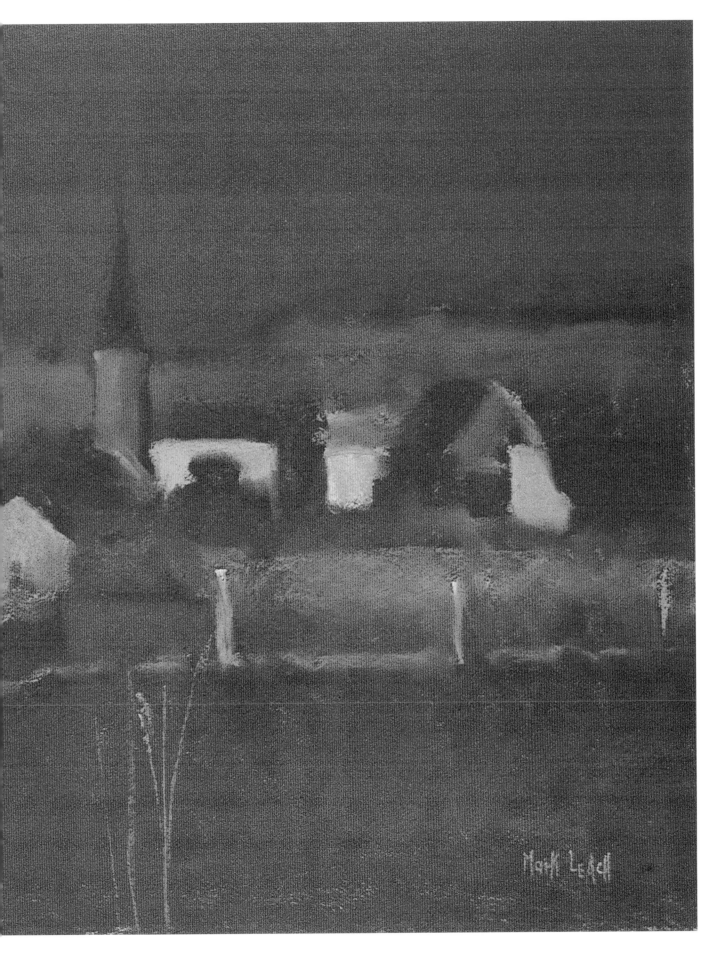

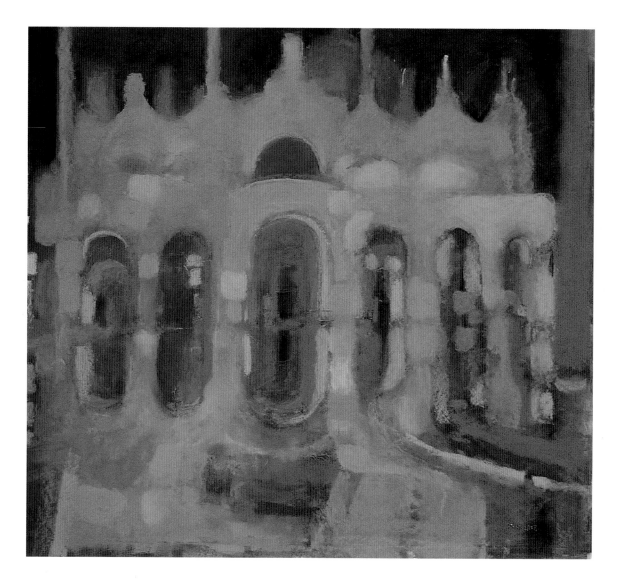

Cityscape: Venice

I am no longer a city dweller. Cities for me are now places
to visit, stay a while, or view from a distance. As an outsider,
however, I am fascinated and awestruck by aspects of city
life. The city encompasses the very best and the very worst of
mankind. There is grandeur and decadence, riches and poverty,
hope and despair. These are all magnificent themes for the artist
to consider, and although I am primarily drawn to the land and
nature, there is no way that as a landscape artist I can ignore
what the city, and city life, expresses.

The Magic of Light

The jewel of all cities, for me, is Venice. I am sure most who have
ever been there would agree, and those who have not are missing
one of the most rewarding experiences I can think of. To see what
people can make of a few lonely, mosquito-ridden islands in a
lagoon is something we all deserve to take great pride in. More
than anything, I want my paintings to celebrate this. I am less
interested in the detail – the complexities of history and

San Marco
Pastel on board
73 x 80 cm (29 x 32 in)
A winter's night, when the crowds are all gone,
and Venice is left to itself.

architecture. What does inspire me is simply that it exists, that its builders have put beauty above function, and continue to do so. If nothing else, the overall visual impact of Venice is what appeals. The pale and limpid light of the lagoon is unique, and an inspiration on its own. This light reflects on the calm waters to create an aura of green and blue that is both calming and exciting. When I paint Venice, it is always the light and the water that take prominence. However magnificent, man's works will always take second place to nature. We see great beauty in Venice, but in all the pomp and majesty there is also frailty and transience. As artists we are perhaps driven to capture what we know is fading, and will one day be lost. There are no other cities like this. She is like a fine old lady, proud and dignified, with a straight back and just a slight tremble. She is dressed in expensive lace, slightly faded and frayed at the edges. She expects and deserves the utmost respect.

Towards San Giorgio
Pastel on board
73 x 80 cm (29 x 32 in)
One of the most famous views of Venice. The combination of sea, land and sky can prove irresistible to the landscape painter.

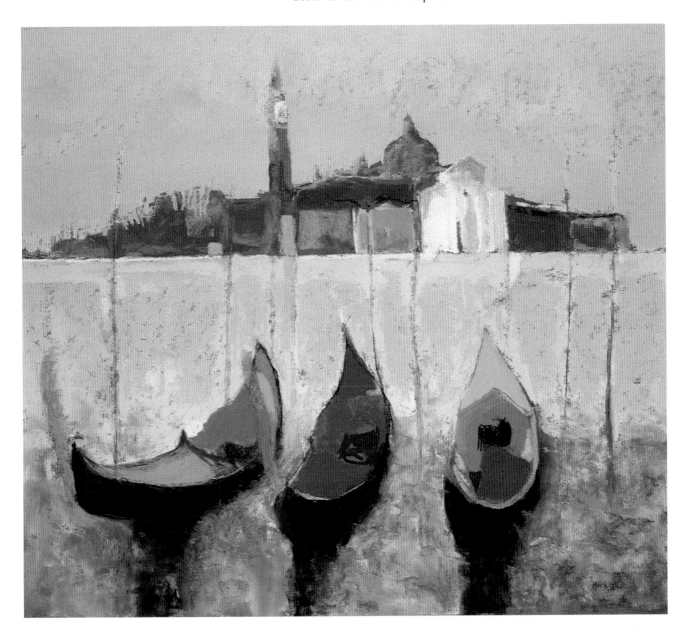

I have visited Venice many times, and will continue to do so. Over the years it has made such an impression on me that I no longer need to refer to sketches or photographs. I can walk the streets and alleyways in my head and somehow all I need is there. Certainly, through tackling innumerable paintings I feel I know my favourite places intimately – the island of San Giorgio, the basilica of San Marco, and the churches of Il Redentore and the Salute are all major landmarks that I have approached in a thousand different ways. I continue to sketch and photograph, for there are always new ways to see, but my main compositions will always reflect what is inside me.

The Colours of Venice

Pastels are the ideal medium to capture the colours and textures of Venice. Although they are not best suited to the translucence of sky and water, there is something about the dryness and opacity that does suit Italian landscapes, and architecture, particularly well. From a compositional point of view, Venice is able to provide a natural balance that can be very helpful to the landscape artist. The lagoon and canals allow us to reflect the lightness of the sky at the base of the painting. This helps to draw our attention continually to the centre of the painting. This is surely one of the reasons artists are so attracted to painting Venice, even if they are unaware of it.

The natural colours of Venice are an inspiration by themselves. First impressions can be the golden and yellow ochres and russets of the buildings and grand palazzos, the pure golds and lapis lazuli of the church frescoes, or the jet-black gondolas. Above all, we are overwhelmed with the green-blue reflections from the canals and lagoon of that alluring Adriatic light. Wherever we go, it is this light and colour that dominates, reflected in all we see. At one stage, nearly all my paintings of Venice were predominately blue. This was the only way I could express how the colour and light of the city affected me. At times I have contrasted other colours, but this has to be done with great care. However much bustle, with crowds of tourists and endless motor boats creating a confusion of activity, I want to paint Venice as a place of tranquillity and reflection. Too much use of colour, and that essence is lost. By choosing a particular colour of Venice, and only working with other colours that are closely related, I hope to define and express a particular characteristic. By seeing through the detail, and calming the movement and contrast, one has a chance at least of touching the very soul of this magnificent city.

Venice Sunset
Pastel on board
70 x 75 cm (28 x 30 in)
Reduced to little more than abstract symbol,
well-known landmarks can offer greater scope
for experiment and expression.

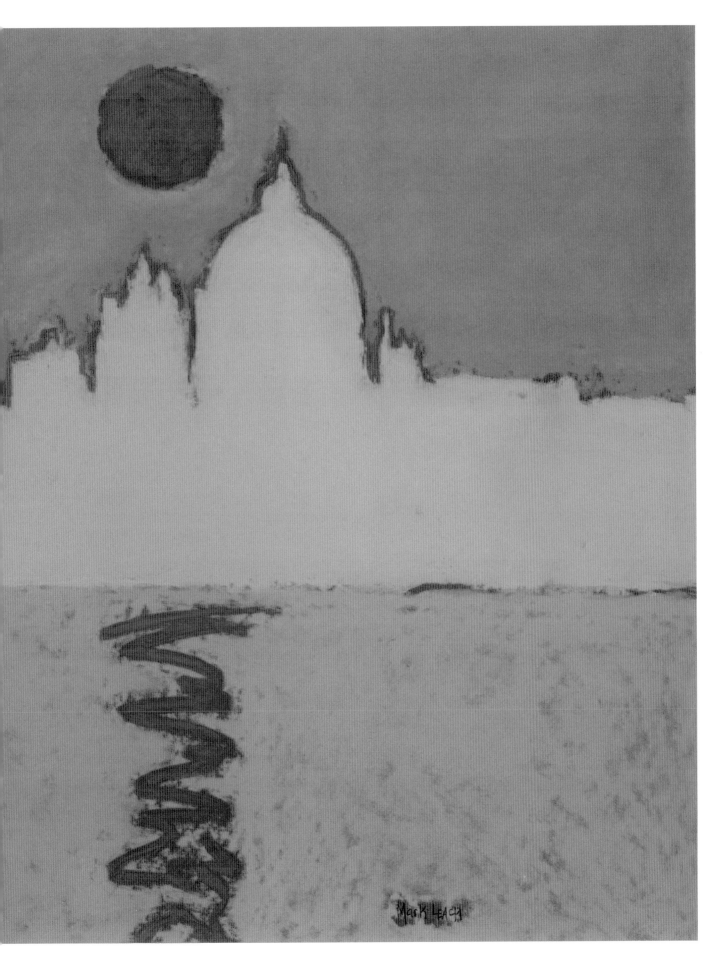

Cityscape: Paris

Nearer to home, my favourite city to escape to is Paris. Since I was a small boy, I have felt totally at home here. There is simply something for everyone, from magnificent splendours, palaces, museums and grand boulevards, to the chic and petite, the village streets of Montmartre and alleyways of Saint-Germain. For me, the very fact that it drew the most significant painters during the most remarkable era of modern painting means that it will always have my love and respect. When I sold my very first painting, my foremost thought was that I could afford to go to Paris for a weekend. To treat Paris as my Mecca then made absolute sense, and it still does. There is a magical feel to Paris, something that is almost impossible to put into words. Many things contribute to this sense of purpose, importance and reason to be. Over the centuries, Paris has evolved this distinct personality that expresses characteristically French qualities. There is dignity, indifference, formality and pride, and also glamour and gaiety, a love of fine things, philosophy and art. Somehow, I wish to capture all this, to identify these elusive qualities that words can only describe, to create that atmosphere that is solely Paris.

Le Consulat, Montmartre
Pastel on board
108 x 60 cm (43 x 24 in)
The small restaurant in Montmartre that was a haunt of the Impressionists. It is always inspiring to walk in their footsteps.

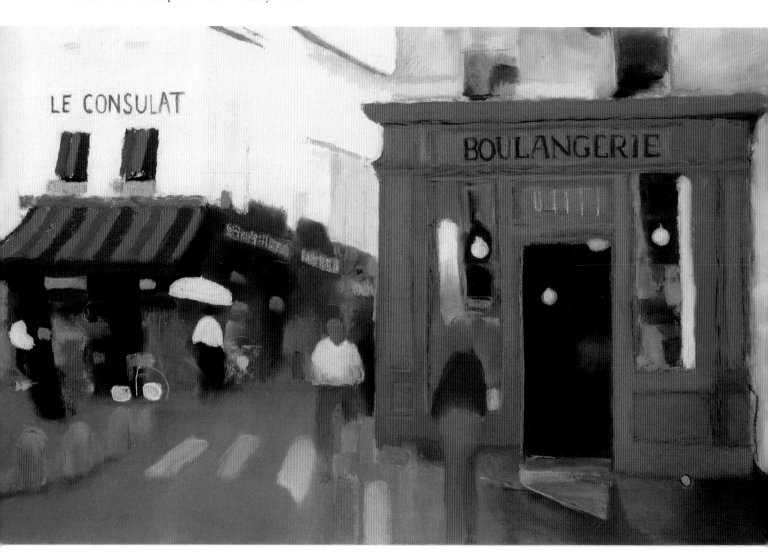

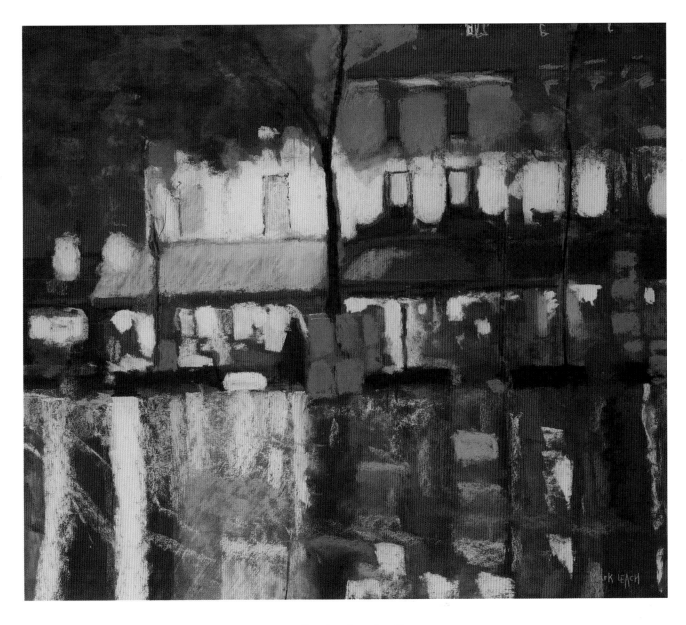

Place du Tertre, Paris
Pastel on board
73.5 x 86.5 cm (29 x 34 in)
Strong horizontals and verticals hold this composition of night time in a rainy Montmartre together, as well as suggesting the formality of city life. Warm reds and oranges imposed on a blue ground give a balance between wet streets and warm interiors, as well as a sense of movement and life around the deserted square.

Illuminating the City

People recommend Paris in the springtime, and I would not disagree. If it is truly the City of Light, then what better time to come, when the leaves of the plane trees are fresh and green, and the parks and streets come to life. If you wish to paint a youthful, hopeful, lively Paris, then this is it. But I have to admit that in many ways I prefer the late autumn and winter. Here, when the skies are heavy and grey, the streets quieter, and the lights come on early, Paris makes the most of what it has to offer. Street lights and shop illuminations bring more colour than you will find on the sunniest summer's day. Damp streets display a carnival of colourful reflection. Everything is intensified by darkened skies and a low-lying sun. The cold and wet draws you into places you might not normally notice – small candlelit bistros and zinc-topped bars that bring you close to your fellow Parisians. This is my favourite Paris, a quiet intimacy amid all that civic prominence.

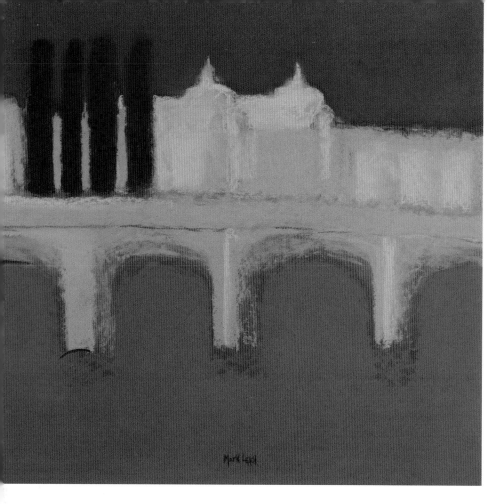

Orsay
Pastel on board
70 x 75 cm (28 x 30 in)
The magnificent Musée d'Orsay houses some fine
and very precious pastel works. Through greys
and pinks, I aimed for an image that was intimate
but respectful.

However much I love the quiet back streets and more intimate
areas of Paris, I am inevitably drawn to the grand, the stately and
the majestic. In the centre of the city, topped by the resplendent
Arc de Triomphe, we have the broad sweep of the Champs-Élysée,
which leads down to the Place de la Concorde and on through
the Tuileries gardens to the splendours of the Louvre. To the
north we find the Haussman boulevards, department stores and
the magnificent opera house (the Palais Garnier). To the south,
the slow-moving waters of the Seine divide the city and give us
famous bridges, the islands of St Louis and the Cité, with the twin
towers of Notre Dame. On the banks of the Seine we find the
architectural treasures of the Grand and Petit Palais and Hotel
des Invalides.

Impressionists Inspired by Paris
In these few square miles are housed some of the greatest works
of art of the Western world. The Louvre needs no explanation,
nor does the Musée d'Orsay with its unequalled collection of
Impressionist work, including some very fine pastels by Degas and
his contemporaries. To explore what has followed, a short walk
to the Pompidou Centre and its collection of 20th-century masters
is equally inspiring. Smaller museums and galleries, such as the
delightful Musée Picasso, are all close to hand. I feel it a duty, as
well as a great challenge, to explore and paint my passion for this,
the very heart of the city. This can be difficult. Many of the
buildings are imposing, and the architecture complex. There is
limited colour, with the light and shadows often no more than
a pale grey. Bridges are notoriously difficult to paint, with their
uniformity and their emphasis on the horizontal. And of course,
these are places that are very well known and easily identifiable.
We do not want our paintings to resemble little more than tourist

postcards; there is no point to straightforward renditions. With all this in mind, it is even more important to paint how one feels, rather than simply what is before us. It is very rare that I would paint Paris on the spot, so it is usually little more than my memories that come out of the painting. If I set out specifically to paint the Musée d'Orsay, then I would probably have a lot of difficulty worrying about the architecture and the surrounding detail. This is not what I want. Far better to simply start applying colour that sets an emotional tone, and then let memories slowly suggest a composition. If really necessary, subsequent detail can be verified against sketches and photographs as the painting progresses. In most cases, the grander or more identifiable the subject, the less detail is required. The joy of painting well-known places is that you do not need to do much explaining. There is less need for illustration and the emphasis can be on the abstract and emotional content. Through this approach I can share my impressions, sentiments and love for Paris in a very personal yet hopefully accessible way.

Right Bank
Pastel on board
58 x 53 cm (23 x 21 in)
This is a favourite viewpoint. An interesting mix of colours that are, in fact, all from the blue colour range.

Still Life

For a landscape painter, still life offers the chance to come indoors and reflect. If I compare my landscape work to a journey, an exploration of what is out there, then my still lifes are possibly the destination, or conclusion – a coming home. Both my landscapes and still lifes' have similar aims: a harmony of the man-made and the natural. However, with landscape painting the emphasis is on nature, and man's place within it. Still life lets me explore the other side of the coin, with the accent on what humans have made of nature and natural things. I feel a great sense of the spiritual with my still-life work: it is a wonderful way of showing respect for the simple things we hold most dear. I am sure we all consider an apple as a miracle of nature, a fine example of what nature has to offer. If we paint an apple on a tree, it is seen as only part of something much larger. If we bring the apple indoors and place it on the table we see it in isolation. There is less distraction and we can concentrate on what the apple alone says to us, and about us. It is this facility, first and foremost, that encourages my still-life work.

Blue Table
Pastel on board
25 x 30 cm (10 x 12 in)
An interesting abstract design is key to my still-life work.

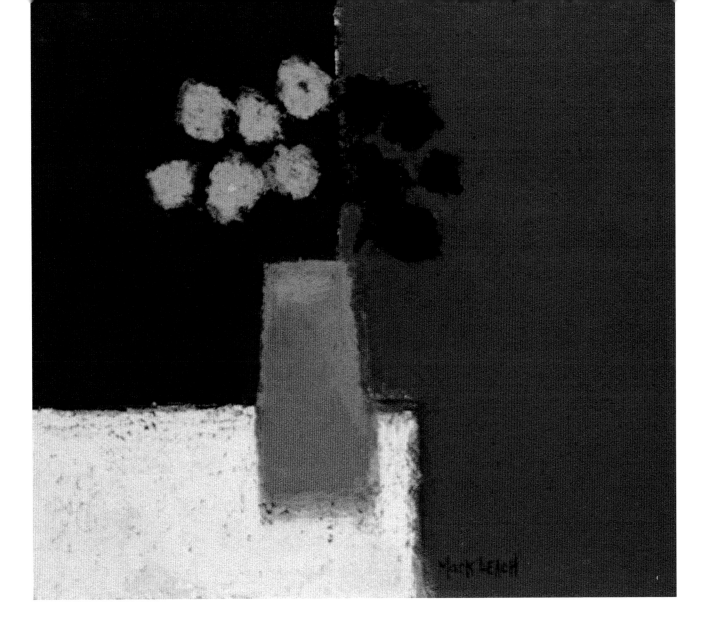

Orange Vase
Pastel on board
20 x 23 cm (8 x 9 in)
I try to capture the spiritual through simple things, simply rendered. Reducing colour and composition to a bare minimum can imply honesty and integrity.

Approaches in Still Life

The idea of painting interiors and the objects of domestic life first came to major prominence in the Netherlands in the 17th century. The English term 'still life' comes originally from the Dutch *still-leven*, literally 'still nature'. It seems these paintings were as much exercises to show off the skill of the artist as any serious attempt at ideal or allegory. Food and flowers were always popular subject matter, with the paintings celebrating the artist's ability to make the transient appear permanent. The paintings sometimes reflected on Protestant ideas of material wealth, with the introduction of motifs such as skulls and hourglasses to remind the viewer of the transitory nature of things. Since these times, still-life painting has maintained a significant importance in Western art. In the 18th century, French artists such as Jean-Siméon Chardin (1699–1779) continued to laud the properties of inanimate objects. In the 19th century, Cézanne took the genre to a whole new level by emphasizing an overall formality and structure. This led directly to Cubism and the colour work of the Fauves and the Expressionists. This development has had a undeniable effect on all types of contemporary painting. Today, our approach to still life will continue to influence, and indeed be an important part of, all our other work.

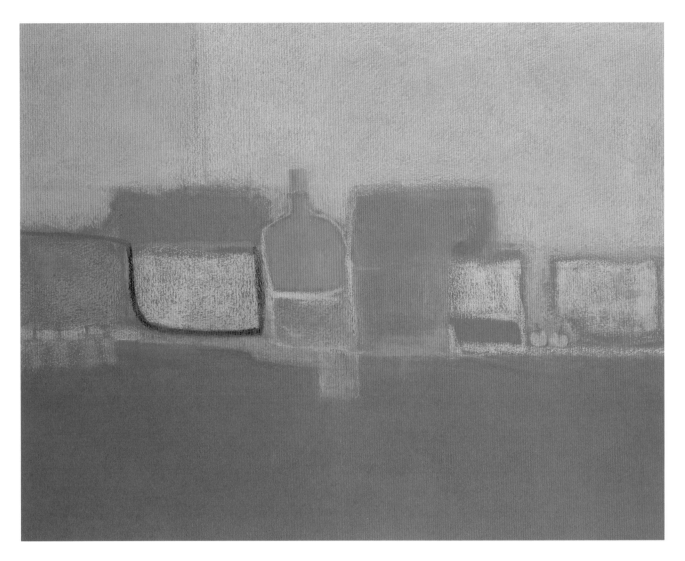

I approach a still life as I do all my other work. I certainly would not set up or arrange objects to copy or interpret. I would find this a very limiting, almost academic procedure, to say nothing of not being much fun. Of course, there is a need to practise one's drawing skills and find new ways of seeing light, colour, tone and texture. This I put down to practice, or even research. For a successful and meaningful composition, my still life must come from the heart. I use objects as symbols. I am not particularly interested in capturing how the light reflects off a glass, or the texture of a rose petal. This would detract from the abstract qualities that are my main concern in this genre.

I aim for still lifes to be almost iconic. They defer to the simple, modest things in life, and for this they must be modest in themselves. This attitude encourages me to explore colour, form and texture in a pure and unadulterated way. I want the paintings to suggest this as much as the objects, and what they represent. Colour is all-important in this exercise. I find I have much greater control of colour when painting still life than in landscapes or figure work. This is probably because I am dealing with interiors, where natural light and backgrounds have less influence.

Back Home (A Moment of Reflection)
Pastel on canvas
60 x 70 cm (24 x 28 in)
This started as a landscape, until I turned it upside down. A lot of my work comes from the accidental and unexpected.

There is a lack of depth to the image in a still life that means large areas of flat colour are more acceptable. This I can use to great effect. An overall colour tone can suggest an emotion for the whole painting. Red, for instance, will demand attention and give importance to the subject. Blue will create distance and calm. Greens and yellows will be more concerned with the practical and the here and now.

To create a mood for quiet reflection I often use closely related colours – the more closely related they are, the greater the effect. Also important for the sake of creating spiritual ambience is a harmonious composition. This is essential for all successful paintings, but especially when working on a basic, minimal level. The few simple shapes must have perfect balance of both form and colour to serve any real purpose (I discuss this more fully in the next chapter). For the sake of compositional harmony, it is also important, for me, to maintain a flattened picture plain. All areas of the painting must have equal importance. This means limiting the effect of perspective and keeping tonal modelling to a minimum. Subsequent layers of pastel may also create a suggestion of the third dimension. If detailed subjects, such as a vase or flower heads, are the last areas to be painted, then that layer of pastel will stand proud of earlier layers, and we will tend to lose the illusion of flatness. To avoid this I often draw subject matter into the top layer of pastel with a dry brush, to let under-layers or undertone show through. This can either be left as it is, or subsequently drawn onto. It is a surprisingly effective way of working.

Still Life with Fig
Pastel on paper
76 x 71 cm (30 x 28 in)
A rich red background and centrally placed objects give a strong spiritual, almost iconic, feel to this painting. A pale ochre was rubbed into watercolour paper and fixed. A thick layer of cadmium red was then applied to the whole surface, and the basic composition drawn in by removing the top layer of pastel with a dry sable brush. A touch of complementary colour based on the triad system (see 'Creating Contrast', page 52) adds depth and focus. The minimal result emphasizes the spiritual over the physical.

Composing and Developing Images

Painting is all about composition. The process of composition allows us to craft and render our feelings and emotions through no more than the simple application of colour to paper. It is the art of thinking and working in two dimensions, of abstracting and making sense of what our eyes see and minds feel. Without a proper understanding of composition – of how to balance form, colour and meaning – our work will mostly be in vain.

The act of composition starts when we first stand before a blank canvas and make that initial mark. All our preparation, the stocking of the studio, the sketches, the inspiration and anticipation focus on this one point. No matter how much we have prepared, this is the most daunting time, and like an athlete waiting for the starting pistol we have to be psyched up and at our peak. All our emotions have to be focused on the track ahead, knowing that if we concentrate, do not stumble, and use everything we have inside us, we may just achieve our goal. This makes the act of painting sound traumatic and exhausting. It is. The first hour or two of a new composition is the most demanding thing I do. It is essential to all that has gone before, and all that will follow. It is the high point in terms of effort, but can equally be the high point in its rewards.

Café Life
Pastel on paper
40 x 50 cm (16 x 20 in)
Avoiding specific focal points brings movement
and life to this impression of Parisian café life.

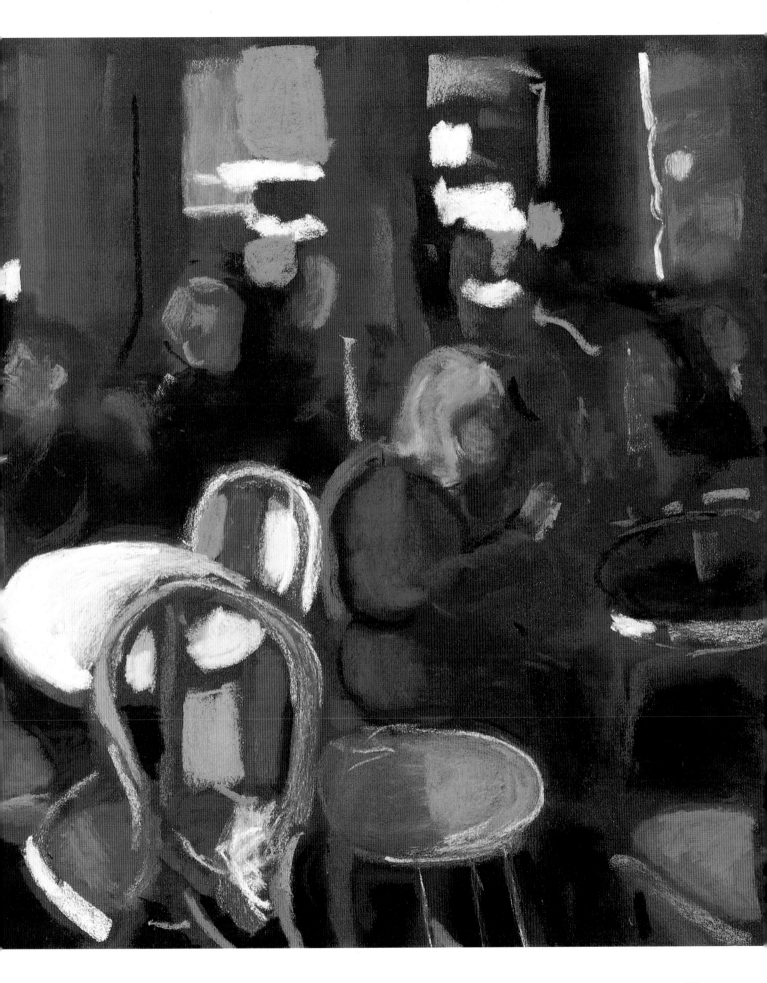

It is difficult to recommend approaches to composition. Composing is where training, preparation and method must give way to personality. If our paintings are to be unique, a totally personal statement, then so must be the way we compose. There are accepted techniques, such as linear perspective and the rule of thirds (see 'The Golden Mean', page 116), but if these are followed too consciously we are liable to dampen the joy of our own self-expression. However, It is important to understand existing and past techniques, have an appreciation of colour theory and of the qualities of our materials as a basis for developing our own unique approach. To be properly prepared in this way, and have confidence not only in our technique but also our inspiration and working environment, is essential for producing our best work.

My Studio

To produce the best painting we need the best working environment. Ideally, this should be somewhere dedicated, all set up and waiting, to which we can return at any time and find things just as we left them. There should be acres of wall space, floor space, flat surfaces and shelving, with as much natural light as possible and a variety of adjustable synthetic lighting. It should be free of damp (especially where pastels are concerned), noise, telephones, friends and family alike. A sink and water supply are very useful; you may think pastel is a dry medium, but constant hand-washing is a must. If we have the space, there should be music (unless you find it distracts you) and books and things of beauty. More than anything, the studio should be somewhere you want to be, that suits and fits you, and makes you feel welcome.

The more you can achieve this, the more your mind will be free to paint. Of course, it is not essential. Many successful pastel artists have no studio at all, and many paint only *en plein air* (out of doors) and finish off at the kitchen table. Pastel is ideal for all approaches, but for serious professional work a functioning dedicated studio space is the best solution.

Fortunately, I am blessed with the perfect location: an outbuilding just a hundred-metre walk from the family home. Originally designed as a music studio, it sits on the edge of ancient woodland with views across the Sussex hills and the sea beyond. As well as a small kitchen and cloakroom, there are two main studio work rooms and a further room that acts as a small gallery. The smaller work room is reserved for oil and acrylic work, while the main room is solely for pastel.

At one end of the pastel room is a long work surface, roughly 7.5 x 1 m (25 x 3 ft), which allows me to lay out and maintain a vast and varied assortment of soft pastels and associated tools. This area is sacrosanct – my high altar. Pastels are laid out by type (manufacturer) in flat boxes with a sponge base. There are separate boxes for each of the main colours: reds, greens, yellows, blues, purples, browns, neutrals and greys. In some cases these are further split by warm and cool hues, such as blue-green and blue-violet. Behind these boxes of working pastels are further boxes of new stock, labelled and sequenced to ensure I never run low on my favourites (I still do). Directly before this work surface is a

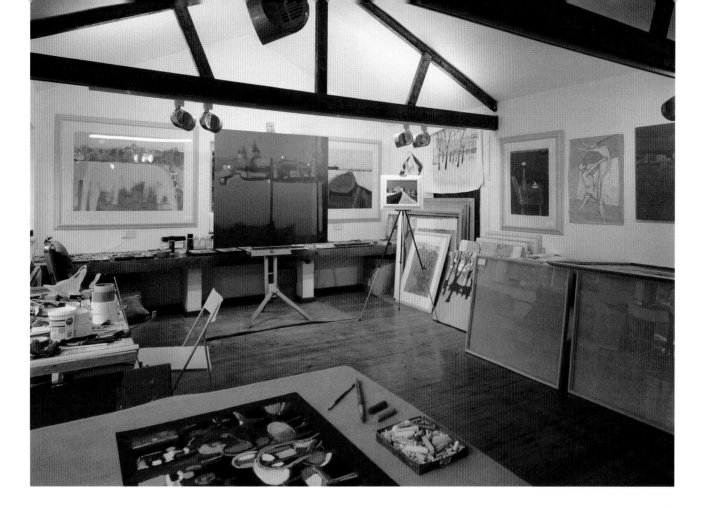

Above:
My studio – a dedicated work area gives freedom for expression.

large upright sketching easel, which supports a square piece of chipboard 1.2 m (4 ft) on each side, to which I pin or clip my pastel boards or paper. A lack of natural light means the easel is highlighted by a barrage of fluorescent and daylight spot bulbs (bulbs designed to emit light across the entire visible spectrum, mimicking sunlight, to allow colours to be properly judged). To one side is a table with further tools: brushes, putty rubbers, assorted blenders, cans of fixative, tissues, rags and a large bowl of usually murky water for rinsing the hands. The floor is wooden, but a large piece of carpet under the easel catches most of the falling pastel dust. Around the room there are further tables and work surfaces, some empty for working and sketching on, others holding framing tools, stacks of half-finished paintings, books, photos, CDs, and a variety of drawing instruments.

A lot of artists are concerned about the safety of using pastels. Although common sense should apply, there is little cause for such concern. The majority of poisonous compounds that were formerly used in pigments such as white lead, cobalt violet and Naples yellow are no longer used. Cadmium is used, but in such small quantities as to be harmless. Of course, it is best to avoid constantly breathing in pastel dust. More importantly, fixative should never be inhaled. It is against my nature to worry over such things, but I do hear of people going to absurd lengths to protect themselves. There are those who recommend the wearing of surgical hats, masks, gloves and footwear, the use of special mats that are washed each night, electronic air filters and so on. I clean my studio once a year, and the surgical hat and mask I'll save for Halloween.

Preparation

'Be Prepared' was my rallying cry as a Boy Scout. Although I gave it little heed in those tender years, it certainly has relevance to my life now. Nothing can be more dispiriting than being unable to realize an impulse as inspiration strikes. Ideally, an artist should never be without a pen and paper, notebook or sketchbook, or a camera. There is really no excuse not to be, especially since some digital cameras today take up no more space than a credit card.

Equally, there should be no excuse for lack of preparation in the studio. The worst offence is to run out of essential pastels in mid-flow. My way of working is intensive: in the initial stages of a painting, composing requires an emotional high. This I can sustain for an hour or two at most, but once it slows it rarely returns. So to be let down by your tools and materials at a times like that does not make for a happy artist. Ensuring that the studio is sufficiently stocked at all times is therefore paramount. As I mentioned, as well as the boxes of working pastels, I try to maintain at least one spare stick for all the most common pastels I use. I would guess this is in the region of a hundred sticks. For the favourites, no less than three spares are required (I can easily get through this many on one painting). Apart from the pastels, the other items which may run out are fixative and possibly putty rubbers. Neither are absolutely essential to the composition process, but I do feel wary if they are not around.

If you wish to work as inspiration strikes, then it is also necessary to have a good stock of paper and supports to hand. If you are using ready-made papers then this should not be a problem. Pastel

Bird on a Wire
Pastel on paper
63 x 63 cm (25 x 25 in)
A truly abstract composition that shows how simple shape and colour can create emotion. With no obvious representation, there is poise, balance, movement, transience – a fleeting moment in time.

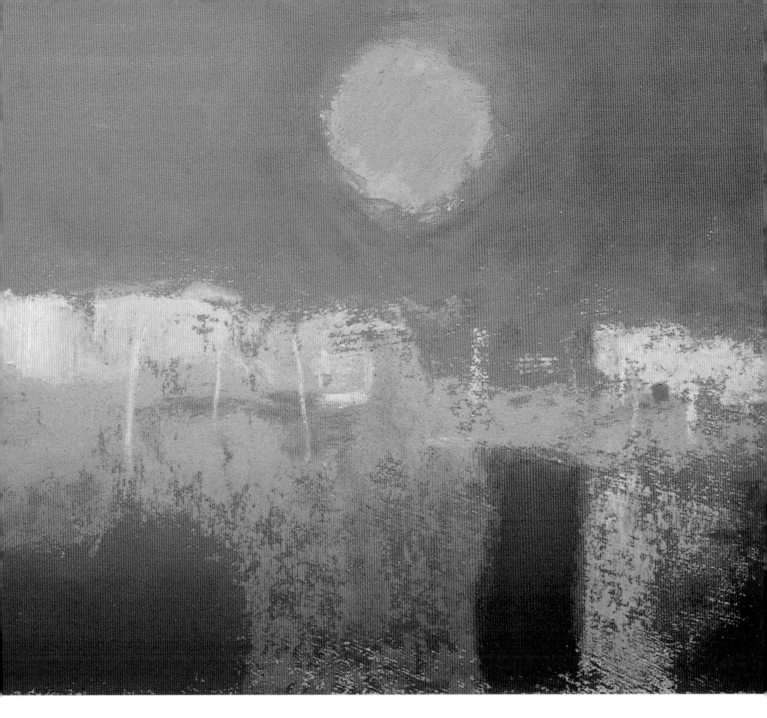

Honfleur Sunset
Pastel on board
22 x 16 cm (9 x 7 in)
A small homage to a place that helped inspire
Monet to such great things.

artists soon decide what supports suit them, and ensure they have a ready supply. Even those such as myself who prefer to prepare their own supports should maintain a stock of ready-made paper. My own preference in these is for the darker shades of the Sennelier pastel card, in all the available sizes. To prepare supports for future use is not always feasible. The main reason for preparing one's own supports is to have control over their size, colour and texture, but it is not easy to plan this without knowing what paintings you intend to make. I do make minimal preparation by priming boards with a mixture of pumice powder and acrylic gesso in readiness for future work. Following this, all that is required is an additional coat of acrylic paint (plus some further pumice or marble dust) of the desired colour. This can be done immediately prior to starting the pastel painting. Most acrylic paints dry within an hour or two, although they are ideally best left until the following day.

Choosing Size and Format

The only other consideration before you start to paint is the size and format you are going to use. My inclination is to paint big. To feel at one with what I am painting I prefer the picture surface to fill my field of vision. Assuming I am standing a few feet from the easel, the area that is in direct focus is roughly one-third of a square metre (4 square feet). This is large enough without being so large that I have to continually step back, so I am most relaxed when painting to this size. Of course, one has to compromise for all sorts of reasons: commission and gallery requirements, transport, cost and so on always have to be considered. It is also important to note that, with pastel, the larger the work surface, the more diluted the colour will appear. I have yet to work out why this is, but if you wish to maintain the strongest colour saturation, it is probably best to paint pastels no larger than about 1 square metre (9 square feet).

Apart from the practical concerns, the size and shape of a painting will obviously have an important effect on the viewer. We sense that smaller works tend towards intimacy, or the incidental. They can also feel more personal and immediate. For instance, we usually sketch and do preparatory work on a smaller scale to the finished painting. The smaller size allows us to capture our feelings more quickly, as they are happening. This sentiment seems to me to be inherent in all smaller works. Does

Seine Nocturne
Pastel on board
79 x 229 cm (31 x 90 in)
Painting in triptych is an exciting approach to landscape painting. For me, it breaks a painting down to a beginning, middle, and end. I use this to encourage a sense of journey.

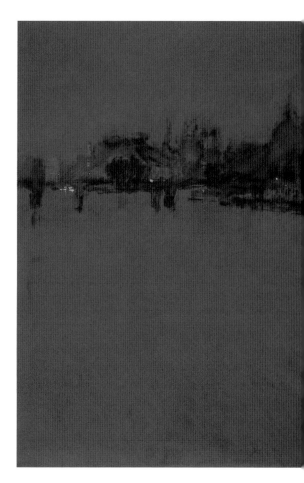

this mean therefore that larger works are less intimate and personal – that large automatically equates with loud? I do not think this need be the case. Admittedly, large works will always draw attention, and if you want to say something loud, then large is probably the way to do it. But I also think that larger works can create a special sort of intimacy. The scale means we seem that much closer to what is being depicted; there is the silence that comes with large empty spaces; and the work is more a part of the world around us and less simply a picture of it.

Choosing the format of board or paper has a great influence on the final composition. Assuming that we work to the square or rectangular, there are numerous standard sizes of paper that have evolved over the years. Mostly these sizes and shapes are traditional rather than functional or particularly aesthetic. Either way, these should not dictate the artist's preference. If we wish to start with a pleasing, balanced oblong, then one can always consider a variation on the Golden Mean (see page 116), especially if we are going to introduce this compositionally. I would not want to recommend this. If we start thinking mathematically, even at this stage of the composition, we are likely to dilute our natural instincts. For a lot of my work, instinct tells me to work just off the square, say 75 x 80 cm (30 x 32 in), or 120 x 130 cm (48 x 52 in). This I find a comfortable shape to work with, either in landscape or portrait orientation. The ratio of these sizes (approximately 1:1.07) does not impose itself on the

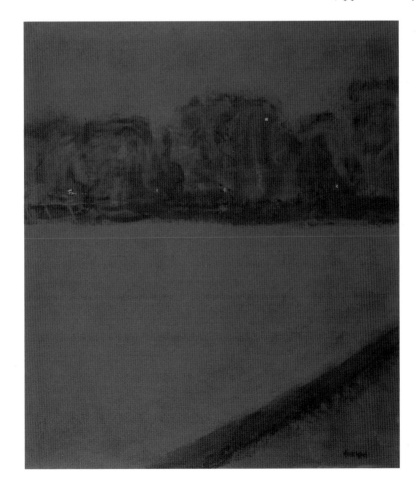

composition, as neither length nor width are dominant, but it also avoids the formality of the square. To avoid stagnating, I do experiment with many other ratios. The greater the ratio, the more significant the painting's orientation becomes. In the West, we tend to read landscape-shaped paintings from left to right, and portrait from top to bottom. Because of this, landscape ratios lean towards telling a story, while portrait ratios are closer to making a single statement. The greater the ratio, the more this applies. The lesser the ratio, the more we reach a compromise.

Making decisions based on these understandings is the first significant step in the compositional process. It is probably something most artists do not do consciously, and in most cases it is probably best left to instinct. It is always helpful, though, to have some understanding of what our instincts dictate.

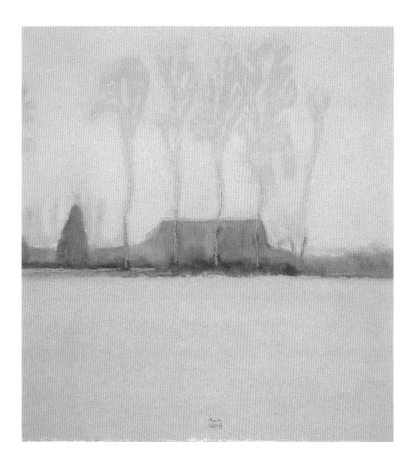

Veneto Landscape
Pastel on paper
68 x 68 cm (27 x 27 in)
The basic composition of trees and building has been drawn into the top layers of pastel, revealing the colour beneath.

Seeking Inspiration

Although I have discussed favourite subject matter, it is important to understand what it is that then inspires us to paint. I do think it helpful to identify and come to terms with just why we want to put pastel to paper. What are we trying to achieve by transposing our feelings into a two-dimensional image? If we do not have a proper sense of purpose, then our attempts to compose will most likely flounder. It is knowing what we are trying to achieve that encourages our own compositional technique. We need to develop a personal language of colour, shape and texture that allows us to express fluently. Knowing that we have this language is then our inspiration. It is all very well being excited by the colours of a sunset, but it is only knowing that we have a way of visualizing that excitement and sharing it with others that inspires us to head for the studio, or reach for the sketchpad. Inspiration comes from having confidence in our technique and taking joy in our ability.

Over many years I have evolved my own approach. As a professional artist I rarely have the luxury of waiting for inspiration to strike. Commissions and exhibition schedules leave little time for flights of fancy. Every moment spent in the studio is precious and I need to be as productive as I can. This is not that difficult. The more I have painted, the more I see the world the way I paint. I no longer need to seek out inspiration because I find it all around. As our skills develop, it becomes less important to seek out the picturesque and meaningful, for we are better equipped to create it for ourselves. That is our purpose.

Inspiration, then, comes from within. Although I travel the world, sketch, photograph, meet people and exchange ideas, my paintings come from how this has affected me rather than from direct translation. Nearly all my paintings come from memories. Sketching helps me to see and to remember, but I rarely use this as the basis for a painting. Nor am I particularly happy painting something directly before me, however visually exciting. There is usually too much visual disturbance to work direct from life, and the dust has yet to settle. Each of our minds are full of a lifetime of wondrous images that have distilled over time into something essential. The art is to make best use of our skills and materials to bring these forth, and inspire in others that which has inspired us.

Canal Saint Martin, Paris
Pastel on board
75 x 85 cm (30 x 34 in)
A strong diagonal draws us into the painting, and along the towpath.

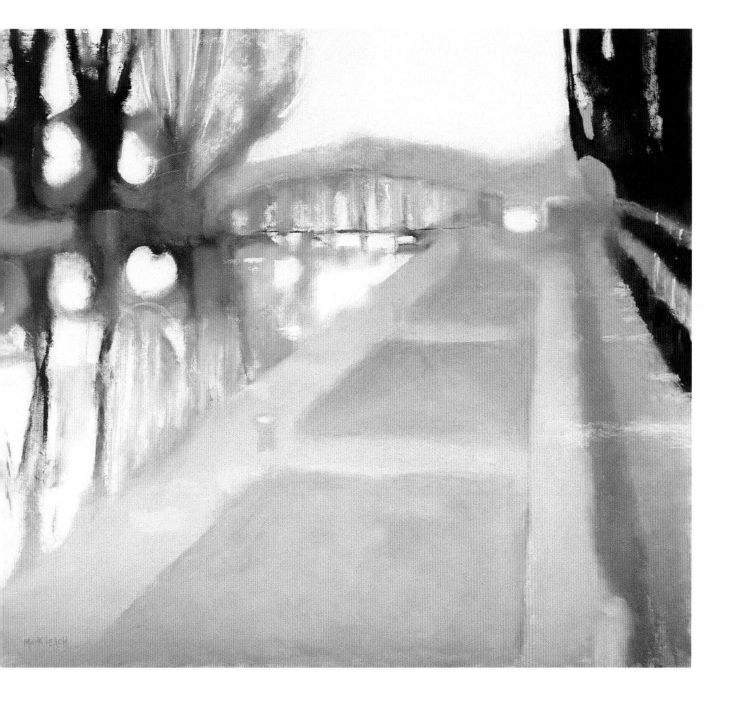

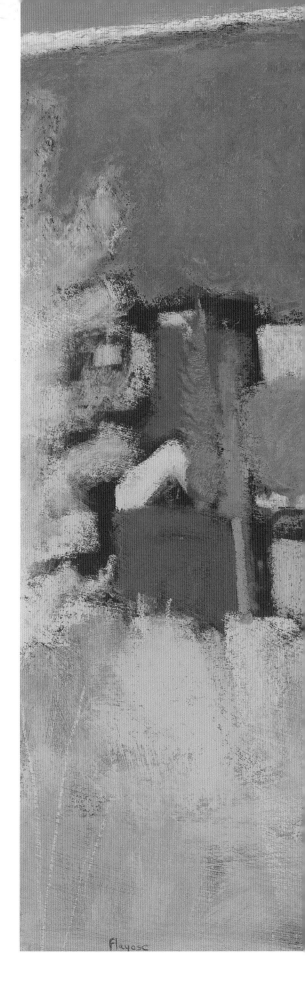

Working in Two Dimensions

The art of pictorial composition is the considered arrangement of two-dimensional colour. Understanding what inspires us to do this is essential. When we look at the world, the third dimension stretches to infinity. This is a difficult concept for us to deal with. By removing the third dimension we make the world more accessible and manageable. This is what drives our image-making.

Working in two dimensions demands rationalization: even without our own interpretations, the process will transform any painted object into a subject. However representational, a two-dimensional image will always be subjective, an act of creativity by one person for the sake of communication to others. A painting is always no more than this: a set of flat shapes and colours that can tell a story, yet be appreciated for their own two-dimensional qualities.

It was the work of Paul Cézanne that, more than any other, encouraged an awareness and appreciation of the two-dimensional nature of painting. To him, the flatness of the picture plane was all. He understood that proper balance was essential to composition. His later works explored ways of uniting space and volume through careful consideration of texture and colour quality. He was the first prominent artist to encourage us to see beauty in the two-dimensional form of a painting as well as its interpretation of its subject matter.

When painting today, we cannot ignore Cézanne's legacy. Gone are the days of the need for the representational. Since the advent of photography, and all that has followed, we no longer marvel at how a two-dimensional image can represent a three-dimensional world. The skills and trickery of perspective and tonal modelling are no more than optical illusion. To me, there no longer seems to be much purpose to this. If we simply try to reproduce what we see before us, then all we are doing is returning what should be subjective back to being an object; we risk losing all sense of expression and humanity, and therefore art. What excites us about Cézanne's apples, for instance, is not that they look like apples, that they appear real, but the manner in which they have been expressed.

Flayosc
Pastel on board
75 x 80 cm (30 x 32 in)
Foreground, subject matter and background are
combined through colour and tone.

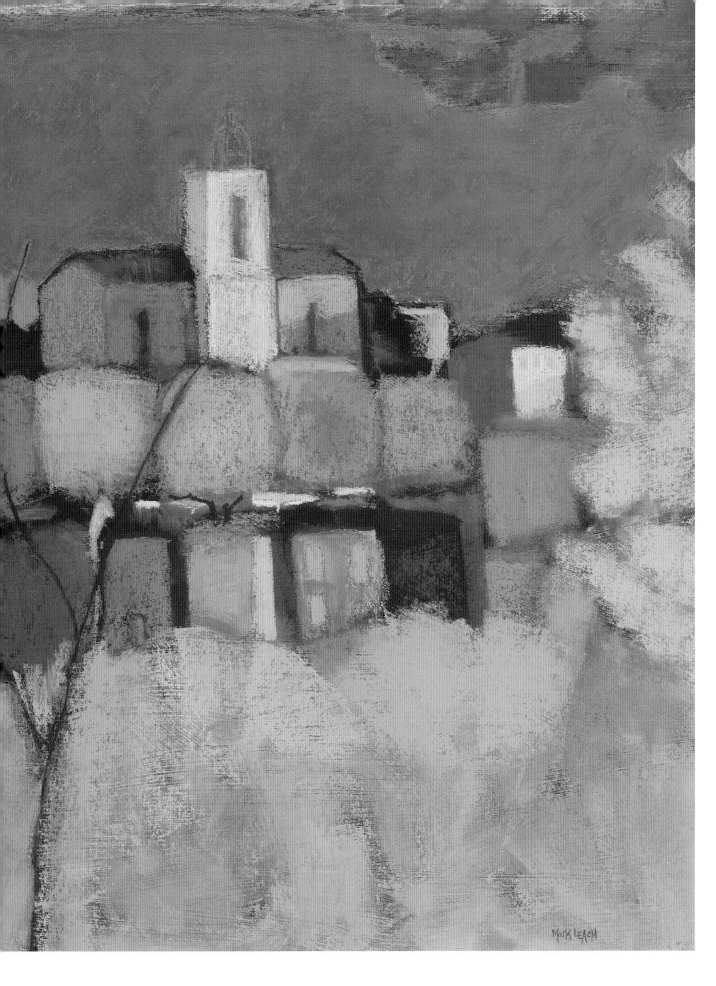

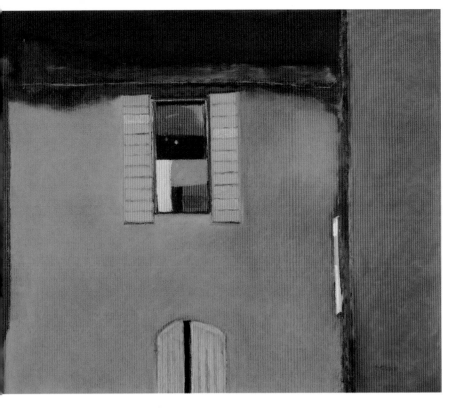

Window in Arles
Pastel on board
75 x 80 cm (30 x 32 in)
Sitting outside a café one evening, I could not take my eyes off this window. The green shutters with complementary red interior proved an irresistible combination.

Maine
Pastel on paper
68 x 75 cm (27 x 30 in)
Placing subject matter centrally can give it symbolic and spiritual significance.

Principles of Composition

There is little to fear in the art of composition. Fortunately, no-one is qualified to say that this painting is right or that painting is wrong. Our mentors are there to open our minds to other possibilities, not make judgment. The only critic an artist really need pay heed to is himself. It is only the artist who knows what he wants to say and how he is attempting to say it. When it comes to composition, only we know if we have it right or wrong.

Having said that, why are we so often dissatisfied with our work? What is it about our composition that frustrates us? Why do we often feel something is lacking? The answer is almost always balance. Balance is fundamental to the natural world, to the way we live and think. Our inclination in all things is to balance and harmonize. In many ways painting is, above all else, a celebration of balance. It is our way of making sense and reason out of confusion.

Balance is my absolute ideal, not only in terms of composition but subject matter as well. My work is essentially about the balance of humanity and nature, and this must be evident also in the composition. From the moment I start a painting, each mark I make relates to what has gone before. I am performing a balancing act. If the work is a landscape I will usually start at the top, which more often than not is the sky. As this is applied, I am constantly aware of the empty space below. Because this has been under-painted, there is already a contrast of colour forming between sky and land, and this must be carefully balanced. If I then sketch in some distant hills, a third plane is introduced. This will no doubt upset the original balance, and so my next marks will attempt to redress this. A figure placed in the foreground will add a weight that must be offset elsewhere. And so the process continues, constantly seeing the developing work as a whole, where no one part is more important than another.

Grand Canal II
Pastel on board
75 x 80 cm (30 x 32 in)
A simple balance of colour and texture. I was very pleased with the elemental strength of this composition, which any further detail would have diluted.

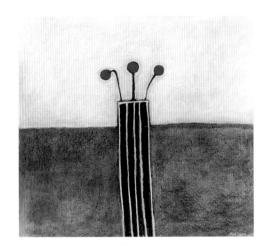

This does not mean that I am aiming for symmetry – far from it. Perfect symmetrical balance, where two sides are equally proportioned, tends to the clinical and mathematical. If both sides of a painting, or a part thereof, have exactly equal prominence, then our eyes come to a full stop. For our eyes to move around the painting, certain areas need to dominate and draw our attention, but these must be balanced so that we naturally gravitate and move on from one to another. It is creating this movement that gives the composition life.

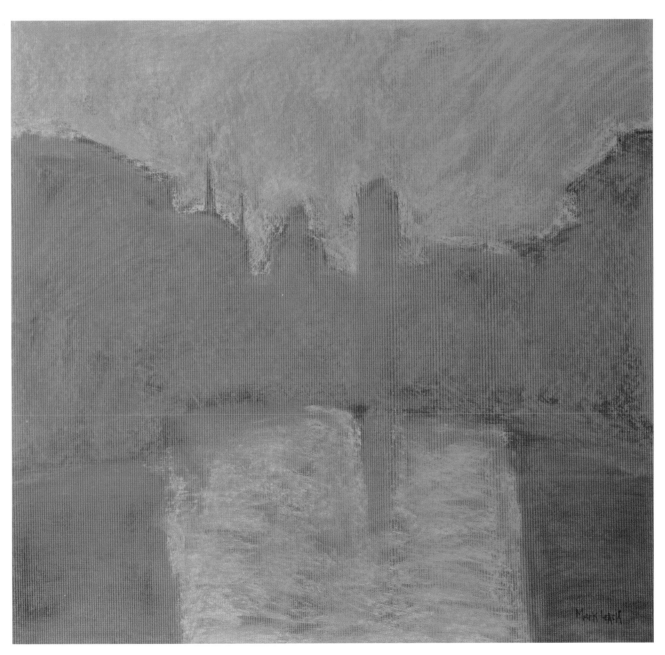

Creating Balance

Compositional balance is achieved in many ways. Firstly we must consider linear design. This is either the initial drawing or, if you start your composition, as I do, by laying down areas of colour, the lines created where the areas of colour meet. Whereas tone suggests depth, and colour light, it is this two-dimensional design that tells the story. The principal balance of a composition is dictated by this design, so it is essential that it sits comfortably within the picture frame. Mostly this is an intuitive skill – among the most important an artist can develop. There are aesthetic tools that can assist, such as the Golden Mean (see page 116) which are fascinating in themselves but better used to see where we may have gone wrong, rather than dictate how we should start. A simple test for balance is to imagine two lines bisecting the painting vertically and horizontally (dividing the area into four equal parts). Does each part have equal strength and purpose? If not, then it may be necessary to add extra weight by altering the design, or through changes in the tonal or colour contrast (as described below). The same test should be applied to each quarter in turn. The important point is, if it doesn't feel quite right, it isn't. If you do not achieve balance at this stage it is probably not worth carrying on.

When balancing the linear component of our paintings, we should also be aware of the effects of linear perspective. Even if we are not using perspective to create an illusion of depth, our eyes will automatically seek the vanishing point of two or more converging lines. This we can use to our advantage, but we must always be careful not to let this direct our eyes out of the composition.

The next consideration is tonality. The quartering exercise can be repeated, this time considering the composition in terms of dark and light. If there are very dark or light areas, then these are best balanced through areas of the opposite brightness. This reflects the natural world, where the strongest light produces the darkest shadows. Whereas linear design is strictly two-dimensional, tonality also suggests depth, with lighter shades appearing nearer on the picture plane, and darker shades receding. This apparent third dimension also needs to be carefully balanced.

Maintaining tonal balance while painting with pastels is relatively straightforward, as one tends to use sticks of equal strength at each stage of the work. Starting with a dark undertone, my first steps are usually taken using a contrasting light tone. The colour at this stage is less important, but will usually be analogous (similar) or complementary (opposite on the colour wheel). What is important is to use a reasonably strong contrast to effect an overall balance of tone and form. It is essential that I get this stage right, as the rest of the painting will depend on it.

Linear and tonal balance must be maintained as the painting progresses, but as more colours are introduced, I need to consider and balance their properties as well. The two principal considerations are the effects of complementaries, and colour temperature. By using complementary colours we can both enhance or temper the effects of tonal contrast. With temperature, we have seen that cool colours recede while warm colours appear

Camargue III
Pastel on paper
63 x 63 cm (25 x 25 in)
The Camargue region in the south of France has always fascinated me. I love its flatness, and my paintings explore this. To this end, a warm violet sky gives balance to the more detailed foreground.

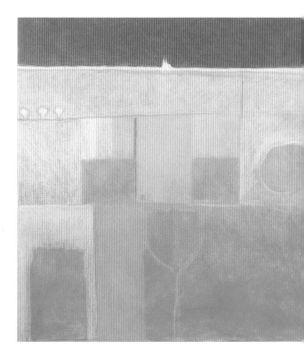

Towards Chartres VI
Pastel on paper
80 x 83 cm (32 x 33 in)
Without a strong sky, the main area of this painting would have been far too dominant. Even so, it was necessary to limit the foreground detail for best effect.

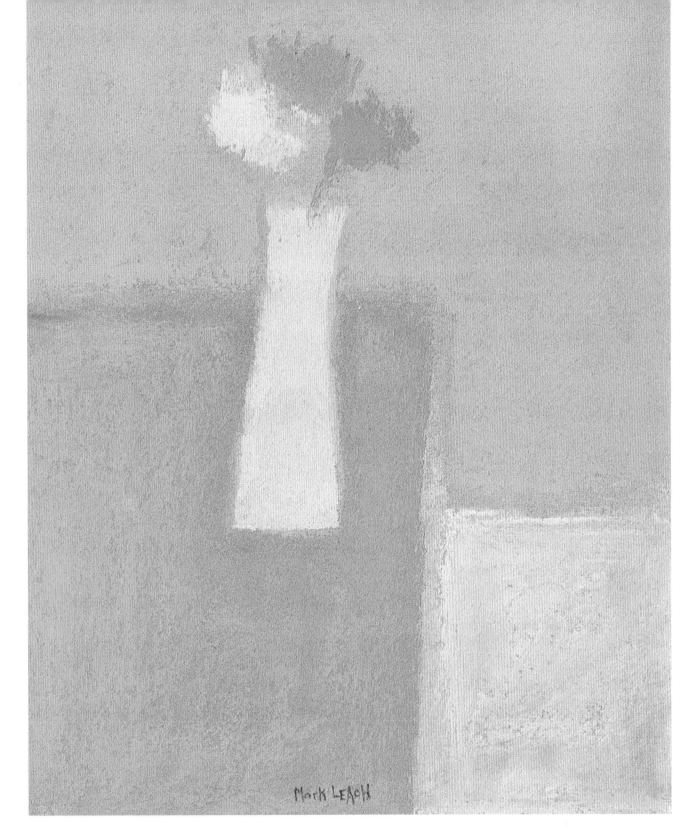

Flowers in Yellow
Pastel on board
30 x 25 cm (12 x 10 in)
Closely related colour and tone aids overall
balance. A slight diagonal introduces an
interesting tension.

nearer. When we combine this effect with that of tonality, and possibly also linear perspective, the fun really begins! These spatial illusions can give a tremendous depth to our compositions. The important thing to remember is that we should never be daunted by these effects, but enjoy and benefit from the power they give us. Tone, form and colour are our compositional tools and will do whatever we tell them to. They give us all the control we could possibly want.

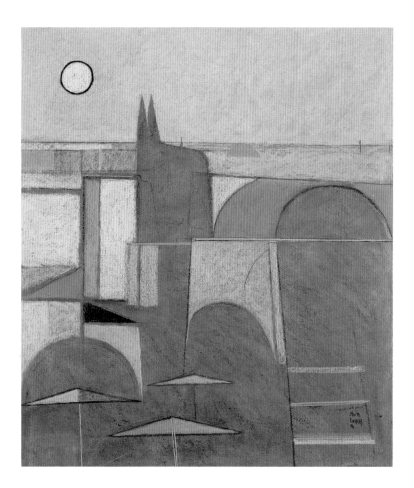

Cologne
Pastel on paper
88 x 75 cm (35 x 30 in)
An early composition using loosely geometric
forms. Proportional balance is often better
sensed than calculated.

The Golden Mean

One of the best-known methods for reaching balance within a picture is by use of the Golden Mean (sometimes also called the Golden Section). This special ratio, possibly first discovered by the ancient Egyptians during the construction of the Great Pyramid, gives us the most natural and satisfying proportion when dividing a line, or creating a rectangle. The ratio derives from that point in a straight line where the length of the shorter portion is in the same ratio to the larger as the larger is to the whole. In numerical terms this ratio, which is referred to by mathematicians as *phi*, is, to three decimal places, 1 to 0.618. In other words, roughly 0.6 of the length of the line, or a little less than two-thirds.

This figure is fundamental to us in many ways. Scientists have discovered that it applies to widely divergent aspects of the natural world: cellular growth, the way petals grow on flowers, population expansion, the spirals of a shell, and proportions of the human body, to name but a very few. It is little wonder that we naturally relate to this proportion, for it is a part of our very make-up. The ancient Greeks made much use of it in their architecture, as did the Romans. Spaces between columns, doors and windows, in fact whole buildings, were often proportioned on the basis of the Golden Mean. In the world of the arts, Leonardo da Vinci was one of the first to knowingly apply the ratio to his work, and it was probably he who first named it the Divine Proportion. His monumental painting of the *Last Supper* is infused with this proportion. Since then, many artists have made conscious use of the ratio for the sake of perfect balance and to convey a sense of the spiritual.

Provence Farmhouse
Pastel on paper
42.5 x 57.5 cm (17 x 23 in)
Without any conscious consideration on my part, the top, bottom and centre of this farmhouse all fall into the proportions of the Golden Mean. This probably happened because I was aiming for a natural sense of calm.

In many ways, when we look for beauty, it is the proportions of the Golden Mean that naturally guide us. Generally, our compositions will tend towards this proportion without us consciously seeking it. If, like Leonardo, we were to measure and calculate our paintings totally on this basis, our works would soon risk losing their humanity. The Pointillist painter Georges Seurat (1859–1891) made much use of the Golden Mean. If we look at some of his major works, such as the *Bathers at Asnières*, there is a pleasing structure and formality, but the natural spontaneity of life on the riverbank seems to me to be missing. In many ways, then, it is necessary to be aware of the effect and power of the Golden Mean, but not consciously design work on it. If we accept that the ratio approximates to two-thirds, and base the focal points of our compositions with this in mind, then this will make for the most obviously pleasing balance of subject matter and overall design. However, remember that the skill of the artist is to push and bend these given rules, to explore and celebrate that which science and mathematics have yet to explain.

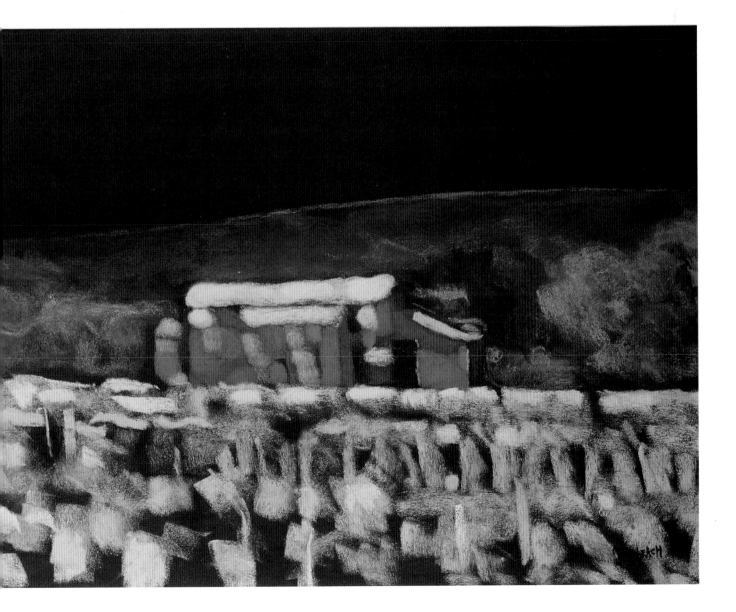

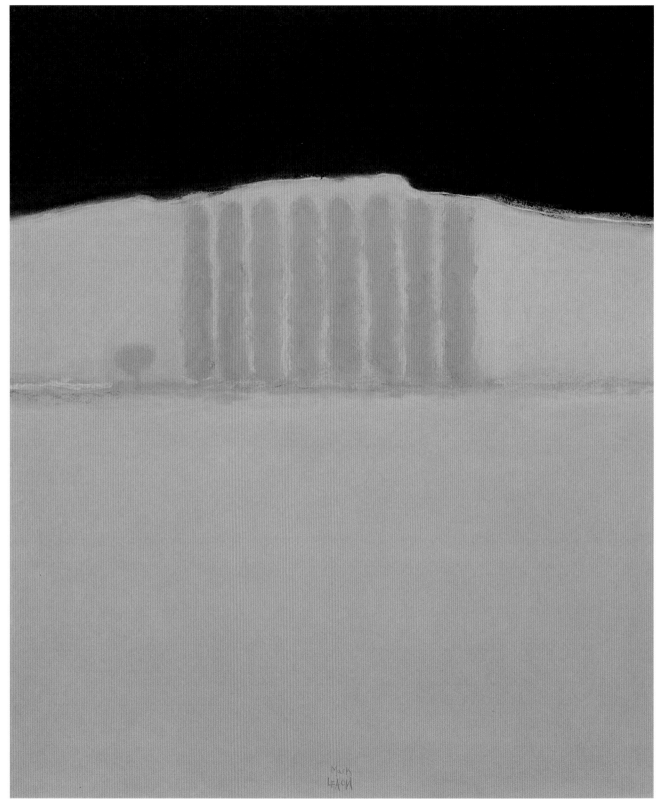

Canal du Midi II
Pastel on paper 71 x 66 cm (28 x 26 in)
A dark, almost black sky gives strength to an otherwise calm and reflective landscape. The gentle, uplifting qualities of the blues and greens are emphasized by a powerful contrast. The black gives extra weight to the sky, providing a more balanced and complete composition.

Silent Tree
Pastel on paper
60 x 43 cm (24 x 17 in)
This is not a painting of a particular landscape,
but a sensual interpretation of the nature of the
land. My concerns were the organic and natural,
the tree as a symbol of growth, and the faint mark
of humanity.

Abstracting the Image

If nothing else, the advent of abstract art taught us that we can view a painting purely as an object in its own right. A composition need not represent or illustrate, but can be enjoyed simply for the structure of its colour and form. Nowadays, painting has evolved still further: in many cases, the purely abstract has returned to the more figurative. The language of painting has moved on. However, abstraction has left us more conscious of a painting's structure; its plastic qualities are as important as the image it depicts. Even the finest of fine art now depends on the language of abstraction.

I find that my own work depends very much on its abstract qualities. A satisfying and exciting balance of two-dimensional form is essential to all successful paintings, and if a painting cannot stand on its own in this respect, it will undoubtedly fail. To me, composing is no more than abstracting what I have seen and how I feel about it. Abstraction is not the goal, but it is how I realize my ambition and quantify my inspirations: it is the way of reaching the essential.

Is there method to this approach? Many would teach that we abstract through reducing what we see to a more simplified form. There are obvious examples, such as not painting every leaf on a tree, or every blade of grass. These certainly remind us that all painting is a form of abstraction. However, I tend to think of this approach as an act of reduction rather than creation. I see little point in what is only a simplified image, however well crafted. Instead, I work with what my mind has already abstracted. By concentrating on the canvas before me and slowly building up colour and form, ideas and memories come back to me, forms will start to appear and take on significance. For instance, in *Canal du Midi II* I started with a plain blue undertone, but little other thought in mind. As I started to apply a pale blue-green pastel to the whole area, my mind wandered to the Midi, and vague memories of the distant canal in the peace of the early morning. All is calm and still, and a strong light starts to break through the mist. The forms of tall poplars are the first things to take shape as the sun starts to rise. I am not trying to recreate what I saw, because it is probably an amalgam of many experiences looking over that landscape. What I am remembering of these experiences is indistinct, but it is presumably the distillation of what mattered to me. I do not need to consciously abstract further, for that has already happened. All irrelevant detail has disappeared over time, and left me with something intrinsic, even spiritual.

Towards Chartes III
Pastel on paper
80 x 88 cm (32 x 35 in)
The simple, abstract qualities of this composition
are what give it strength and purpose. This is
essential to all composition.

A Summary of Compositional Technique

I have emphasized the necessity of balance and harmony for a successful composition. Inherent in our need to express visually is the mastery of two-dimensional form, colour and tone. To achieve this, we have to train ourselves to become fluent in seeing and thinking two-dimensionally. In the same way that one can only become articulate in a foreign language by thinking in it, we have to overcome the translating phase and think hue, shade, form, pastel. Only then, having overcome our conscious concern for technique, will we start to get places.

In other words, the art of good composition only comes with time. In my time I have hopefully evolved and progressed, and learnt a few tricks along the way. Mostly I have learnt by making mistakes, and not being afraid to. More importantly, I have studied the works of others, the great masters that are always there behind us, looking over our shoulders and egging us on. Their influence is invaluable.

In addition to all I have said, I list a few further thoughts on composition that may prove useful:

- There is no such thing as background. Positive and negative spaces are equally important.
- Always work from dark to light, or light to dark. With pastel the choice is yours.
- The centre of interest is always in the light. This is where the eye is drawn first (especially if rendered in warm colours).
- The darkest areas should ideally be contrasted with the lightest.
- Tonal contrast should be increased when colours are weak, and reduced when colours are strong.
- Do not divide the painting. Strong horizontals should be tempered by verticals, and vice versa.
- Horizontals and verticals will suggest calm, whereas diagonals encourage a sense of movement.
- Even a slight suggestion of verticals at the base of a painting will help to give it weight and structure.
- The eye will naturally start at top left and move to bottom right (this is why we normally sign our work at bottom right), as if reading a page of text. Use high points to encourage the eye back around the painting.
- Occasionally view your painting through a mirror to get a fresh view of its compositional balance, though remembering that we have composed with the above in mind.
- Periodically turning the painting upside down, and working on it this way, will help overcome errors of balance.
- The joy of the two-dimensional can easily be lost through perspective.
- Texture, especially with pastel, can greatly influence movement and direction. Blended areas tend to calm and rougher textures to excite.
- It is not something I do, but if a composition has failed and cannot be rescued, careful cropping (cutting one or more sides to make a picture of a different size and shape) can often restore balance.

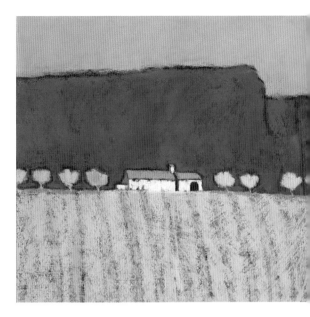

Lubéron
Pastel on board
76 x 81.5 cm (30 x 32 in)
Fields of lavender, and cherry and olive trees, surround this typical Provençal farmhouse. Rising behind, the ancient hills of the Lubéron massif dominate. I have expressed this simple, dry landscape through heavy layers of pastel on a strongly textured ground. The farmhouse is central to life here, and its importance is signified by its position in the composition.

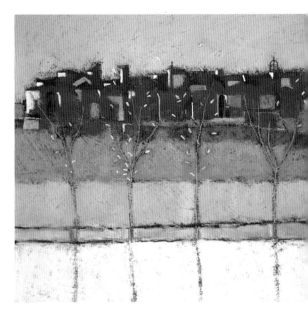

Midi Landscape
Pastel on board
75 x 80 cm (30 x 32 in)
In this composition, strong, static verticals and horizontals are tempered by the playful movement of leaves on the trees.

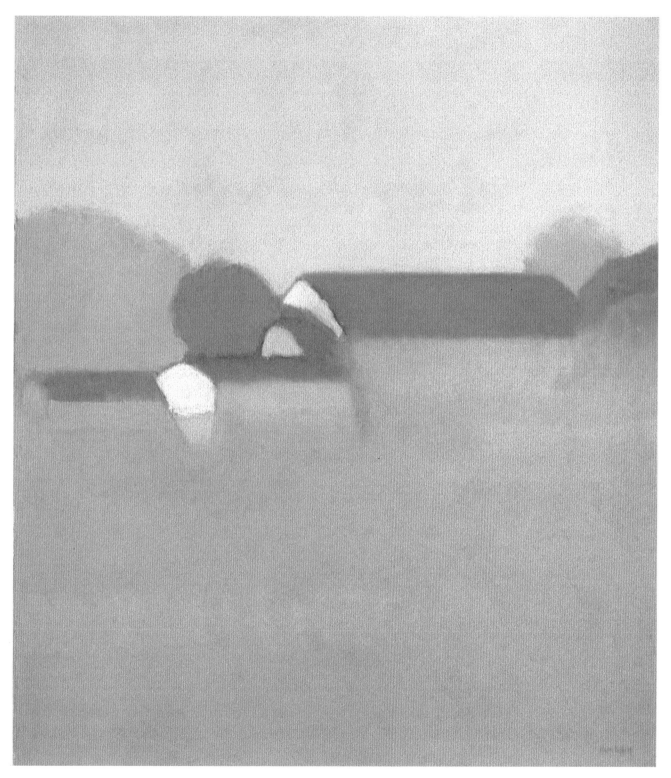

Sunrise – Périgord
Pastel on board
85 x 75 cm (34 x 30 in)
As the sun slowly rises, colour grows out of the
blue-grey dawn.

Working from Sketches and Photographs

A lot of practical art guides place emphasis on the use of preparatory sketches. It is generally assumed that these are a fundamental part of the painting process. We are told that a major painting requires a degree of planning and exploratory drawing before we commence on the work itself. Many artists feel a sense of guilt if this is not the case. I have to admit that I very rarely approach a new painting in this way. I can certainly see the point as regards a very large mural, or any other situation in which the size and shape of the painting are predetermined and cannot be changed. Michelangelo must have had a fairly clear layout in place when he started painting the ceiling of the Sistine Chapel, but in most cases I find this approach too formal and academic. Unlike the times of the Renaissance, painting today is viewed as a means of expression as much as an exercise in skilled craftsmanship. Craftsmanship today is more concerned with capturing the artist's feelings, which a too-considered and technical approach tends to stifle. Certainly, I like to think of even my largest works to be themselves primarily sketches. I approach all my work as I would a sketch, since even if it takes me many weeks of toil to complete, it is essential that I maintain that sense of spontaneity. To my eye, the very essence of painting and image-making can be found in the simplest of sketches. In many cases I find that smaller sketches by the great masters say far more to me than their major compositions. For instance, the small watercolours of Venice by Turner have a wonderful sense of intimacy and immediacy, whereas I find his grander oils on the subject a bit staged and excessive. I would therefore recommend that every sketch, however basic, be considered and approached as an artwork in its own right. If you use a sketch as a basis for a larger work, ask yourself what you expect to gain by the preliminary stage. The act of sketching helps us to see, explore and remember, but is probably best not copied from. In the studio, I ideally make use of what my sketches have taught me, but I only refer back to them, possibly to confirm detail or formal aspects, once the painting is well under way.

The same should apply to the use of photographs. Once again, many artists suffer pangs of guilt over working from favourite snapshots. This is, of course, absurd. Genuine artists will make full use of everything they can get their hands on. Working from life is a fabulous experience, and essential to some artists who feel that it is the only way to truly see and capture reality. However, this is not the only function of art, or the only way to approach painting. Photography is such a wonderful invention that any serious artist would be mad not to make full use of all it has to offer. I agree that copying directly from a photograph can be a stale exercise, in the same way as from a sketch, but if you are not too fastidious about it, it can be a great stimulation to the imagination. In the studio, I often use both photographs and sketches to stimulate or bring back memories. However, I would not copy. I would put them aside during the painting process, to prevent them imposing on my thoughts, and I would only refer to them again, if at all, towards the end to clarify particular detail.

The advent of digital photography has opened up all sorts of possibilities with regard to image-making and understanding the

San Giorgio
Pastel on board
75 x 83 cm (30 x 33 in)
If not painting on site, it would be impossible to depict such classical architecture without reference to sketches or photographs. I ensure I know my subjects well enough that this is only necessary in the final stages.

way pictures are composed. For any artist who is genuinely fascinated by colour and the two-dimensional, there are all sorts of fascinating software, such as Photoshop, to help us manipulate images downloaded from a digital camera. Once again, there are purists who would strongly condemn such games. I see their point, and of course no artist wants something else to do the work for him, but anything that helps us see the world in different ways should be welcomed, not shied away from. As with photographs and sketches, Photoshop is simply another tool that has allowed me to find new ways of playing with colour and form to excite my imagination, and I feel my pastel painting is all the better for it.

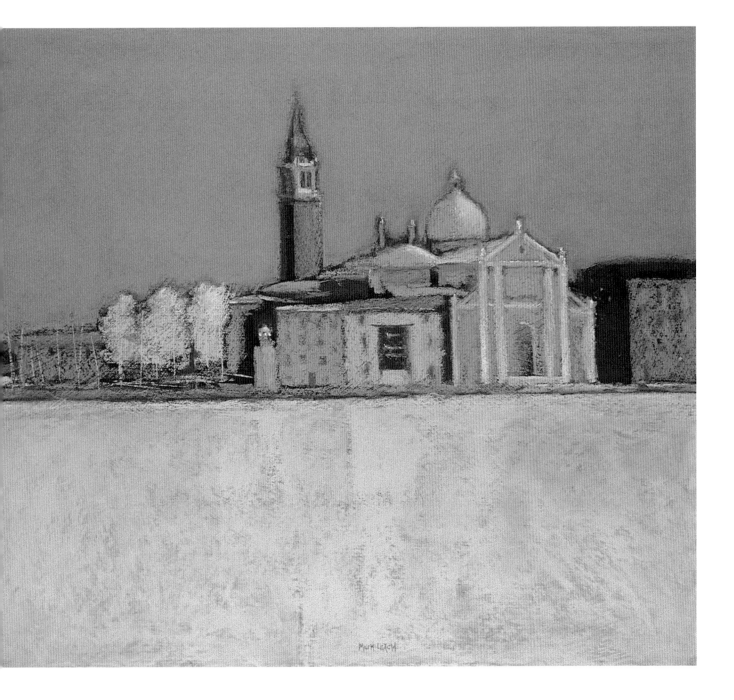

Stages of Development

The view of the Institut and Pont des Arts shown here was intended to balance the formality of the intellectual centre of Paris with the informality of the natural world. This theme is, I hope, evident in most of my work. I am fascinated by the way our species feels the need to impose its will by trying to improve upon the natural world. Our paintings are, in a way, also a part of this process: an attempt to make sense out of chaos.

I started this work with a prepared piece of mount board, coated with a mix of acrylic primer and pumice dust. This was painted with a base coat of acrylic ultramarine to a size of 70 x 80 cm (28 x 32 in). With this board mounted on the easel, I initially had little idea what I was about to paint. The base coat was a fairly dark tone, which encouraged me to work from dark to light. To this end, my first move was to make use of a lighter-toned ultramarine pastel, which I applied roughly but evenly over the

Institut
70 x 80 cm (28 x 32 in)
A favourite subject that combines the formal and the natural, with strong diagonals and horizontals. It is a challenge I often return to.

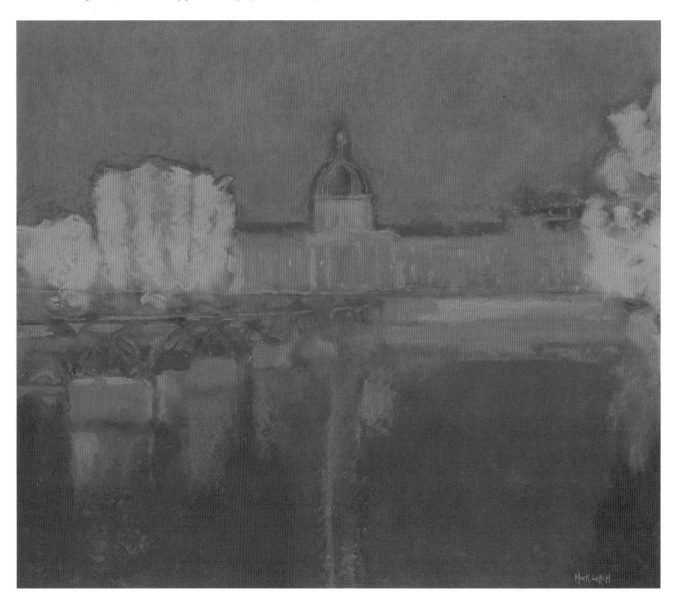

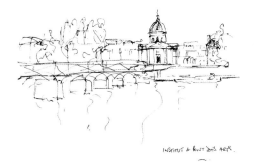

INSTITUT & PONT DES ARTS.

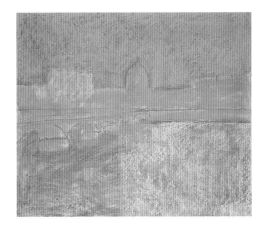

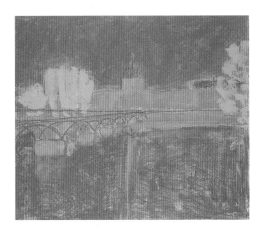

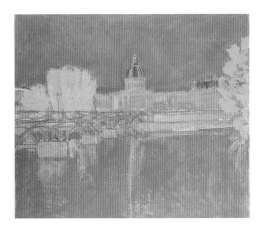

board, working from top to bottom. At this stage, my only thoughts were that this would probably be a landscape, possibly of Venice. To this end, I took a lighter tone of ultramarine and roughly blocked in an impression of water. It was only at this point that I made a decision as to what the subject matter would be – a Parisian scene rather than a Venetian – and with a further shade of blue vaguely sketched in the formal shapes and structure of bridge and buildings as best I remembered them.

I was not worried at this point about being true to the scene, but just used my many memories of this part of Paris to create a balanced composition. This is the most critical time, and a good composition is essential for the rest of the painting to work. Although I made no conscious decisions on the overall structure, it is interesting to note how the top and bottom of the central buildings both respond to the Golden Mean. If the buildings were higher, then the focus would have been on the water; any lower, and they would have possibly divided the picture. The dome of the Institut appears centrally, for initial impact and a sense of formality.

It was now time to develop the composition, and tell the story. At all stages of composition, it is my intent to do this using the least amount of detail as possible. The more I leave out, the more the viewer will put in, and be able to relate to the painting. Too much detail tends to repel, and dampen curiosity. The painting at this point seemed a bit monotone. If I highlighted the buildings they would be too prominent, so I needed to darken the sky and the water to retain the balance. For the sake of maintaining a sense of calm and dignity I decided to use only closely related colours, based on the primary blue. Contrast and balance would instead be created through tonality and temperature. Highlighting the trees with a cool blue-green against the warmer ultramarines gave a sense of depth and movement to what was a rather flat composition. I also felt it necessary to anchor the buildings and bridge to the bottom of the painting through a suggestion of reflection. This will always help a painting with strong horizontal lines.

Only at this stage did I feel it helpful to refer to some earlier sketches. I wanted some degree of accuracy with regard to the overall architecture, or at least an idea of what seemed important at the time of sketching. Adding touches of detail to the buildings improved balance with the foliage and the darkest tones of sky and water. Extra highlights were added to the dome to encourage a central point of focus. Most highlights were made with contrasting blue-green for added depth and movement. Finally, I wanted to remove as much sense of line as I could from the painting (not easy when it includes a bridge made of steel girders). In a colour composition, strong lines are often divisive, which causes disharmony. To overcome this, I gently blend lines and any hard-edged contrasts with my finger, all the while moving over the painting to maintain the overall balance.

Finishing a Painting

It is commonly agreed that one of the great arts of composition is knowing when to stop. This is generally something that comes with time and practice. It is not so much that the less skilled or less experienced have the urge to keep on working, but that poor basic composition at the start of the process leads to a painting that always seems unfinished. As compositional, and therefore painting, skills develop, we find we can stop at almost any stage and still have a satisfactory painting. The pressure is off.

I always aim to stop my painting as soon as possible. The less I have had to put in, the closer I feel I have got to the essential. My composition of the view down the rue Lepic in Montmartre was just such a case. I found the initial blocking-in of colour so pleasing that I knew any further work would detract from the sensation. This does not happen very often; mostly we are driven to explain our painting through further and further detail. This inevitably leads to ongoing changes in compositional balance, which we then have to redress, and we can seem to find ourselves turning in never-ending circles. This certainly has to be avoided with pastels, where any more than three working layers will usually kill all original colour. In some ways this can be helpful, for by this stage there is often no alternative but to throw the painting away: good riddance to bad composition.

I can usually tell that I am pleased with a painting when I have the urge to put my name to it. This quite often happens at a very early stage. I know from that point that I have got it right, and the feeling is like riding on the crest of a wave. At other times I keep working until, hopefully, I reach that point. If the point does not come, well ... you cannot win them all. Unfortunately, if you do reach perfect balance, it will be impossible to add a signature without upsetting that balance. Conversely, the final signature can often be placed in such a way as to fully complete the final composition.

These are possibly minor concerns, but this is a major point to reach. All that has gone before – the inspiration, the emotional highs and lows, the creative struggle – have slowly been reduced and refined. We never reach absolute perfection, but in our attempts we have taken a fascinating journey. It is not necessarily the destination that matters, but the journey. Each painting tells that story.

From rue Lepic
Pastel on paper
60 x 50 cm (24 x 20 in)
From the heights of Montmartre we look into the heart of Paris.

Côtes du Rhône
Pastel on canvas
105 x 95 cm (42 x 38 in)
Seeking the essence of the vine-covered hills and mighty Rhône.

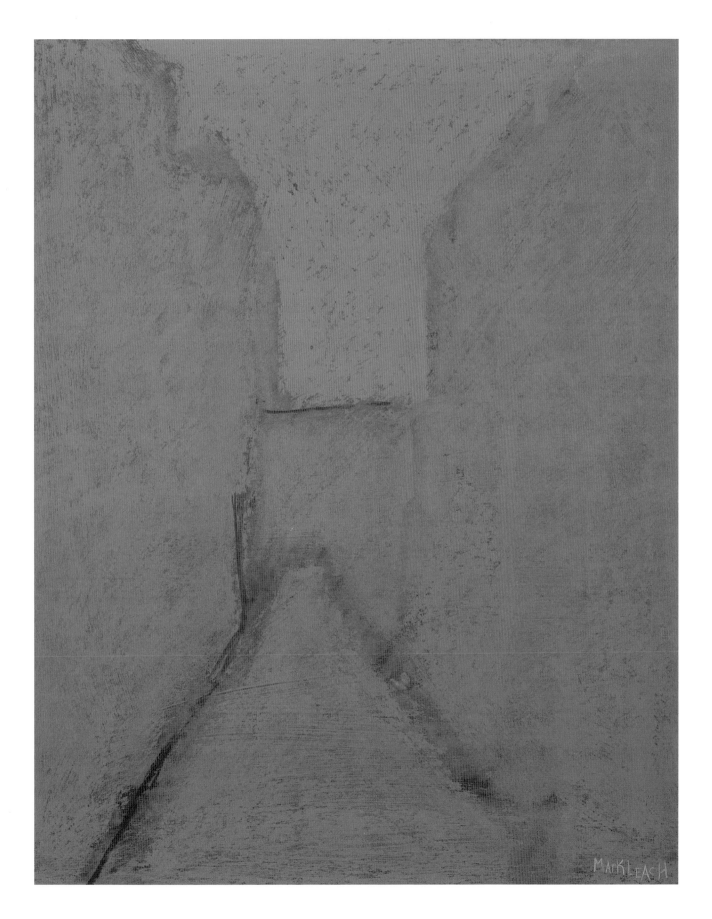

Index